D1572538

STUDIES IN AFRICAN LITERATURE
▼▼▼▼▼▼▼▼▼▼▼▼▼▼▼▼▼▼▼▼▼

The Arab Avant-Garde

Recent titles in

STUDIES IN AFRICAN LITERATURE

A Teacher's Guide to African Narratives
Sara Talis O'Brien

Women's Voices in a Man's World: Women and the Pastoral Tradition in
 Northern Somali Orature, c. 1899–1980
Lidwien Kapteijns with Maryan Omar Ali

Running towards Us: New Writing from South Africa
Isabel Balseiro, editor

Alex La Guma: Politics and Resistance
Nahem Yousaf

Recasting Postcolonialism: Women Writing Between Worlds
Anne Donadey

Colonial Histories, Post-Colonial Memories
Abdelmajid Hannoum

Aeroplane Mirrors: Personal and Political Reflexivity in Post-Colonial
 Women's Novels
Elizabeth Morgan

Less Than One and Double: A Feminist Reading of African Women's Writing
Kenneth W. Harrow

Truth and Reconciliation: The Confessional Mode in South African Literature
Susan VanZanten Gallagher

Forms of Protest: Anti-Colonialism and Avant-Gardes in Africa,
 the Caribbean, and France
Phyllis Taoua

Remembering Africa
Elisabeth Mudimbe-Boyi

"City of Steel and Fire": A Social History of Atbara, Sudan's Railway Town,
 1906–1984
Ahmad Alawad Sikainga

▼▼▼▼▼▼▼▼▼▼▼▼▼▼▼▼▼▼▼▼▼▼▼▼▼▼▼▼▼▼▼▼▼▼▼▼▼▼▼

The Arab Avant-Garde

Experiments in North African
Art and Literature

Andrea Flores Khalil

PRAEGER

Westport, Connecticut
London

Library of Congress Cataloging-in-Publication Data

Khalil, Andrea Flores.
 The Arab avant-garde : experiments in North African art and literature / Andrea Flores Khalil.
 p. cm. — (Studies in African literature, ISSN 1351-5713)
 Includes bibliographical references (p.) and index.
 ISBN 0-325-07129-2 (alk. paper)
 1. North African literature (French)—History and criticism. 2. Arabic literature—Africa, North—History and criticism. 3. Literature, Experimental—Africa, North—History and criticism. 4. Arts—Africa, North—Experimental methods. I. Title. II. Series.
 PQ3988.5.N6K46 2003
 840.9′961—dc21 2003052893

British Library Cataloguing in Publication Data is available.

Library of Congress Catalog Card Number: 2003052893
ISBN: 0-325-07129-2
ISSN: 1351-5713

First published in 2003

Praeger Publishers, 88 Post Road West, Westport, CT 06881
An imprint of Greenwood Publishing Group, Inc.
www.praeger.com

Printed in the United States of America

The paper used in this book complies with the
Permanent Paper Standard issued by the National
Information Standards Organization (Z39.48-1984).

10 9 8 7 6 5 4 3 2 1

▼▼▼▼▼▼▼▼▼▼

Copyright Acknowledgments

Portions of these chapters or earlier versions were published as follows:

Chapter 1: a small portion appeared in French as "Rhizomes, corps, et villes d'origine dans *Talismano* d'Abdelwahab Meddeb," in *Nouvelles approches*

des textes littéraires maghrébins ou migrants, volume 27 (Paris: Har-
mattan, 1999).

Chapter 3: an earlier version appeared as "Ruin and Affect in Assia Djebar's
Vaste est la prison," in *Alif: Journal of Comparative Poetics*, number 20
(Cairo: American University of Cairo Press, 2000).

Chapter 4: a different version appeared as "Images of Another Tunisia: A
Film Trilogy by Moncef Dhouib," in *The Journal of North African Stud-
ies*, volume 7, number 2 (London: Frank Cass, 2002).

Chapter 5: parts appeared as "The Myth of the False: Ramses Younan's Post-
Structuralism *avant la lettre*," in *The Arab Studies Journal*, volume 8,
number 2 and volume 9, number 1 (Georgetown University, fall 2000–
spring 2001).

Chapter 6: an earlier version appeared as "A Writing in Points: Autobiog-
raphy and the Poetics of the Tattoo," in *The Journal of North African
Studies*, volume 8, number 2 (London: Frank Cass, 2003).

▼▼▼▼▼▼▼▼▼▼

Contents

Preface, ix
Introduction, xiii

PART ONE
MULTILINGUALISM OF THE NORTH AFRICAN NOVEL

Chapter 1
Metamorphosis and Modernity
3

Chapter 2
Other Voices, Other Spaces
29

Chapter 3
Ruin and Affect
47

PART TWO
THE VISUAL ARTS AND POLITICAL RESISTANCE

Chapter 4
Film and the Mystic Image
67

Chapter 5
Poststructuralism *Avant la Lettre*
83

PART THREE
URBAN SPACE IN NARRATIVES OF RETURNING HOME

Chapter 6
The Forked Idiom
101

Chapter 7
The Fault Line
115

Conclusion
131

Appendix: Plot Summaries of Films by Moncef Dhouib, 135
Notes, 141
Bibliography, 149
Index, 155

▼▼▼▼▼▼▼▼▼

Preface

This book was written over a span of about six years, from 1996 up until the fall of 2002. What was most appealing for me about writing this book was that each chapter was written in a different place, and almost each one in a different country. The first chapter I wrote, on Abdelwahab Meddeb, was part of my doctoral dissertation, and I wrote it in Fontenay, France while at the Ecolé normale superieure in 1997. While I was in Morocco during the year 1997–1998, I wrote two chapters, on Abdelkebir Khatibi and Mohamed Choukri. During that instructive year in Morocco I interviewed as many writers as I could find. They were all generous and interested in the work being done on them and on Moroccan literature. Armed with loads of material and impressions I had collected in Morocco, I returned to Cambridge, Massachusetts and wrote the chapter on Mohamed Khaïr-Eddine and his fiction of trauma and cultural marginalization. After graduating from Harvard, I went to Cairo, where I had a one-year teaching appointment. During that year, I researched and wrote about Ramses Younan and his avant-garde artistic group Art and Freedom that was based in Cairo during the 1940s. I met the late Younan's wife, a charming and humble woman who divides her time between Paris and Cairo and lives among her husband's paintings and (some) still unpublished writings. The last chapter I wrote, on Moncef Dhouib, was written last year (2001–2002), during which I had a visiting position in Tunis, Tunisia. Dhouib is perhaps the most subversive of the recognized Tunisian film-makers, and I found his work more contestatory and penetrating than the other film-makers that I met and studied in Tunisia. That said, Ferid Boughedir was a fascinating, good-humored, and extremely helpful interlocutor. I interviewed Dhouib after I finished writing the chapter on his trilogy, and became close friends with his wife Maha. Most of the introduction and conclusion were written in Brooklyn, New York.

Each chapter was somewhat of a life experience—getting to know people, engaging in long-distance travel, learning dialects, expressions, local urban geographies, train schedules, and literary milieu or scenes. I loved this

period of my life, which was not just about conducting research on art and literature in North Africa but was also about learning how to live in Morocco, Egypt, and Tunisia and interact with the people who live, work, and create art there. I talked to all of these writers except for Ramses Younan and Mohamed Khaïr-Eddine who are deceased. That human contact added an inexplicable yet always independent level of engagement with the project. Especially the conversations with Abdelwahab Meddeb, conducted on different occasions in Casablanca, Cairo, Tunis, Paris, and Rabat, have been a considerable intellectual inspiration to me while writing this book. He is one of the more insightful and inspiring thinkers about the Arab world and I feel privileged to have been able to converse with him about his and my work. Conversations with Abdelkebir Khatibi, Mohamed Choukri, Moncef Dhouib, Assia Djebar, and the wife of the late Ramses Younan were also important experiences. Some conversations were more formal, verging on interviews, but most of them were very open, relaxed, and enriching. I always waited until I had finished that chapter before sitting down with the writer in question. I was fascinated while comparing my impressions of their work with their own readings of their work, but I never felt an impulse to change or submit my interpretation to the author's different and sometimes more pragmatic approach. The two perceptions remain wonderfully independent interpretive experiences. I'm not sure if any of those exchanges show through or emanate from my analyses, but those conversations have all left deep impressions upon my memory and very positive feelings about the writing of this book.

Although most of the writing and thinking about this book occurred in Morocco, Tunisia, and Egypt, there was a significant amount of it that was produced in the United States, namely Brooklyn and Cambridge. On the U.S. side, some of my colleagues and mentors have been very helpful and interested in my work. Susan R. Suleiman has remained a strong intellectual influence on me and I am grateful to her for initiating me into the study and scholarship of the European avant-garde. Tom Conley has also been a solid mentor, advisor, and even translator for this book. He generously translated some of those tough passages by Meddeb; he was the only translator whom I felt confident could do justice to Meddeb's baroque style of writing. Both he and Susan Suleiman were always available, even at long distances, to give their expert opinions and human support. John P. Entelis has been the most supportive of the U.S.-based specialists of the Maghreb. He is brilliant on "things Maghrebi" and has the best sense of humor in the field. Aida Bamia was kind enough to read through this book before it went to the publisher, and her reading helped me in the prepublication stage. I'd like to mention my dear colleague Clare Carroll at Queens College whose enthusiasm in an-

ticipation of this book's publication has been refreshing and very supportive. In addition to these people, it is my husband Mohamed and our daughter Noha who have helped in keeping me happy and grounded during an otherwise very nomadic few years of writing.

▼▼▼▼▼▼▼▼▼

Introduction

This book is about experimental art and literature of North Africa, predominantly but not exclusively written in French. In my analysis of these experimental and subversive texts and images from Tunisia, Morocco, Algeria, and Egypt, the general problematic is not particular to the geographical area of North Africa. The general problem that I am referring to is the recent and still partial emergence of minority literatures and marginalized voices into an international, global discourse. The tensions between local and global, traditional and modern, authentic and general have been raised by countless scholars in relation to many regions of the so-called Third World. My reading of the literary and artistic production of North Africa is part of this corpus of scholarship on the cultural production of the "Third World." However, my primary aim is not to produce an overarching theory about the global phenomenon of the emergence of previously spoken-for cultures and their literatures. I am more interested in describing the particular cultural dilemma and the literary texture that is created when Arab writers from North Africa engage idioms of the "Other," in particular European avant-garde and French poststructuralist theories.

On this matter of my use of the term "avant-garde," I would like to provide a caveat. I am not referring to an Arab avant-garde group *per se*. Although there have been groups of artists in North Africa and the Middle East that have considered and even called themselves avant-garde, I am not aiming to study any of these particular groups. Even if they make reference to notions of the European avant-garde, I am not situating this selection of writers in direct relation to the historical avant-garde movements that we know of as Surrealism, Dada, and Futurism. These movements were entirely against any notion of the past or tradition, and as I will make clear, these writers I am studying in this book express a desire to draw new relations between their past and their future. The reason I have used the term avant-garde in reference to these writers is that the way they make connections to the past is experimental; they are completely opposed to a pure and simple

restoration of the past in the definition of their future. The way in which they establish a relation to the historical and literary past is troubling in the contemporary context of the region. I am interested in how writers from North Africa and the Middle East use the idioms of the Other to formulate a new representation of their culture of origin. The articulation of a modern Arabo-Islamic culture, when it is performed in the "avant-garde" ways that I will describe, implies its dissatisfaction with both fundamentalist and pro-Western cultural discourses. Both of these discourses, alternating in time and space, first one then the other, form the political hegemony against which these writers are struggling. These literary texts are experimental performances, strategies, and creative processes by which a new image of a historically engaged Islamic identity can be forged. These writers are not so preoccupied with representing their relation, deeply conflicted as it is, to the colonizer or the colonial language itself as they are with finding tenable solutions to problems of their own disrupted cultural history. These writers, in a rejection of on the one hand Islamic fundamentalism and on the other hand Western folklorism, are haunted by the need to produce a new aesthetic and language by which to represent Arabo-Islamic culture. This new aesthetic language contains in its fabric many politically and culturally charged questions; for example, how do these writers articulate the process of literary self creation given the thorny issues of colonialism, Islamic fundamentalism, and bilingualism that are at work defining their art and their writing?

What is experimental or avant-garde about these texts is the way in which Western languages and discourses intervene in the representation of the Islamic past and the Arabic literature in relation to which these writers continually situate themselves. Despite the ironic and critical distance with which Francophone North African writers regard their own Arabo-Islamic identity, there remains an overwhelming perception of similarity between their avant-gardist literary preoccupations and the preoccupations they glean from a distant cultural past. Whether or not they write in French, these modern literary figures of North Africa continually reach back into history in search of their literary genealogy. By way of introduction, I will start this book by describing an uncanny riddle that is at once contemporary and ancient. It illustrates the ironic engagement of both prior and present cultural idioms. The riddle demonstrates how the contemporary North African writer continues to gather and rewrite fragments of Arab literary precursors, even when writing in the French language. The reference to and content of this riddle is instructive for understanding contemporary North African Francophone literature and perhaps the art of the region in general.

In an essay written in 1985, a Moroccan author writing in French, Abdelfattah Kilito, draws on Jahiz, an Arabic writer from the ninth century,

to explain the bilingualism of contemporary Morocco. Establishing a cultural continuum, whether explicit or imagined, between the modern and the ancient literary experience is a predominant reflex for modern North African writers. The reason that this ancient text is brought to bear on Moroccan bilingualism is that Jahiz's text *Kitab Al-Hayawan* (Book of animals) takes up the same sentiment of loss experienced by the contemporary North African writer. The same issues of bilingualism, retracing one's steps home, and the desire to disturb the conservatism of the community come up in both ancient and modern texts. As I will explore throughout this book, this persistent relationship between modern and ancient writing is a troublesome yet seemingly necessary one. The central reoccupation of this study is the problem brought up by the desire to create such a relationship. How can writers create a new cultural identity, forge into the future, while tracing their cultural heritage in a movement backward?

The Riddle

A closer look at the following riddle will illustrate a response. The modern interpretation of Jahiz's text is an eminently playful essay and mimics the narrative structure of the riddle. The strangeness of this riddle is found in its answer because, instead of resolving a predicament, as the answer to a riddle usually does, the answer is a riddled predicament in and of itself. The question is: "Question-devinette: que faisait l'Arabe d'autrefois, quand il se perdait, la nuit, et qu'il n'arrivait pas à retrouver son chemin? Quel strategème employait-il pour trouver de nouveau les habitations des hommes, pour se retrouver?"[1] (Question-riddle: What did the Arab of yesteryear do when he lost his way, at night, and could not find his way? What strategy did he employ to find the people's homes, to find himself?) Normally a riddle would be followed by a simple answer that is, however, difficult to ascertain because of an inherent enigma in the question. In this case, the answer is both difficult to ascertain and rather enigmatic in and of itself: "Malin comme un singe, il recourt au procédé suivant: il se met à aboyer (incroyable mais vrai)."[2] (Clever as an ape, he finds recourse in the following procedure: he begins to bark [incredible but true].) The question—how does the bedouin lost in the desert find his home?—pertains to finding other human beings that he knows or returning to the civilization that he has lost. The bedouin finds his path toward home, or at least some signs of life, through a metamorphosis into a dog, and rhetorically, into an ape as well for he is "clever as an ape." The author explains: "le thème de notre propos est la perte, la privation, la diminution et la déperdition, en bref, la metamorphose."[3] (The theme of our topic is loss, privation, reduction, and degrada-

tion, in brief, metamorphosis.) This explanation of the riddle is not self-evident and increases the enigma. It suggests that the key to finding one's home is found in a metamorphosis, or a transformation into what one is not. But this is a paradox: the human must bark, becoming a dog, in order to find his way back to civilization. In order to become *oneself* one must turn into an *Other*: "pour re (devenir) un homme, il faut au préalable se transformer en chien."[4] The explanation that is given by the riddle is cleverly matter of fact: because "s'il y a des chiens dans les parages, ils vont se mettre à aboyer à leur tour et ils signaleront (les chiens hantent généralement les lieux habités) au marcheur perdu la présence des habitations et des hommes."[5] (If there are dogs in the area, they will begin to bark and they will indicate [dogs habitually hang around inhabited places] to the lost walker the presence of living quarters and of men.) However, the reader or auditor of the story should take care not to interpret this answer too literally, for if the traveler is within earshot of a dog belonging to the tribal community, he could just as easily cry out in his language. What then is the meaning of this barking? Who is this barker?

This literary allusion, written in the French language, to Jahiz's ancient text provides the occasion for an astute commentary on the situation of the Francophone North African writer of the late twentieth century. In some respects, the Francophone writer, like Jahiz's bedouin lost in the desert, is removed from and seeking to return to his culture of origin. A native Arabic or Berber speaker, the Francophone North African writer can be seen as this bedouin, deploying foreign idioms, languages, and cultural references as a strategy to return to the Arabo-Islamic origin. But like the answer to the riddle, the literary answer is as enigmatic and complex as the larger, cultural question. The response that these writers seem to repeat over and over again in their fiction is actually a question: How can I return to this identity without creating false and retrograde self-representations?

If the writer is trying to return to or at least participate in the literature of his civilization, what is responsible for his separation from this civilization? One perspective on this cultural separation has been suggested by Abdelwahab Meddeb in his recent book *La maladie de l'Islam* (2002). According to Meddeb's argument, both colonial domination of the Arabo-Islamic world and the rise of Wahabism in Arabia produced a rupture in the culture of Islamic societies. As I will note in the following analyses, there is a sense of double rupture in the North African's vision of his origin. Looking at Arabo-Islamic culture from the perspective of the Western modernist tradition in which they were educated, compounded with the purist image propagated by Wahabite Islam, North African intellectuals regard their past with increasing unfamiliarity. This rupture was gradually internalized by

writers who were born into a detached relationship to their own past. The late-twentieth-century Francophone North African writer is writing within this inherited situation of strangeness vis-à-vis his culture of origin.

As the bedouin lost in the desert can bark to find his tribe, the Francophone North African writer can use the French language as an ethical strategy to rediscover his lost tradition. In both cases, it is not simply a question of finding the tribe. The question has been overladen with a new urgency that seems to have been already written in the ancient. It is a question of restoring the tribe's humanity, of restoring the dignity of the community, a matter of civilizational life and death. The bedouin would neither regain his humanity nor continue to live at all if he did not bark, for he would be stranded and probably die in the desert. Likewise, the threat of cultural disappearance threatens the Arab writer. A refusal to look critically at oneself can lead to total disappearance of the already weakened culture. How one returns to one's cultural origins has become a question of survival. A total erasure of the language of the other, which reproduces the unethical strategies of colonial relations, would suggest the irreversible marginalization of one's cultural language. As I have already suggested, Islamic fundamentalism (and its destructive cultural conservatism) excludes other cultures and languages. As Deleuze and Guattari remind us in their pertinent work *Kafka: Pour une littérature mineure*, the minoritarian use of foreign language (in this case, French) revitalizes and recreates the (here, Arabo-Islamic) culture in which it is spoken. Kafka's Gregor, like our lost bedouin, like the weakened Arab culture, has spoken in a foreign and monstrous language in a vital attempt to conserve the community's humanity. But their project is not a simple one, and both Kafka's Gregor and Jahiz's bedouin encounter resistance and some difficulties.

Gregor, who turns into a giant beetle, in the *The Metamorphosis*, is beaten with objects and mortally wounded when his family pounds him with an apple core. Likewise, the bedouin's community is threatened by his subversive transformation into a dog. There is general social resentment with respect to the introduction of the foreign, barking "idiom." In the riddle, the bedouin who undergoes metamorphosis (the barker) reconfigures the home and the native language as potentially duplicitous. This conception of the home society and language remains contrary to the traditional legends of the community. "Canine Words" reads: "aucun mythe, aucun conte (parmi ceux qui circulent dans la tribu) n'a raconté l'histoire d'un homme qui se serait mis à aboyer"[6] (no myth, no legend [among those that circulated in the tribe] ever told the story of a man who started to bark). The conservative forces within the community sustain a collective myth of homogeneity with respect to its behavior and language. Again, let me point out that the tale can

be seen in light of current trends in North Africa and the Middle East, particularly the rise of religious fundamentalism and cultural purism since the early 1980s. The Francophone North African writer disturbs dominant conceptions (both Western and Middle Eastern) of the Arab literary community. Clearly, not all North African intellectuals agree that Arabo-Islamic culture should reexamine itself, and certainly not through the idioms of the West. As if to illustrate this, the barking bedouin disturbs the religious practices of his tribesmen: "Lorsque les siens débattent de choses sérieuses, il formule son opinion par un jappement incongru et profanateur, qui trouble les cérémonies les plus sacrées."[7] (When his people discussed serious issues, he stated his opinion with an incongruous and profaning yap that troubles the most sacred of ceremonies.) The presumed homogeneity of the community is threatened by the new perception of its language as strange, inhabited as it now is by another, incomprehensible language. The barker is the critic, the subversive but humanizing citizen who puts into question the current trends of his society. The barking is threatening because it produces a new discourse, a new heterogenous idiom running contrary to the conventional and coercive unity that defines the community. It is in this way that I consider these writers "avant-garde."

Both for the barking bedouin and the avant-garde writer, this multilingual idiom is always a strategy for rediscovering the humanity of one's community. The texts treated in this book, although written in French and clearly influenced by French culture and criticism, are always representing a critical place from which they can see, understand, and reinvent their home. "Barking" is an interstitial, artistic location allowing for a new relation to the mother tongue and civilization. Whether the metamorphosis is through writing in a foreign language as if it were maternal (texts of Meddeb, Djebar) or speaking the maternal language as if it were foreign (texts of Choukri, Dhouib), this metamorphosis consists of an understanding of the self and home vehiculated through foreign conceptual or iconic idioms. The cultural origin is rediscovered through the expression of its repressed multilingualism. But as we shall see, this repression comes in many forms and is not just in relation to the Western idioms. In Algeria, the Berber language is culturally marginalized, and in Tunisia, the Arabic language becomes the object of politically motivated cultural repression.

The Minor Literature

This subversive literary language—this bedouin's barking—is not a metaphor. It is an example of a metamorphosis. The bedouin's simulation of the dog is a perception of the mother tongue, the home, identity as a metamor-

phosis, a process of becoming someone new. Since this is a book about liter-
ary production and analysis, I would like to take some time to clarify the dif-
ference between these two literary terms, "metaphor" and "metamorphosis."
In *Kafka: Pour une littérature mineure*, Deleuze and Guattari explain:

> La métamorphose est le contraire de la métaphore. Il n'y a plus sens
> propre ni sens figuré, mais distribution d'états dans l'éventail du
> mot. . . . Il n'y a plus ni homme ni animal, puisque chacun déterri-
> torialise l'autre, dans une conjonction de flux, dans un continuum
> d'intensités reversible.[8]
>
> (Metamorphosis is the opposite of the metaphor. There is no proper
> meaning or figurative meaning, but a distribution of states in the
> inventory of a word. . . . There is no longer either man or animal,
> since each deterritorializes the other, in a conjunction of flux, in a
> continuum of reversible intensities.)

A metaphor banks on, indeed gains the reader's interest through the opposi-
tion of elements: man–dog; African–French; Muslim–non-Muslim. The
Francophone Arab writer, like the bedouin barker, is not reaffirming a dou-
ble identity (Maghrebi–French). The experimental writer articulates Maghre-
bi identity as a metamorphosis between two cultures that have come to re-
press each other due to historical circumstances. If the Arab avant-garde is the
general theme of this book, then metamorphosis is the operative literary
trope. Metamorphosis is a conceptual space of loss for both these elements:
"dog" no longer means what we thought, nor does "human." Maghrebi is no
longer the opposite of French. It is an immobile traveling between places, a
de-subjectifying process, stealing the dog's meaning for the human's becom-
ing, robbing the human's meaning to become the dog. What Deleuze and
Guattari write about *devenir-animale* (becoming an animal) is appropriate to
quote in this context: "[C]'est que la métamorphose est comme la conjonc-
tion de deux déterritorialisations . . . le devenir-animal ne laisse rien subsister
de la dualité d'un sujet d'énonciation et d'un sujet d'énoncé, mais constitue
un seul et même procès, un seul et même procès qui remplace la subjectiv-
ité."[9] (It's that metamorphosis is like the conjunction between two deterrito-
rializations . . . the becoming-animal leaves nothing of the duality between
the subject of enunciation and the pronounced subject, but constitutes one
and the same process that replaces subjectivity.) A Francophone writing in
North Africa involves a metamorphic entry into a conceptual horizon, a
movement into the interstices of what foreign and native identities signified
in metaphoric language. These Francophone writers do not simply embrace
or reject their Arabo-Berber culture or religion. They are describing a return
to Arabo-Islamic identity that disturbs and disrupts the ideological discourse

that defines this identity by silencing criticism, polyvocality, and heterogeneity within Islamic societies.

In a related discussion, Homi Bhabha describes the immigrant's de-territorialization of national (metaphoric) languages. The Francophone Maghrebi writer is like an immigrant in his own country and disrupts nationalist and xenophobic languages. Bhabha writes:

> The patriotic voice speaks in metaphors. The foreign use of the national language articulates the death-in-life of the metaphoric idea of the "imagined community" of the nation; the worn-out metaphors of the resplendent national life now circulate in another narrative of entry permits that at once preserve and proliferate, bind and breach the human rights of the nation.[10]

The avant-garde Arab writer "demetaphorizes" the relationship of language to national identity. Speaking like a foreigner in his own country, he incorporates the outside, the geopolitical Other (Britain, France, the West) into the language of the postcolonial nation (Algeria, Egypt, Tunisia, Morocco). Learning from the violences of history, this writer courageously steps outside the dialectic that has made him a victim, seeking a new and ethical form of nationalism that does not rely on the position of the Other as enemy. A humane and sovereign nation can better be spoken through an inclusive language of national identity. The colonialist and nationalist languages used by the French colonizers, postcolonial dictators, and their successors need to be abandoned. The Francophone writers of North Africa that I am calling the "Arab avant-garde" push ahead into another historical version of their national identity. They do not react to their weakened state by looking back, through ossification of their African-ness or Arab-ness or by a blind acceptance of the superiority of the West. They seek to produce a language that dissolves the repressive ideologies of their societies, they untangle, through the web of their fiction, the problems of fundamentalist returns to Islamic authentic identity. According to our previous example, they all confront the problems of postcoloniality through a disruptive "barking" metamorphosis. They are disruptive writers, but are never aggressive. Their literary posture is an uncanny mourning of an identity lost in the triumph of Wahabism and colonial occupation. They are all "barkers" and seek to remain human through the language of the Other and the loss of self. The Arab avant-garde has produced a literary discourse that includes, rather than represses, the language of the socially and historically constructed Other.

I would like to step back for a moment and consider the language that I am using to describe this literary discourse. The notion "loss of identity" sounds very familiar to those versed in deconstructive approaches to cate-

gories of identity. One could claim, then, that the writers are simply adopting Western discourses or, even worse, that I am reading this literature through Western glasses. Abdul JanMohamed and David Lloyd make this important critique clear when they argue against reading what they call Third World literatures through the lens of poststructuralism:

> [T]he critical difference [between Western intellectuals and minoritarian thinkers] is that minorities, by virtue of their social being, must begin from a position of objective nonidentity that is rooted in their economic and cultural marginalization vis-à-vis the "West." The non-identity that the critical Western intellectual seeks to (re)produce discursively is for minorities a given of their social existence. But as such a given, it is not yet by any means an index of liberation, not even of the formal and abstract liberation, which is all that poststructuralism, in itself and disarticulated from any actual process of struggle, could offer.[11]

Indeed, minoritarian thinkers are writing from a position of objective "nonidentity," whereas Western thinkers have the luxury of producing this nonidentity discursively. However, it is part of the strategy of these writers to employ European critical discourses to show that they have been intellectually colonized. Their engagement with poststructuralism mimics the imposition of French values that has occurred in history. These texts consciously "speak" the language and engage these notions as part of their intellectual genealogy, pointing to their colonized identity and criticizing the hypocrisy that at once rewards and stigmatizes it. At the same time, their ironic use of the Other language is superimposed upon the ironic use of the language of religious radicalism, a language that always simulates a return to precolonial times. A strange, circular, temporal effect is produced, always returning and moving ahead at the same time.

I will give an example that will be further elaborated in the chapters on Abdelwahab Meddeb and Moncef Dhouib. The notion of loss of identity is said to be a contemporary Western theoretical construct that Western readers impose on Third World literatures that already speak from a state of nonidentity. However, in Islamic mysticism (which dates back to ancient times) there is a notion of loss of self that is valued as the highest state of spirituality. By using such a notion in their artistic creations, Arab writers are both moving backward in time and moving forward. They are critically superimposing, and indeed confusing, the so-called Eastern with the contemporary Western, and thus, on yet another level, dissipating the identity that had been defined by this "East–West" opposition. My aim as a critic is to describe the effect, the interplay of these multifarious influences on the pro-

duction of a new literary discourse. My conclusion, with respect to these avant-garde writers and perhaps others whom I have not included in this book, is that their literary discourse is threatening to the political and cultural authorities under whose jurisdiction and control they ostensibly fall. The intellectuals of North Africa, at least the ones treated here, deploy foreign idioms, not to accept or reject the historical reality of French domination of the Maghreb, but primarily to struggle against an internal hegemony that continues to rely on cultural oppositions and that risks further weakening the region. Arif Dirlik explains the importance of being critical of internal cultural hegemonies:

> In order to be thorough, the critique of culturalist hegemony must be extended to the role culture plays as an instrument of hegemony within societies. As Third World Marxist critics of culturalist hegemony have long understood, this critique of internal hegemony is not only necessary if liberation from hegemony is to be total, extended beyond the elite to the people at large, but is also a precondition of cultural liberation of the society as a whole. Those Third World intellectuals who refuse to acknowledge this necessity take recourse instead in the affirmation of a pre-Western tradition as a source of contemporary identity, or simply reject that tradition in favor of Westernism as an obstacle to development, only serve as grist for the mills of Western cultural hegemonism which finds confirmed in them its own tendency to view those societies as prisoners between the past and the West.[12]

This critique of internal hegemony is central to the present study of Francophone writers of North Africa. An Arab writer's use of Western media and/or idioms engages a twofold problem: on the one hand, of how to retain one's artistic and intellectual integrity, how to remain one's self (which is already inhabited by the West) while refusing Western cultural hegemonic definitions of the self; on the other hand, how to return to one's culture of origin without complying with what Dirlik called "the affirmation of a pre-Western tradition." The subversive writer—and this is what is subversive about him/her—seeks to challenge both of these oppressive and hegemonic cultural forces. The Arab avant-garde seeks an ethical political existence (national independence and freedom from the West) while troubling all political forces, whether pro-Western or anti-Western, at work in the Arab world. Using a duplicitous linguistic or communicative practice that is excluded from the nationalist discourse, the avant-garde Arab writer is searching for an entirely new solution to the predicaments of contemporary Arab society and culture. Although some of these writers write in French and oth-

ers in Arabic, they are all critical of internal cultural politics that repress irony, critique, and bilingualism.

In part 1 of this book, I examine three novels from Morocco, Tunisia, and Algeria, respectively. I have selected a novel by the Tunisian cultural critic and novelist Abdelwahab Meddeb, one by Mohamed Choukri, a Moroccan writer who writes in Arabic, and a novel by the Algerian writer and film-maker Assia Djebar. One could argue that these three writers are too different to be compared, and indeed, in interviews I conducted, two of them made precisely this point. Nonetheless, I consider these novels comparatively, as part of a single and complex literary discourse about the multiplicity and multilingualism of Maghrebi identity. Although their styles and even languages are quite dramatically different, the three novels are haunted by a central historical and literary problem: they are all centrally concerned with a historically generated multilingualism and show how different languages can work on each other to produce innovative, critical, and experimental fictional narratives. In chapter 1 on Abdelwahab Meddeb, narrative fiction becomes its own sort of resistance to internal and external cultural hegemonies. His novel *Talismano* (1979, 1987) tells of a return to the origin through a process of metamorphosis. In this chapter I describe the notion of metamorphosis as a genealogical process and the political implications this process has for the contemporary Arabo-Islamic writer. The method of returning (to Tunis and to the origin) is actualized through a critical process of moving away from the origin. A theory of the "home nation" (inside) is conceptualized through an explosive move outside. An archeology of the self is articulated through a simultaneous movement towards the Islamic origin and the language and culture of the Other.

In chapter 2, I take up a Moroccan text titled *Al-Khubz al-hafi* (1983) that was originally written in Arabic but that was first published in English and then in French. As I will note in reference to Assia Djebar's novel, the independence struggle in Algeria ushered in and institutionalized a hegemonic dominance of the Arabic language over the French and Berber languages. With various degrees of intensity, Berbers in Morocco have also expressed what they see as the social and cultural repression of their languages to the advantage of Arabic. This relation of power is important for the production of Mohamed Choukri's autobiography *Al-Khubz al-hafi*. This "polyglot" Moroccan novel involves linguistic relationships among French, English, Spanish, Berber, and Arabic. Choukri, an Arabophone Moroccan Berber, produces a "diasporic text" that functions as a critique of linguistic hierarchies in Morocco. The subversion of this linguistic hierarchy is coupled with the questioning of a theological verticality. This critique is wrought through a linguistic and conceptual movement toward exterior cul-

tural idioms: French and Spanish languages, Christian references, and so on. The text seems to propose a vision of Arabic culture in which the self is diasporic and inclusive in its genesis. The novel's critical posture vis-à-vis Islamic theology's "vertical" conception of meaning is controversial, especially when read in Arabic. In a radical critique, the novel violently reminds the reader that originally, Islam included within its practice and self-conception elements of the pre-Islamic—the Christian and the Hebraic traditions. However, Choukri articulates this critique in a way that remains unacceptable to the majority of the Arabo-Islamic readership. This text has been rejected and censored by the Arabic literary community. This reaction is testimony to the power of the current Arabic literary community's internal hegemony and the deeply subversive quality of Choukri's fiction within this field.

In chapter 3, the notion of archeology of the self is told through a historical and archeological narrative in Assia Djebar's *Vaste est la prison* (1995). Algeria is a particularly violent context of Francophone literary production: it, more than any other North African country, was transformed into part of the French nation. The French language and national territory were powerfully and completely imposed upon the Algerian population. During and following the independence struggle, the reassertion of the Arabic language as the national language became a way to achieve independence from France—French was to be violently rejected by radical Islamic forces within the nation. It is well-known that many Algerian writers live outside of the country because of the repressive identity and language politics that have developed. As a result of the violent reassertion of Arabic, more violence has arisen from Berber communities who claim the right for Berber languages to be recognized alongside the hegemonic Arabic language. This chapter explores the perilous process of self-discovery through historical inquiry. In *Vaste est la prison*, Djebar fictionalizes (both the protagonist's and the text's) search to recover a lost Berber identity and language. This identity is sought through incessant attempts to dig up the ruins of Berber and Arab monuments. The more the protagonist attempts to put back the pieces of what she once was (or perhaps never was), the more she becomes removed from it, because all the records of the archeological digs into the ruins of ancient Berber and early-Arab Algerian sites are written in the French and English languages. Djebar's novel shows the realization that Algerian history and the protagonist's own identity are inextricably entangled with French historiography and literary history. Derrida's analysis in *Monolinguism de l'Autre* comes to bear on this look into the struggles of the bilingual author in the face of a monolinguistic and oppressive Other (the French *and* the Algerian), which is also double—in this case the "self." This inevitable and haunting multilingualism runs contrary to the political claims of identity groups violently battling for sole "custody" of Algerian national identity.

Part 2 takes up the visual arts and politics in North Africa. The end of the chapter on Assia Djebar, in the section named "The Monocle," begins to theorize what in part 2 will become the central analytical question: How does the visual image allow the North African artist to produce a critical perspectival switch? Taking the role of the scientific image-maker (historically the position of the Orientalist), these North African artists make subversive images about their own societies. In chapter 4, I show how filmic production in Tunisia confronts a strong, internal, and politically driven cultural repression. Western discourse has been used to limit and control the expression of traditionally Tunisian art forms. In the context of this cultural politics, the image becomes allied with a "Western" self-image, and the "Eastern" becomes strange, distant, and absent. I take the example of a film-short trilogy made by the Tunisian film-maker Moncef Dhouib to show how this internally generated Orientalist discourse can be turned on its head. The "image" is reinterpreted as both Western and Islamic, defying both the secular authorities as well as the Islamic fundamentalist opposition. While the other authors were still able to launch debate and criticism about their Islamic culture, it is much more problematic to represent Islam in Tunisian art, literature, and society. Dhouib is working against this double, internal political hegemony in his films *Hammam D'hab* (1985), *Al-Hadra* (1990), and *Tourba* (1995). These short films tell religious stories and deal explicitly with the practice of popular forms of Islam. The visual language of the trilogy about Islam becomes foreign in the context of the modern Tunisian image. Through this "visual barking," to return to the lost bedouin, the films produce a renewed vision of Islamic practice and critique Tunisian cultural politics.

In chapter 5, I take up the work of the Egyptian avant-garde and Francophone writers Ramses Younan and Georges Henein. These two writers engage in a debate, published in 1948, about avant-garde painting and the Surrealist definition of the art object. Although the linguistic situation of the French language in Egypt differs quite significantly from the Maghrebi context, this debate reveals that the use of French by these writers is strikingly similar to the critical posture of Francophone Maghrebi writers one or two decades later.[13] Egypt was colonized by the British and was the site of French political and economic interests as well. Seeking national independence and political and cultural pan-Arabism, Jamal Abdel Nasser aimed to exclude any foreign languages in an attempt to strengthen the Arabic language and culture. Ramses Younan's art and writing combine foreign with Arab aesthetic elements in what he believed was a more effective method of strengthening national culture. Younan worked within a Francophone artistic and literary milieu that was attempting to free Egyptian culture from what it viewed as repressive, anti-Western cultural politics that would only further weaken the nation. Younan supported Egyptian nationalism and the pan-Arabist project

of his day, but believed in the total freedom of art from the political realm. The target of his critique was the political language that would force cultural identity into a sterile and false homogeneity. His work on poststructuralism, before it was really invented, is central to our interrogation of how the art of the Arabo-Islamic world and the West communicate and mutually redefine each other. This chapter shows that the ideas that later will become central to poststructualist theory in France are used to forge new space for artistic and literary production in the Egyptian cultural field. Younan is a precursor to the other writers in this book: his work is exemplary of how multilingual forms of art in North Africa critique nationalist languages that restrict, homogenize, and censor cultural expression.

In part 3 of the book, the shared literary theme in these novels is how space—divided and interrupted in the colonial occupation—needs to be revisited and recreated in order to become "de-colonized." Both of these Moroccan narratives tell the semiautobiographical story of the narrator's return to this home city. They trace the effects of spatial compression and defamiliarization resulting from colonial transformations. Chapter 6 presents an analysis of the Moroccan novelist Abdelkebir Khatibi's *La Mémoire tatouée*. In this novel, the description of space predominates in a search for a literary language outside the binary France–Maghreb. Reflecting on his childhood, the narrator describes the space of the medina, and then the French quarter built with the arrival of the French. His childhood memories, as well as the writing itself, seem to struggle with an oppressive and antagonistic dialectic. The solution is an ancient and modern, French and Arab poetic form. The text superimposes the ancient script of the bedouin woman's tattoo onto a Derridian poetic of the writing of *différence*. Outside the binaries of the "word," outside the spatial binary inscribed in the Moroccan space (*medina–ville nouvelle*), the ancient and the modern, the Arab and the French come together in a perfectly harmonious and abstract union. The return to the script of the pre-Islamic tattoo signals a mythic romanticism that is countered by a similarly romantic folding into the language of Derrida. What remains characteristic of the Arab avant-garde is this literary discourse where, if only for a moment, the reader is at once reading the ancient Arab sign and the French language of poststructuralism.

The final chapter presents a similar revisiting of the urban space of the Moroccan home in the fiction of Mohamed Khaïr-Eddine. Khaïr-Eddine was a Francophone Berber novelist, and his Berber identity belies our title, *The Arab Avant-Garde*, for although he is an avant-garde writer, Khaïr-Eddine is not an Arab. Both he and Mohamed Choukri are ethnic Berbers, and I note how Berber marginality vis-à-vis the Arabic language and culture will enter into and further inflect their writing with an internal multiplicity. Khaïr-Eddine wrote highly contestatory prose that sometimes included

direct criticisms of the Moroccan King Hassan II. The first part of the chapter engages his novel *Légende et vie d'Agoun'chich* (1985) in which the death of Moroccan legend as the primary source of symbolic transmission is provoked by the displacement of the inhabitants from their land. The second part of this chapter focuses on his first novel *Agadir* (1967), which has long disappeared from the shelves of Moroccan libraries and bookstores. One wonders whether it is the radical poetic violence of the text or the political critique that it expresses that has earned this book its exile. In *Agadir*, cultural production is linked to the earth, as it is in *Légende et vie d'Agoun'chich*, and the novel seems to enact the earthquake that it is describing. When the Agadir earthquake occurs, which it actually did in 1960, modern techniques intervene in the reconstruction of the city. With this new architecture comes a new language and scientific way of understanding the city. A poetic and explosive language becomes a symptom of an uncomfortable—because abrupt—cohabitation of ancient and modern scientific symbolic systems. In this novel, poetic language emerges from the combination of modern language practiced in the modernized city and the memories of past idioms of cultural production.

My analysis of these North African texts is clearly situated within the field of literary and visual studies. However, the relationship between the French and Arabic languages has become political. Perhaps language is inevitably related to political power, but in this case the relation is inflected by another power relation. Arabo-Islamic and Western cultures are currently involved in political confrontation. Some elements from both sides feel mortally threatened by the other. Realistically, there is no way to divide these two cultures and consider them as separate civilizational blocks: populations, information, and culture are mobile elements and circulate quickly in all directions. The West has deeply penetrated Arabo-Islamic societies; the reverse is also true, although not from the same platform of strength. There are no visible but only mental borders to clearly divide the two radically heterogenous cultures. However, there remains a strong perception that, in a contemporary, global dialogue about culture, the Arabic language and Arabic identities remain essentially Other, because this global dialogue is Western-dominated. I firmly believe that the writers studied in this book are justly in search of future Arab identities that are not based on strategies of enmity, hatred, or fear of the Western Other. These authors' courage resides in their willingness, even their pointed determination, to examine their own civilization in all its weakness and faults. This critical examination of the self is the only way to regenerate the weakened Arabo-Islamic civilization that is continually recognized in these novels as a rich, ingenious, and beautiful one not to be easily abandoned.

PART ONE

MULTILINGUALISM OF THE NORTH AFRICAN NOVEL

Chapter 1

▼▼▼▼▼▼▼▼▼

Metamorphosis and Modernity

Abdelwahab Meddeb (b.1946) is a Tunisian writer who resides in Paris and whose many publications include *Talismano* (1987), *Phantasia* (1986), *Le Tombeau d'Ibn Arabi* (1987), *Aya dans les villes* (1999), and, most recently, *La maladie de l'Islam* (2002). Meddeb is an erudite and sometimes hermetic novelist, poet, and essayist. However, readers who manage to decipher this apparently opaque writing will discover a penetrating vision into one of the central problems faced by North African writers today; namely, what is the North African writer's position in relation to, on the one hand, Arabo-Islamic writing and culture ("the origin") and, on the other hand, Western writing and culture ("modernity")? The question has become so familiar to scholars of North African literature and perhaps to political and social science as well that it has almost lost all meaning as a question. However, the predicament is so persistent (and seemingly ever-widening in importance) that we are forced to continue to seek a solution. As if harkening back to the riddle of the barking bedouin, Meddeb's solution is located in the notion of metamorphosis between idioms of the ancient and modern, between the French and Arabic literary traditions.

In the first part of this chapter I will focus on why a search for identity must be a search through a multiple genealogy and not just for a singular origin. The explanation of the contrast between origins and genealogies serves both as an extended introduction to the problem raised in this book and as part of the analysis of Meddeb's writing itself. Perhaps more than any other contemporary Maghrebi writer, he is concerned with the phenomenon of cultural interruption and the complexity of searching for origins in the Arab world. Thus, before proceeding to an analysis of his novel *Talismano*, I will explore Meddeb's, and others', thoughts on the multiplicity of identity and what impact this has on literary and cultural production.

Origins versus Genealogies

The question of North African cultural genealogy is elaborated both in Meddeb's literary and philosophical writings. When one reads his novel *Talismano*, one perceives that it is at once a French novel and an Arabic novel—one cannot decide between the two possibilities, since it appears as a novel in metamorphosis between the two literary traditions. It could be assimilated into the development of the modern French novel and at the same time shows itself motivated by obsessions particular to the Islamic tradition and to the Maghreb's history. Meddeb's writing shows traces of the Quran and the writings of Ibn 'Arabi, Hallaj, and Sohrawardi, to name just a few of his textual precursors. He recognizes the seductive and creative power of a dialogue with myths of origin. He writes, "vous garderez de l'ancien de vives traces, vous en ferez une des sources de vos creations."[1] (You will keep vivid traces of the ancient, you will make of them one of the sources of your creations.) To become modern—that is, to continue to exist as a cultural presence in the contemporary epoch—the Arab intellectual must form a dialogue with original cultural forms: "J'ai estimé nécessaire d'appréhender ma généalogie originelle comme trace à inscrire dans le cadre culturel dominant, origine absente à faire revenir dans la scène contemporaine."[2] (I deemed it necessary to apprehend my original genealogy as a trace inscribed in the dominant cultural milieu, as an absent origin to bring back in the contemporary scene.)

However, the role of origins in the cultural of modernity is seen from the perspective of a rupture, never forgetting the violence of history, as necessarily inhabited by the interruption of colonial history and the hegemonic dominance of Western culture. Meddeb insists on the chaotic nature of the self's expression in modernity:

> Fonder un lieu dans la modernité continue à être pour moi un souci majeur. . . . Un Européen naît d'une manière naturelle dans la modernité. . . . Or, quand on est issu d'une généalogie arabe et islamique, le lieu est occulté. La tradition s'absente. La modernité n'advient pas comme une opération logique, historique. La modernité est une intrusion chaotique et subie.[3]

> (To establish a place in modernity continues to be a major concern for me. . . . A European is born naturally into modernity. . . . But when one is from an Arab and Islamic genealogy, the place is occult. The tradition is absent. Modernity does not appear as a logical, historical operation. Modernity is a chaotic and oppressive intrusion.)

In order to emerge into modernity, Meddeb explains, the Arab writers must recognize the historic interruption and cultural mixing undergone by the Arabic tradition. He writes:

Il n'est pas inutile de restaurer cette littérature si nous souhaitons briser le mythe qui fait croire qu'une langue peut être au-dessus de la loi du monde et des humains qui le peuplent, loi fondée sur le mélange et le jeu incessant des influences, des emprunts, de la traversée des frontiers.[4]

(It is not useless to restore this literature if we are to break the myth that leads one to believe that one language can be above the law of this world and the people that populate it, the law founded on the mixing and the constant play of influences, of borrowings, of crossing of borders.)

A nonrecognition of this intermingling with exterior influences produces a false, brutal simultaneity with Islamic origins. This strong assertion of the self risks leading, paradoxically, to the radical marginalization and even disappearance of the Arabo-Islamic cultural imagination. Meddeb thus refuses to advocate the return to a pure Arabic language and literary expression of Islam. "Vous avez l'intuition que jamais vous n'avez interrompu le lien avec l'origine. En effet, vous vous nourrissez d'une telle illusion pendant que la perte engloutit vos valeurs, vos signes, vos villes et vos paysages."[5] (You have the intuition that you never interrupted the link with the origin. In effect, you are feeding yourself with this illusion while loss swallows up your values, your signs, your cities and your landscapes.) Meddeb is conscious of this contradiction (communication and interruption) of the conditions of cultural modernity in the Maghreb. For this reason, he acknowledges Arab origin through the languages and cultures that have infiltrated the Maghreb throughout history. He articulates a vision of the Arabic language that will remain crucial to our hypothesis about the use of the French, Berber, English and Arabic languages in the Maghrebi narrative. Seeming to describe the Islamic origin, Meddeb writes in his article, "La disparition" (The Disappearance): "Comment instaurer la séparation d'avec l'origine (qui est préalable pour la remontée en amont) si la langue n'est pas perçue comme un paysage ayant subi d'amples métamorphoses?"[6] (How to establish a separation with the origin [that is a prerequisite for pushing ahead] if language is not perceived as a landscape having undergone many metamorphoses.) Note the crucial association of languages with geographical places that become, in minoritarian writing, a heterotopic space of metamorphosis in the French Maghrebi novel.

To demonstrate Meddeb's search for his multiple genealogy, I will look closely at the novel *Talismano* where the narrative alternately returns to one of the three points of its own origin: (1) French literary history, (2) the colonial presence as origin of the French Maghrebi novel, and (3) Arabic texts as a means of dialogue with Islamic origins. These three "origins" of writing are

elements of a metamorphosis that continually intervene in the representation of Tunis, the home city to which the narrator returns in the story. Because he recognizes the rupture with tradition and origin, Meddeb's experience of modernity is expressed *a*-rhythmically, repeatedly interrupting teleological movement. Thus interruption and repetition characterize this almost impenetrable narrative. His strategy of returning to multiple origins produces a conception of history that we see in Ibn Khaldun's seminal history *Muqaddimah* (written in the 8th [Hijra]/14th [Christian] centuries) in which history is cyclical: epochs repeatedly decaying, dying, and recommencing. Meddeb's use of this ancient Arabic historian's conception of time puts him in opposition to a Marxist, dialectical, and teleological conception of history and creates a dialogue with ancient Arab writing. Cultural modernity for Meddeb must spring from its cyclical recommencing: French being inhabited by its colonial relationship with the Maghreb, and Arabic likewise speaking through the vocabularies of European thinkers. Meddeb writes of decentering French hegemony and literary styles: "Ce décentrement diffuse à l'échelle du monde une double perspective de transformation critique, l'une troublant le canon occidental, l'autre démontant les systèmes de valeurs des cultures traditionelles d'où sont issus les écrivains et les artistes qui ont essaimé hors de leur contrée native."[7] (This decentering on a worldwide scale produces a critical transformation, one disturbing the Western canon, the other dismantling the value systems of traditional cultures from which writers and artists originated and have dispersed.) This decentering, doubled because of its targeting both internal and external cultural hegemonies, is what makes the writer "avant-garde." In addition to decentering the French language through its "Maghrebi" usage, the European language acts on the Arabic language in a critical way. Meddeb writes that in the same gesture, he effects a criticism of the sedentarism and stagnancy of the culture of origin. This part of the critique, in which Arabo-Islamic culture and interpretations of the Arabic language are problematized, is becoming more urgent given the rise of fundamentalisms across the Arab world and the linguistic struggles in Algeria. Meddeb has consistently insisted on the double-edged nature of his writing, which both works to decenter the French language and to launch a critique of traditionalist discourses of Arab identity.

The phenomenon of cultural discontinuity experienced by the postcolonial writer is echoed by a phenomenon of rupture at the origin of the Islamic tradition itself. One example is the figure of Hagar, the exiled Other of Sarah and mother of Ismaël. On this subject, the Algerian literary critic Beïda Chikhi explains that in Islamic writing, there is a more general form of separation of man from his origin that is rooted in the very text of the Quran. Chikhi writes: "En Islam, comme dans la religion hébraïque, le Livre sacré

est l'origine absolue pleine de la présence de Dieu, c'est-à-dire de son énigme irrattrapable et de son commencement indécelable; énigme de la séparation entre l'homme-lecteur et son origine, Dieu."[8] (In Islam, as in the Hebraic religion, the sacred Book is the absolute origin impregnated with God's presence, that is to say its unreachable enigma and its undetectable origin; enigma of the separation between the man-reader and his origin, God.) This ancient, textual phenomenon of separation paired with the modern, colonial imposition of separation from tradition form the double nature of a writing of separation and melancholy. What Chikhi writes about Edmond Jabès is quite true for Meddeb as well: "où tout livre se partage entre son origine et la répétition de cette même origine perdue, où tout livre est à la fois une trace et son effacement."[9] (Where every book is split between its origin and the repetition of this same, lost origin, where the whole book is at once a trace and its erasure.) This melancholy spirit will appear in many of the texts, Assia Djebar's and Mohamed Khaïr-Eddine's among them.

The doubly ruptured genealogy (Islam as rupture between the individual and the divine, colonialism as rupture within Islam) produces an effect of continuous transformation in the articulation of North African culture. These heterogeneous geographies of rupture, France and *dar-al-Islam*, are not in a relationship of metaphor but of metamorphosis. The hidden culture of Islam is manifest here as a displacement of the French. The writings of Gilles Deleuze and Félix Guattari are instructive when they write: "Une littérature mineure n'est pas celle d'une langue mineure, plutôt celle qu'une minorité fait dans une langue majeure. Mais le premier caractère est de toute façon que la langue y est affectée d'un fort coefficient de déterritorialization."[10] (A minor literature is not that of a minor language but rather that which a minority produces in a major language. But the first character is, by any means, that the language used is affected with a strong coefficient of deterritorialization.) The narrative structure of the text resembles the lines of flight described by Deleuze and Guattari and Nietzsche's formulation about genealogy. There are moments in *Talismano* that mimic this larger rhizomatic, rootlike phenomenon: "deux racines: l'une va à la mère, l'autre à la rue . . . la rue c'est pas la mère; mais la mère ça lui arrive de sortir et de se mêler des histoires de rue" (*Talismano*, 77).[11] (Two roots: one goes to the mother and one to the street . . . the street is not the mother; but it happens that she goes out and gets involved in stories of the street.) Divergent paths, emanating from distinct roots, become each other; their binary opposition is dismantled.

All the North African writers and artists that form the subjects of this book are writing literary genealogies in opposition to what they articulate as an oppressive notion of a singular origin. The two notions are quite simply

opposed to each other. Genealogy spatially resembles the Deleuzian rhizome. Yet, how can the rhizomatic be likened to the genealogical if in *Mille plateaux* the distinction is clear?: "Le rhizome est une antigénéalogie."[12] (The rhizome is an antigenealogy.) In fact, the rhizome is being opposed to a generative principle of binary nature, the Chomskian, tree-like conception of origin. The search for origin is defined by Michel Foucault as a belief in a final place of truth where identity can be located. "Enfin dernier postulat de l'origine, lié aux deux premiers: elle serait le lieu de la vérité."[13] (Finally a last postulate of the origin, linked to the first two: it would be a place of truth.) The latter concept is analogous to a literature that represents a homogeneous, nostalgic, and spiritualist formulation of the home space, and the cultural practices of that space. In this case, the home, or origin, would constitute a truth-value that sanctifies and essentializes the home space. "La haute origine, c'est la 'surpousse métaphysique qui se refait jour dans la conception qu'au commencement de toutes choses se trouve ce qu'il y a de plus précieux et de plus essentiel.'"[14] (The high origin, it's the "metaphysical overdrive that brings itself to light in the conception that in the beginning of all things is found that which is the most precious and most essential.") This notion of origin is described by Deleuze and Guattari as the *arbre-racine* (tree-root). The classical aesthetic of the root has a certain shape and logic: "Mais le livre comme réalité spirituelle, l'Arbre ou la Racine en tant qu'image, ne cesse de développer la loi de l'Un qui devient deux, puis deux qui devient quatre. . . . La logique binaire est la réalité spirituelle de l'arbre-racine."[15] (But the book as spiritual reality, the Tree or the Root as images, continues to develop the law of the one that becomes two that becomes four. . . . The binary logic is the spiritual reality of the tree-root.) This definition of identity as a root resembles structures of origin—is in fact opposed to genealogy as it is signified here. Nietzsche's concept of origin can be read as being compatible with Deleuze's root: both are opposed to the rhizomatic or genealogical.

The genealogical conception of the self is shaped like a rhizome. The main characteristic of the rhizomatic shape is exteriority and horizontality: "L'idéale d'un livre serait d'étaler toute chose sur un tel plan d'extériorité, sur une seule page, sur une même plage: événements vécus, déterminations historiques, concepts pensés, individus, groupes et formations sociales. . . . Les multiplicités plates à n dimensions sont asignifiantes et asubjectives."[16] (The ideal book would spread out each thing on a plane of exteriority, on the same page, on the same beach: lived events, historical determinations, thought concepts, individuals, groups and social formations. . . . Flat multiplicities with x number of dimensions are nonsignifying and nonsubjective.) Different or incompatible ideological systems can be in an unhierarchical communication in the rhizomatic book. Indeed, in Meddeb's fiction, historical

events, personal experience, and French and Arabic cultural registers are in a relation of open and horizontal communication: "N'importe quel point d'un rhizome peut être connecté avec n'importe quel autre, et doit l'être."[17] (Any point of a rhizome can be connected with any other, and should be.) The rhizome resembles the Nietzschean genealogy, commented on by Foucault: "La généalogie ne s'oppose pas à l'histoire comme la vue altière et profonde du philosophe au regard de taupe du savant; elle s'oppose au contraire au déploiement métahistorique des significations idéales et des indéfinies téléologiques. Elle s'oppose à la recherche de l'origine."[18] (Genealogy is not opposed to history like the haughty and profound view of the philosopher to the mole's view of the scientific mind; it is opposed, on the contrary, to the metaphysical deployment of ideal meanings and teleological indefinites. It is opposed to the search for the origin.) These notions of interconnectedness recur in the experimental literature of the Maghreb. The concept of genealogy, with its infinite beginnings and exterior openings, is opposed to the search for the origin that is singular and teleological by definition. It is precisely this exterior, accidental space that is represented by Meddeb as the performance of genealogical cultural identity.

In this and other narratives of the postcolonial Maghreb, the notion of a multiple origin is linked to the rejection of linear story lines. Foucault describes the relationship between genealogy and writing: "La généalogie est grise; elle est méticuleuse et patiemment documentaire. Elle travaille sur des parchemins embrouillés, grattés, plusieurs fois récrits."[19] (Genealogy is grey; it is meticulous and patiently documentary. It works on clouded, scratched, many times rewritten skins.) Meddeb's novel is many times written and traces these *parchemins brouillés*. The text of *Talismano* resembles "mosaïques émaillées: couleurs andalouses, motifs industriels" (p. 16) (ceramic tiles: andalousian colors, industrial motifs). The crossing paths of this image are evident from the combination of the Arab and Andalusian heritages (mosaics and colors) that coexist with the modernist architecture and motifs of the Tunisian city. The narrative of returning to the home city of Tunis is highly exteriorized according to the narrator's affect, first by the fragmenting movements of the human body. Then cultural elements will destabilize Tunis from the outside, producing an overall image of a city in ruins. Ruin is seen here as a significant image in the representation of Maghrebi space, in that its influences prove heterogeneous, scattered, and in the process of degeneration.

Returning and the Body

Meddeb's writing is constantly complicating the simplistic notion of a singular Arabo-Islamic origin. In his fictional writing, the double origin (Islam/France) is thematized through the descriptions of body. The nervous

web of the body is a sign of the multiple interruptions provoked by history. The cultural origin, which is by definition singular, becomes a multiple genealogy because of the ruined, wounded, and historically engraved body. How do these concepts take their place in literary production? These notions of the genealogical (time in Foucault) and the rhizomatic (space in *Mille plateaux*) resemble the movements of *Talismano*. In this novel, the process is inscribed in the body. The body will act as a molecular force through its nervous system, through its plurilingualism, and through the return of inaugural languages inscribed on the body. Desire generates the excavation of prior experiences and languages that confound and resist agents of repression. As the Moroccan critic Abdelkebir Khatibi describes it: "Le dialecte est inaugurale dans le corps de l'enfant; la langue écrite est apprise ensuite, et en période coloniale, cette langue, cette écriture arabes, ont été combattues, refoulées et remplacés au service de la langue française. Telle est l'archéologie de l'enfant."[20] (Colloquial Arabic is inaugural in the child's body; the written language is then learned, and during the colonial period, this Arabic language, this Arabic writing were beaten, repressed, and replaced in the name of the French language. Such is the archeology of the child.) This archeological question is linked to the search for cultural and linguistic origins. The memory of childhood takes place in an exterior place; the city of Tunis is constantly described in relation to other cities, other epochs, and other languages.

As I have suggested, the text begins with the narrator's return home to Tunis. The title of the first chapter is "*Retour/Prostitution*" (Return/Prostitution) and the first sentence of the chapter begins: "Me voici de retour . . ." (p. 15). (Here I am, back again.) Returning is linked to identity and territoriality, since home is conventionally defined by a distinction between a familiar, formative place and an unfamiliar one. However, through the effects of a body marked by historical events, the narrative of returning will include foreign lands and their languages. History has affected the body and it in turn produces a fragmented representation of space, history, and the self. The story of the narrator's return to Tunis resembles what we have described as the Foucaultian *provenance*, or genealogy, that is at once a designifying process and a performance of the relations that constitute the self. Foucault has explained this phenomenon in the following way:

> Sur le corps, on trouve le stigmate des événements passés. . . . Le corps: surface d'inscription des événements (alors que le langage les marque et les idées les dissolvent), le lieu de dissociation du Moi (auquel essaie de prêter la chimère d'une unité substantielle), volume en perpétuel effritement. La généalogie, comme analyse de la provenace, est donc à l'articulation du corps et de l'histoire. Elle doit montrer le corps tout imprimé d'histoire, et l'histoire ruinant le corps.[21]

(On the body, is found the wounds of past events. . . . The body: surface of inscription of events [when language marks them and ideas dissolve them], the place of disassociation of the self [to which tries to lend the chimera of a substantial unity], volume in perpetual chipping away. Genealogy, as an analysis of provenance, is thus to the articulation of the body and of history. It must show the body all imprinted with history and history ruining the body.)

In Meddeb's narrative, the body serves as a witness to historical events. Violence, punishment, political repression are written on the body: "Corps jetés plusieurs par cellule, espace à peine respirable rongé par le mal-vivre, musique des gémissements et autres paralysies, portion de souffrance perturbant les gestes les plus simples du corps" (p. 19). (Bodies jettisoned, some cell by cell, an asphyxiating space eaten away by ills of life, a music of groans and other paralysis, a portion of suffering making disjointed the simplest bodily gestures.) In this novel, forces of history, politics, and struggle accumulate in the body. Real historical struggle wounds the body and blood coagulates on the skin. Nationalist history remains visible and the text expresses the relationship between histories of control and the body: "Le territoire national, tendant à centraliser, à annuler les différences, à incorporer les bourgeoisies et d'autres régions et villes . . . en un projet commun et cohérent facilitant l'exploitation de l'ensemble des corps" (p. 50). (National territory, tending to centralize, to annul all difference, to incorporate the various bourgeoisies and other regions and cities . . . in a common and cohering project facilitating the exploitation of every single body.) The inscription of histories of national territorialization, of revolts of independence, can be found on these bodies. The body's liberation in this narrative is mediated by a constant reminder of historical events.

Bodies in Meddeb's text are in ruins, and returning reveals the rediscovery of a Maghrebi identity in ruin: "Dès mon enfance c'était déjà spectacle de ruine: la maison, partagée à parts égales entre les femmes, commençait à se délabrer sans que restauration s'ensuivît" (p. 39). (The spectacle of ruin began long before my childhood: apportioned equally among women, the home was beginning to dilapidate without any restoration to follow.) The architecture of the city appears to be in ruins. Returning home reveals a homeland shaken into fragments by confrontation with death: "Pays aimés qui adhèrent aux cellules des corps comme chair décomposée, terre meuble tranchée sol aride" (p. 12). (Lands loved sticking to the cells of bodies like rotten flesh, furnished ground, arid earth cut and sliced.) The inscription of past stories and events on the body directly inflects the form of writing of the narrative: "Par où s'agite l'écriture? Le corps entouré de ses événements et livres s'y déverse par profit des mots autres tant qu'il accumule et dépense, à s'y inscrire image spéculaire témoignant des détails simultanés, miroir où

se glorifie la richesse et la misère indicible du corps" (p. 45). (In the ruts of what path is writing set in motion? Surrounded by its events and books, the body flows into them with the help of other words so long as it accumulates and spends as it cuts into a spectacular image attesting to simultaneous details, a mirror in which are glorified the wealth and silent misery of the body.) The body is in ruins and reflects a type of literary discourse: "(l'écriture) reflète le désordre du corps" (p. 46) ([writing] reflects the body's disorder), and this ruin or decadence conditions writing. The wounded and productive body is the site of generation and waste. Both the body and writing possess this double, excessive nature. "L'écriture vit et meurt simultanement" (p. 45). (Writing lives and dies in the same breath.)

For the narrator, the return home to the Maghreb is a recurrent movement determined by chance—the movement of the body wandering through the city. Meddeb explains that the story of returning home is not one of idealism, lost innocence, of a paradise lost: "A percer le secret des rues et impasses qui ne furent jamais foulées, n'était-ce itinéraires anciens d'une enfance que je ne fabule pas paradisiaque perte" (p. 15). (In puncturing the secret of the forever untrodden streets and alleys, were these not the ancient travels of a childhood that I don't fabulate a paradise lost.) As in Mohamed Choukri's fiction, paradise is only evoked as an impossible place. The Maghreb is not a place of final identity, not the discovery of a root structure, but rather is characterized by the repetition of itineraries that now appear strange. Returning home is simultaneously leaving; returning is also coming for the first time. The shape formed by this movement between opposing meanings of the same word is cyclical, Khaldunian. The history of the self becomes cyclical, always beginning again yet containing new and foreign elements. "*Retour/Prostitution*" suggests a relation of analogy between the two terms. The prostitute speaks familiar and strange languages: "je t'aime, disait-elle sans discontinuer enchaînant l'arabe approximatif au berbère inaccessible pour mes oreilles venues d'où passèrent les tribus qui nous arabisèrent Hilal, Sulaym, Ma'qil" (p. 52). (I love you, she used to say relentlessly mixing approximate Arabic with Berber inaccessible to my ears coming from whence passed the tribes Hilal, Sulaym, Ma'quil that arabized us.)

It is the senses, the nervous system that produce this nomadic effect of returning home. As Meddeb suggests: "Les sens éclaboussent la cohérence de l'intinéraire" (p. 17). (The senses splatter the coherence of the itinerary.) In a strikingly similar way, Michel Foucault comments:

> Enfin la provenance tient au corps. Elle s'inscrit dans le système nerveux, dans l'humeur, dans l'appareil digestif . . . c'est le corps qui porte, dans sa vie et dans sa mort, dans sa force et dans sa faiblesse, la sanction de toute vérité et de toute erreur, comme il en porte aussi, et inversement, l'origine-provenance.[22]

(Finally provenance is on the body. It is inscribed in the nervous sys-
tem, in the mood, in the digestive system. It is the body that carries
in its life and in its death, in its force and in its weakness, the sanc-
tion of all truth and of all error, as it carries within itself also, and
inversely, origin-provenance.)

Instead of seeking the origin of the self in a Maghrebi identity (home as ori-
gin), the return becomes the discovery of the repetitive, strange, and con-
flictual movements that make up the history of the self through the body.

Among these descriptions of ruined bodies, pieces are also missing from
sentences. Both language and the body are marked by historical violence.
The wounded body in Meddeb's novel is in revolt against what he describes
as the traditional, paternal inheritance, against the father's

> vouloir, à tout cran et vaille que vaille, vivre en fonction de cet
> héritage. . . . Vient ensuite la blessure: par elle le corps manipule sa
> réalité, se défait de sa représentation factice, aiguise ses possibilités,
> se propose danse, cycle d'ivresse, perte de soi qui n'est pas réponse
> cicatrisante, mais couteau avec lequel on s'approfondit plaie, à ne
> pas fuir douleur, gravité à surpasser joie. (pp. 56–57)

> (To wish, at every notch, for better or worse, to live as function of
> this legacy. . . . Then comes the wound: with it the body manipu-
> lates its reality, is rid of its factitious representation, sharpens its pos-
> sibilities, offers itself as dance, a dizzying and dazzling cycle, a loss
> of self that is not a scarring response, but a knife with which the
> wound is deepened in order not to flee pain, the gravity of exceed-
> ing bliss.)

The revolt against the state in chapter 2 of the novel is not situated in real his-
tory. One is not sure if this rebellion is allegorical, real, or fantasmatic. The
body is written by the past, and it is the *milieu* from which the individual
reintegrates into history. The rebellion is situated in this *milieu*. Events of the
past—colonial war, torture of Algerians, incarceration, repression, revolt—all
accumulate and are actualized in the *a*-temporal—that is, nonhistoric—affec-
tive space of the nervous system.

One of the properties of the minor use of major languages is the inher-
ently political critique it mobilizes. I have alluded to the second part of the
novel where the city of Tunis rises up in a revolt that also resembles a carni-
val. The inspiration for this uprising is a corpse, the *idole*, reconstituted from
body parts dug up from the city cemetery. This festival is produced much the
way as Michel de Certeau describes society's creative forces in *La culture au
pluriel* (Culture in the plural). This inventive use of leftovers or waste re-
minds us of de Certeau's thoughts on the creative uses by which immigrant
populations make of cultural artifacts. He writes: "En réalité la création est

une prolifération disséminée. Elle pullule. Une fête aussi dans les rues et les maisons, pour tous ceux que n'aveugle pas le modèle aristocratique et muséographique de la production durable. Ce modèle a pour origine un dieu et pour effet un leurre."[23] (In reality, creation is a disseminated proliferation. It pullulates. A party in the streets and in the houses, for all those not blinded by the aristocratic and museum-like model of durable production. This model has for its origin a god and for effect a lure.) Likewise, in *La Prise de parole* (The taking of speech) de Certeau describes a form of resistance through minorities' use of the major language. He describes the immigrant community's creation of a cultural presence through *bricolage* (fiddling around) with the dominant culture. In Meddeb's novel, there are several such transformations that occur during moments of revolt:

> [L]a foule redevient intense dans le quartier des bourreliers détourné de sa fonction première, transformé en fabrique d'armes, manipulation par le feu et odeur de forge remplaçant la senteur de cuir et les selles qui imprégnaient jadis cette rue qui s'achève large . . . les orfèvres se sont mutés artificiers, armuriers, à usiner grenades, obus, projectiles incendiaires. (p. 84)
>
> (The crowd becomes intense again in the saddlers' quarters no more a part of its first function, transformed into an arms factory, a manipulation by fire and the odor of a forge replacing the smell of leather and saddles that used to impregnate this street that opens wide at its end . . . the jewelers have been transformed into bomb disposal experts, armor-makers, manufacturers of hand grenades, canons, incendiary bombs.)

Commercial, artisanal spaces become spaces of justice, of rebellion and transformation. Shops and crafts are transformed into spaces and strategies of revolt. There is also the *bricolage* that allows the demonstrators to mummify their idol. The mummification of the idol serves as a cathartic performance that liberates the city of its anxieties:

> Oui, je sais l'art de momifier; oui, je viendrai vous aider; mais quelle erreur d'avoir rassemblé les moignons, cadavres frais à mariner dans du formol; il aurait fallu les laisser macérer dans un liquide à base de natrum; certes votre erreur est réparable; de même, vous n'auriez pas dû greffer les viscères, l'abdomen est à vider et à remplir de lin imbibé de résine. (p. 92)
>
> (Yes, I know the art of mummifying, yes, I'll help you out; but what an error to have heaped together the bodily parts, fresh cadavers to be marinated in formaldehyde; they ought to have been steeped in a natrum-based liquid; surely your mistake can be rectified; further,

you wouldn't have needed to graft the viscera, the abdomen needs to
be emptied and filled with linen soaked in resin.)

This description is similar to de Certeau's notion of the politics of culture in
which minority voices—creative practices of the potent agents of cultural
transformation—act on the culture of the majority.

Because the novel focuses on historical violence and the inscription of the
historical violence on human bodies, the entire narrative is marked by this
"broken" poetic quality. Even the examination of single sentences reveals the
effects of history on the body and on the telling of the genealogical story: "A
la gangrène qui sépare le corps de son énergie s'ajoute la peste qui ronge
jusqu'au sang l'oeil" (p. 18). (Added to the gangrene that separates the body
from its energy is the plague that eats away the eye into the blood.) There is
a decomposing force at work: pieces are missing from bodies, as pieces are
missing from the narrative. The conjunction and the preposition should be
situated between *oeil* and *sang*; the sentence should read: la peste qui ronge
l'oeil jusqu'au sang. (The plague that eats away the eye up to the blood.) The
coherence of this poetic language—that is, ruin both in the sentence (form)
and in the bodies (content)—has led me to the interpretation that Meddeb
is simulating a foreign use of French, his "broken" French being *assembled*
for a particular poetic purpose. His use of French has the deterritorializing
effect of the minor literature on the major language. But as I suggested in the
previous paragraph, there is a real poetics of revolt motivated by the experi-
ence of death. It is a poetics influenced by the metaphysical death in the
absence of God, the void of the interstice (*barzakh*) as well as the historical
death of human beings. He imitates broken French to communicate the gen-
eral state of ruined thought whose expression is generated through real
ruined bodies. The ruin is one form of intellectual inheritance in the
Maghreb, bits and pieces scattered throughout history and space.

Through the close-up images of the body in this narrative, history is ac-
companied by a coagulated aspect that is the event, a set of drives that rep-
resents the eternal part of the history—not the eternal transcendence of
truth, but earthly, material. The body, although inhabited by the real events
of history, produces this materiality that points to a general (as opposed to
individual, subjective) experience of the historical event. Roland Barthes's
thoughts on the body are also pertinent here; its pleasures and anxieties
emerge from outside the linearity of history and its dialectical structure:
"C'est l'Autorité du style, c'est-à-dire le lien absolument libre du language et
de son double de chaire, qui impose l'écrivain comme une Fraicheur au-
dessus de l'Histoire."[24] (It is the Authority of style, that is the absolutely free
link between language and its double the flesh, that impose the writer like a
Freshness above History.) Again showing a clear affinity between his writing

and that of Barthes, Meddeb explains that writing comes forth from the body and thus shares its qualities of exteriority with the writing of history: "L'écriture est le reflet d'un être, d'un corps."[25] (Writing is the reflection of a being, of a body.) The body produces the text and articulation of the self, not as origin, but as a nervous affect that produces a multiplicitous system and excludes a mimetic relation between the text and the body. Relations and representations to the place of experience are filtered through the body. Barthes continues in this sense about literary style: "Le style n'est jamais que métaphore, c'est-à-dire équation entre l'intention littéraire et la structure charnelle de l'auteur. . . . Aussi le style est-il toujours un secret . . . son secret est un souvenir enfermé dans le corps de l'écrivain."[26] (Style is never simply a metaphor, that is to say an equation between the literary intention and the carnel structure of the author. . . . Style is always a secret . . . its secret is a memory enclosed in the writer's body.)

In Meddeb's text, thought is generated through bodily drives, wounds, and vitality. Thought and writing are born from the vibratory movement, the nervous web of the body affected by history: "nervosité qui effiloche les nervures du corps et mélange temps et sentiments" (p. 44). (Nervousness that frays the body's nervous webbings and mixes time and feelings.) The nervous system produces a text with no story line, just odors, nerves, drives: "Odeur forte et prenante: retournée aliment au creux de la gorge, nourriture épaisse et fluide qui se répartit par subtilité de nerfs. Sève du corps coulant par la langue" (p. 53). (A strong and sticky odor: food turned over in the crux of the throat, a thick and fluid food circulated through the subtlety of nerves. Bodily sap flowing over the tongue.) In a similar vein, Nietzsche describes in his prologue to *Le gai savoir* that the provenance of philosophy is not the quest for truth but the body:

> L'inconscient déguisement de besoins physiologiques sous le manteau de l'objectif, de l'idéal, de l'idée pure va si loin que l'on pourrait s'en effrayer—et je me suis assez souvent demandé si, d'une façon générale, la philosophie n'a pas été jusqu'à présent surtout une interprétation du corps, et *un malentendu du corps*.[27]
>
> (The unconscious disguise of physiological needs beneath the cloak of objectivity, of the ideal, of the pure idea has gone so far that we could become afraid—and I have often asked myself if, in a general way, philosophy up until now has been mostly an interpretation of the body, and *a misunderstanding of the body*.)

Meddeb writes about the Maghrebi space and history through the body; thought emanates from the body's memory of infliction and moments of strength. But if there is the superhuman strength in the Nietzschean *jouis-*

sance dionysiaque (Dionisian ecstasy), Meddeb's fiction articulates a decided sickness and weakness: "Non: c'est un mort qui insuffle respiration à sa dulie, fragilité qui lui empêtre le corps . . ." (p. 48). (No, it's a cadaver that inspires breath for its dulia, a fragility that burdens the body. . . .) This is part of the philosophy of the minority, the revolution from the weakened. The ruined body, the melancholy spirit, the "weak" mind become the vital economies of creation and critique. In contrast to the Nietzschean strength we have the ethical insight and humanity of the weak. Khatibi puts it this way in his essay, "*Pensée-autre*":

> Sur la scène planétaire, nous sommes plus ou moins marginaux, minoritaires et dominés. Sous-développés, disent-ils. C'est cela même notre chance, l'exigence d'une transgression à déclarer, à soutenir continuellement contre n'importe quelle autosuffissance. Bien plus, une pensée qui ne s'inspire pas de sa pauvreté est toujours élaborée pour dominer et humilier; une pensée qui ne soit pas *minoritaire, marginale, fragmentaire et inachevée*, est toujours une pensée de l'ethnocide.[28]
>
> (On the planetary scene, we are more or less marginal, minority, and dominated. Underdeveloped, they say. This is precisely our luck, the demands of a transgression to declare, to support continually against any self-sufficiency. Even more, a thought that is not inspired from its poverty is always elaborated to dominate and humiliate; a thought that is not *minoriarian, marginal, fragmentary and unfinished*, is always a thought of ethnocide.)

It is the weakened bodies battered by history that are the provenance of these literary narratives. This is a literary discourse searching to be reinscribed into history. It is an indirect, and at times direct, call for a more ethical relation between human beings.

Unearthing Cultural Spaces

The novel *Talismano* represents the conflation of disparate spaces in the representation of the Maghreb. This literary configuration is the cultural practice of uprooting of fixed cultural identities. Each social space in the text is associated with a language. Tunisian dialect—the vernacular—takes on the characteristic of a culture of locality, sedentarism. Part of Meddeb's geo-politics involves a critique of the Tunisian cultural space that he regards as stuck and ossified and refuses it as an origin. The narrator reflects on the static quality of the inhabitants of Tunis (and the Tunisian dialect) and the fear of his own enracination in locality, in sedentarism. The narrator refers to the temptation of stasis that he sees in the Tunisian space and language, and the

temptation of his own movement without return—that is, a final and defin-
itive movement away from the language of origin. This is a danger, since
nomadism and returning remain necessary for a modern critical conscious-
ness. The vernacular language and its spatial analogue, Tunis, must be relived
through the other language in order to create a livable notion of one's geneal-
ogy. He does this in part through the mythic, sacred Arabic language that is
always elsewhere. It is a language of the beyond. This shifting is expressed in
Meddeb's use of Arabic through its repeated displacement into the French,
into French transcription, and integrated into French language and literary
references. French, in this context, functions both as the "langue véhiculaire,
urbaine, étatique ou même mondiale, langue de société, échange commer-
cial, de transmission bureaucratique"[29] (vehicular language, urban, state-like
and even worldly, language of society, commercial exchange, or bureaucratic
transmission). These linguistic and spatial shifts produce the literary effect of
the genealogical identity.

The thematic of returning home to Tunisia involves questions of lan-
guage and spatiotemporal definitions of language: the languages of the *ici*
(here), the *là-bas* (there), the *au-delà* (beyond), and the *partout* (everywhere).
Meddeb's writing puts into question the oppositions of here–there,
French–Arabic, home–exile. The French is deterritorialized by its Arabic
usage and vice versa. For example: "les souks en cet endroit couverts sont
quasi déserts" (p. 83). (In this spot the souks are covered and almost
deserted.) *Souq* is an Arabic word now used in French, and in this text it is
reinserted into the Francophone writing on an Arabic space. The effect is
that the reader is not sure if he is reading a French transcription of Arabic,
or French itself. Other examples of this mixing abound: "le calame et l'encre
des heures pour accouchement fébrile d'une calligraphie inaugurale" (p. 83).
(The reed and the ink of hours for a frenzied birth of an inaugural calligra-
phy.) *Calame* is another word that hesitates between the Roman and Semitic
languages, and has been adopted from the Roman into the Semitic and then
back into the French. Dozens of words are transcribed from Arabic in this
novel. This use of Arabic not only transposes the foreign (for the Franco-
phone reader) into the French text, but reproduces a calligraphic effect that
is a particular characteristic of Arabic writing. In his insightful article on
Meddeb's *Talismano*, Abdelkebir Khatibi points out what Tom Conley has
called the "graphic unconscious" in Meddeb's text, the calligraphic and Ara-
bic unconscious of the Francophone text. Khatibi writes: "Dans ce livre, l'éc-
riture arabe (sa calligraphie) revient comme commentaire sur elle-même et
sur son absence et son refoulement . . . l'auteur tire la calligraphie islamique
vers la (lettre) mystique, et celle-ci vers la notion du vide."[30] (In this book,
Arabic writing [its calligraphy] comes back as a commentary on itself and on

its absence and repression . . . the author pulls Arabic calligraphy towards the mystic letter, and the latter towards the idea of nothingness.) The French reader perceives the materiality of the hidden Arabic letters, their shape and contour only. There is no interiority to these transcriptions. Through the transposition of the calligraphic characteristic of the Arabic language into the French, the text takes on an aesthetic of three-dimensionality. For the Arabophone reader, the Arabic language is a constant undercurrent to the French text. In the French language, Arabic words and letters are repeatedly suggested and reappear in unexpected ways.

But the Arabic language—this mythical, religious idiom—is not found to be the decisive point of linguistic identity. This is an important posture to underscore. Meddeb's writing always pays homage to the poetry and multiplicity of the Arabic and Quranic language, but always refuses to sacralize it. The mythic Arabic language is demystified through the author's subversion of one of its primary characteristics: the root as finality. In Arabic, most words descend from a common root that consists of three letters. Meaning is produced by a movement from an often tripartite root. The text's movement plays with this otherwise austere and mathematical Arabic philological search for linguistic roots. The authority of the root as inauguration of meaning is most importantly exemplified, because being most arbitrary, by the Quranic *Alif–Lam–Mim* and the like. Three letters announce the revelation of the surah to the Prophet (Peace Be Upon Him). The three letters announce the revelation of the message and its mysterious origin; they remain unquestionable being arbitrary and revealed, divine and given. Meddeb includes the *Alif–Lam–Mim* structure as well as the Arabic philological method as one of the elements of eternal return: "à rêve et fantasme, le réel n'inscrit pas frontière; ces trois genèses constituent un espace n'écrasant pas son sujet par la broyante analyse" (p. 56). (With dream and phantasm the real does not draw a border; these three births constitute a space that does not squash its subject through crushing analysis.) We see the presence of the tripartite root, but in place of *Alif–Lam–Mim* we read the substitution of *rêve, fantasme, réel* (dream, fantasy, the real), which opens the frontiers of what is otherwise an impenetrable and unknowable sacred space. The author plays with the notion of returning to the root structure, which at once mimics the Arabic philological practice and Islamic theological space and produces an open, critical thought.

At the end of the novel we have another return to the so-called root. The narrator returns to Hagar, the exiled mother of Ismaël. Meddeb demonstrates the philologic tendency to follow roots by superimposing the words *Hagar, Hâjir,* and *hijra* (voluntary exile or religious migration), showing that the three words originate from their common root: *h, j,* and *r.* On the one

hand, he demonstrates this Arabic philologic principle as the generator of meaning; on the other, the next step undermines the finality of this herme-neutic principle. Arriving at Hagar as origin, one arrives as an orphan. Through a genealogical return one discovers Hagar, the slave woman forced into exile by her other, Sarah. His concluding return to this originating fig-ure of exile becomes thus a return resembling the one in the initial part of the novel. The home city, Tunis, and Hagar are simultaneously sites of ori-gin, rupture, and exile.

The last part of the novel condenses the movements repeated throughout the entire work. The movement is a repetition of the displacement into French of the foundational Islamic exile, Hagar: "Maintes sorcières et autres énergies tenaces se sont séparées avec nous de la ville. Hijra, migration volon-taire" (p. 241). (Many a sorcerer and other tenacious energies were separated with us from the city. Hijra, a voluntary migration.) The word *hijra* is tran-scribed into the Roman alphabet and then translated into French *migration volontaire*, becoming minoritarian in relation to the dominant French lan-guage. Indeed, this "voluntary migration" could point to the author's feeling of cultural disempowerment and subsequent voluntary migration into the French language, onto French territory: "A suivre le chemin de Hâjir, Agar, hors défaite, vers le retrait: orphelins. Nous savions qu'il nous manquait l'hégémonie positive" (p. 241). (To follow the Hajir Road, Agar, beyond defeat, toward retreat: the orphans. We knew that we were lacking the posi-tive hegemony.) He describes this migration always in relation to his Islamic origin. This writing expresses the collective, minoritarian, and Islamic iden-tification with the descendent of Hagar, Ismaël, who fled into the desert. "[L]ors notre écart vers le désert" (p. 241) (then our deviation toward the desert) indicates Hagar's flight into the desert and again identifies the author/narrator as her descendent, Ismaël, born in the desert. But the desert, a literary topos in the Arabic and Soufi literary traditions, is reiterated by the narrative as a reflection of a European school of thought. The desert is both a Nietzschean landscape and the landscape of Hagar, an incongruous pair-ing: "A me composer ici répétant les mots de Nietzsche: Le désert croît— malheur à qui recèle des déserts! La pierre crisse contre la pierre, le désert nous enserre et nous étouffe" (p. 243). (By composing myself here in repeat-ing Nietzsche's words: the desert grows—ill to he who hides from the deserts! Stone scratches against stone, we are gripped and stifled by the desert.) The space of the (Arab) desert becomes written several times, by both ancient Arabic writing and modern Western philosophic reflection. This pairing has a purpose and carries within it a potent critique. The past and the insistent return to tradition are dangerous: the interruption of the West must be traced in the revivification of the past.

In a similar gesture, an immanently Islamic and ancient expression performs a sudden jump in time, becoming a conflation of the scenes of exile in the Old Testament and in the (post)colonial situation: "Nous savions qu'il nous manquait l'hégémonie positive, que nous allions nous attarder à exhiber le rituel qui nous avait exorcisé de la soumission séculaire" (p. 241). (We knew that we were lacking the positive hegemony that we were going to delay in exhibiting the ritual that had exorcised us from secular submission.) This "secular submission" could refer to the initial persecution of the Prophet in Mecca that explains his flight to Medina. In addition, the repression of the sacred in Meddeb's writing refers both to orthodox Islam's repression of Soufi mysticism and the postcolonial imposition of secular social structures in Tunisia. Once again, we witness the collapsing of disparate spatiotemporal events. Here we see the cyclical, nonlinear shape of history. The past returns in a cyclical fashion: "passé à reprendre" (p. 241) (the past to be taken up again).

The other side of this coin signals a defamiliarization in the use of Western language and concepts. Meddeb reterritorializes French critical concepts in the context of the Arabo-Islamic writer. The Deleuzian notion of *devenir-femme* (becoming-woman) takes on different resonances in this writing. Meddeb's identification with Soufi mysticism adds a specific meaning to a concept such as *devenir-femme*—a cultural force inoperative in the French context. Meddeb expresses the idea, characteristically, in reference to ancient Arabic writing: "Je crois au feminine-créateur. Souvenez-vous du fameux distique de Jâlâl ad-Din Rûmi: 'La femme est le rayon de la lumière divine.'"[31] (I believe in the woman-creator. Remember the famous saying of Jâlâl ad-Din Rûmi: "Woman is the ray of divine light.") And again in his discussion of Bistami, Meddeb writes: "Bistami (IXe siècle), dans l'identification feminine par laquelle passé le soufi (qui se sait femme de Dieu)."[32] (Bistami [ninth century], in the feminine identification through which the Soufi passes [who knows he is the wife of God].) Likewise, the dissolution of the self that we experience in Bataille's fiction or in Deleuze as *devenir* is here inflected by Soufi writings written many centuries before the French texts. A rejection of simplistic, clearly delineated subjectivity (made popular in the West by poststructuralism) is articulated throughout *Talismano* in ways that demonstrate an ancient Arabic heritage. The Foucaultian "death of the author" resembles an ancient concept, since it is spoken about through Soufi texts:

> je ne pus par référence à la spécificité du corps et de la culture, me
> séparer du rappel de l'expérience soufie, pensée et vécue, à la gloire
> de l'extinction du je, matérialisé corps très subsidiairement ascé-

tique: Hallâj sanglote éperdu à rire: Tuez-moi, féaux camarades, c'est
dans ma mort que je retrouve vie. . . . Suhrawardi récidive: Rien ne
peut me vaincre. Je suis vainqueur des ténèbres par la Lumière. . . .
Maqtûl, assassiné et non shahîd, martyre, sang versé. (p. 58)

(Through reference to the specificity of the body and of culture I
could no longer be riven from the recall of the Soufi experience,
thought and lived, in the glory of the extinction of the "I" a materi-
alized body very subsidiarily asceticized: Hallâj is sobbing lost in
laughter: kill me, my loyal comrades, in death I'll recover life. . . .
Suhrawardi is recidivist: nothing can overwhelm me. I am the con-
queror of the shadows through Light. . . . Maqtul, assassinated and
not shahîd [martyred], martyrized, his blood shed.)

At times, in this Francophone text, the absent language, the hidden origin
and the ancient mystic thinkers of Islam are the most powerful and recurrent
references. Speaking about his novel, Meddeb explains that his preoccupa-
tion with death is related to both European influences and Arabic influences
(the Quran and Soufi mysticism). The author also explains that the situation
of the self in the interstice of these two traditions is in itself an experience of
death. He likens in "between-ness," or *barzakh*, to the void of death. He
states that Suhrawardi

nous apprend que l'exil ouvre sur l'expérience de la mort, de l'im-
possible. Notre position intermédiaire nous a permis de dire notre
expérience propre selon une référence double. Nous avons associé à
la chaîne moderne des orphelins de Dieu, Nietzsche, Artaud,
Bataille, la tradition de la démesure soufie. Nous avons occupé le
lieu où s'ouvre la béance sans nous concentrer sur la fiction qui
comble (Dieu). En somme, nous occupons l'espace de la fausse mort
qui prépare à apprendre la vraie mort. Nous logeons dans le barzakh,
ce mot d'origine persane qui apparait deux fois dans le Coran.
(XXV, 53: IX, 20)[33]

(teaches us that exile open onto the experience of death, of the
impossible. Our intermediary position has permitted us to tell our
own experience according to a double reference. We have associated
the tradition of Soufi excess to the modern chain of orphans of God,
Nietzsche, Artaud, Bataille. We have occupied the place where the
gulf opens without concentrating on the fiction that fills [God]. In
sum, we occupy the space of the false death that prepares to learn
the real death. We live in the barzakh, this word of Persian origin
that appears twice in the Quran).

This word *barzakh* has a specific meaning in Soufism. It signifies an in-
termediate world: "la où le disciple s'exerce à adorer le simulacre de Dieu, à

vivre l'expérience de la mort pour convenir au dit prophétique: 'Mourez
avant de mourir.'"[34] (There where the disciple works to love the simulacrum
of God, to live the experience of death to fit the prophetic dictum: "Die
before dying.") The notion of loss of self is inscribed in the narrative with
respect to Arabic poetry. "Elargissement de l'être vers ce qui échappe à
l'homme mais qui n'est pas dieu. Sacrifice de physique énergie: corps exces-
sif qui s'emporte mort par défi de jouissance et non par conscience de sui-
cide: à être martyre, on se serait sacrifié à fin de récompense, morale du troc:
je meurs pour obtenir éternité d'éden!" (p. 58). (A widening of the being
toward what escapes man but what is not god. Sacrifice of physical energy:
an excessive body borne off dead by defiance of bliss and not by conscience
of suicide: in order to be a martyr we would be sacrificed, in the morality of
barter, for the end of a reward: I die in order to obtain the eternity of Eden!)
Loss is underscored by Meddeb's scorn for those who sacrifice themselves to
gain entry into paradise. He engages this spiritual economy of loss through
a discussion of the texts of Islamic heretics and rejects the suicide martyr's
entry into heaven. He critiques the Islamic entry into heaven through sanc-
tified suicide. This combination of the poststructural and the ancient and
Soufi languages complicates the interpretation of a singular cultural inheri-
tance or patrimony.

Death, as Meddeb reads it in the Western tradition, is a mystical experi-
ence following the death of God. The trembling self, in Bataille for example,
is possible only after the morality of Christianity is transgressed. This "post-
Christian" eroticism echoes throughout *Talismano*. Bataille's character Dirty
seems to reappear in Meddeb's adventures. "Elle s'agriffa furieuse à des orties
et se flagella les mains, coulée de sang. Ses rires m'effrayèrent d'autant plus
qu'ils n'étaient pas discret" (p. 41). (She scratched herself furiously with net-
tles and, a flow of blood, flagellated her hands.) Images of Bataille's father's
eyes in several texts (*Histoire de l'oeil*) are conjured here in *Talismano*: "Ses
yeux bleus révulsés, perdent couleur . . . mauvais oeil, jaune d'oeuf, inoui le
cri, la jouissance" (p. 27). (Her blue eyes revulsed, lose their color . . . a black
eye, an egg yolk, cry unheard of, pure bliss.)

The fact that Meddeb's novel is *"un réseau difficile à démeler"* (a webbing
difficult to untangle) in Foucault's words, precipitates the effect of the
author's compression of the spatiotemporal here and there. The compression
is expressed by the interweaving or cross-referencing of the literatures of
France, Tunisia, and beyond. This relentless superimposition of different
places is what forms the rhizomatic shape of *Talismano*. The effect is an es-
sential transformation of the two terms of the metamorphosis, French and
Arabic: "Il n'y a pas de dualisme, pas de dualisme ontologique ici et là."[35]
(There is no duality, no ontological duality here and there.)

Tunis

The effect of this literary metamorphosis is shown in representations of the city of Tunis. Notice this description of the urban space of Tunis:

> Patios: nombrils où ça respire éparpillant en mille trouées le centre virtuel de la ville, à disséminer la convergence: chaque patio est en lui-même centre; la ville s'arrange en hiérarchie de nombrils: il y a le nombril corps public ouvert à l'oeil d'accès légitime: mosquée par exemple; il y a le nombril corps caché, femme à vendre, coeur à cloîtrer. (p. 64)

> (Patios: navels where air breathes scattering in a thousand breaches the virtual center of the city, disseminating convergence: each patio is in itself a center; the city is arranged in a hierarchy of navels: there is the navel-public-body seen and given with legitimate access: a mosque, for instance; there is the navel-concealed-body, a woman to be sold, a heart to be cloistered.)

Tunis again becomes a woman. This transformation causes the image of the city to break apart and loose its clearly defined identity. Tunis is not simply compared to a body with many points of entry, with its many belly buttons. Tunis actually becomes a body, a plurality of nombrilic or generative points as well as possible points of entry. A movement of metamorphosis is effectuated between the home city and the body—a body of infinite entry points. The binary private–public and masculine–feminine does not resist the fragmenting movement of the writing. Tunis is scattered from within and from without.

Tunis is broken apart through the intervention of memories of Fez via the molecularizing particles of music: "Bordel puis musique d'Ici Tunis, sirupeuse et redondante, à déverser après l'appel radiodiffusé des noms propres. . . . Ce même refrain d'Umm Khalthûm écouté à Fez, tard l'après-midi" (p. 63). (Chaos then music, syrupy and redundant, of Here Tunis, spewed after the broadcasted appeal for proper names. . . . This same refrain of Umm Khalthûm listened to in Fez late in the afternoon.) These images demonstrate a movement between places—Tunis and Fez—via the vibratory medium of the Egyptian woman's voice. Spatial differences conflate and identity-places are continually unanchored.

This same molecularizing mechanism can be found in the narrator's description of the birds. The distinction between positive and negative spaces decomposes in the description of the bird populations that inhabit the various cities on the northern and southern shores of the Mediterranean. The space between places becomes a characteristic of the place itself: "between-ness." This deterritorialization of idioms and spaces through bird

populations can be demonstrated in the following passage that I will cite at length:

> Moineaux, huppes, rossignols, pigeons, tourterelles . . . [ellipsis in text] qui partageaient le conifère géant, axe parlant, à jaillir du jardin la fusion des idiomes voyageurs. A chaque ville ces oiseaux: à Tunis, à part les moineaux qui habitent au coucher les platanes, choeur crépusculaire, à part les sansonnets ponctuels. . . . A Paris, il y a à côté de la lourdeur des pigeons embourbés suie, empêtrés infirmes, le bonheur vif et nerveux des merles. . . . Mécaniques pigeons en plastique, couleurs plates survolant le temps d'une illusion d'une Piazza Navona, rivalisant avec les vrais pigeons étonnés de voir pareille concurrence. . . . Mouettes atlantiques de Tanger à survoler par-dessus têtes . . . dérive si mince entre les deux continents. Le Caire tombe pour l'oeil, petits pigeons circulant sur les toits. . . . Pigeons rappelant la tribu comorienne venue une nuit de pleine lune du côté des nuages de Magellan pour veiller sur la tombe mésopotamienne de Hallâj. (pp. 32–33)

> (Sparrows, hoopes, nightingales, pigeons, doves . . . that were sharing the giant conifer, a speaking axis, to thrust out of the game the fusion of traveling idioms. For each city these birds: in Tunis, except the sparrows who live in the plantain trees at dusk, a crepuscular choir, except for the punctual starlings. . . . In Paris, next to the heavy mass of pigeons mired in soot, gnarled invalids, the lively and nervous happiness of the blackbirds. . . . Mechanical plastic pigeons, flat colors flying over the time of an illusion of a Piazza Navona, in consort with the real pigeons astonished to see such a rivalry. . . . Atlantic gulls from Tangier flying over everyone's heads . . . such a narrow divide between the two continents. Cairo falls for the eye, little pigeons milling about on the roofs. . . . Pigeons recalling the Cormorian tribe arriving one night in full moon from the direction of Magellan's clouds in order to guard over the Mesopotamian tomb of Hallâj.)

The representation of the home city of Tunis is scattered between Italy, France, Egypt, and Morocco. The flight of the bird populations between cities blends different cities of the Mediterranean basin. The "bonheur vif et nerveux des merles" (lively and nervous happiness of the blackbirds) reminds us of the nervous movements of the body. The bodily movements that shape the discourse now shape the exterior representation of the city.

Tunis's geographical openness is possible through a nonmimetic form of representation rooted in a language of affect, of subjectivity. To demonstrate this point I will turn to a passage in the narrative where realist representation

is alluded to and then subverted. The novel begins with the narrator's return
to his home city: "Me voici de retour exprimé ville à dédale, ému à me dis-
traire d'enfance: à retrouver des saveurs anciennes à travers les déduits de
Tunis. Les portes, bleu doux tendre, clous noirs, repères où s'incrustent les
ébats incertains de la mémoire" (p. 15). (Here I am back again expressed city
in a labyrinth, moved to distract myself from my childhood: to recover the
ancient tastes from the remains of Tunis. The doors, a soft tender blue, black
nails, points where the jittery flickers of memory are encrusted.) This open-
ing sentence could indicate that the narrator's childhood will be represented
according to realist novelistic convention, with its attention to description
and detail. Further reading reveals that this realist topos is in relation to oth-
ers—other forms of writing, other idioms that transform the first. The next
sentence begins to reveal this dynamic: "Bab 'Asal, porte, puis rue sentimen-
tale" (p. 15). (Bab 'Asal, a door, then a sentimental street.) The previous sen-
tence could still be in the realist register, especially if one happens to know
that the author indeed lived in the medina of Tunis as a child and walked
through the *Bab*, or city gate, of Tunis. The use of the words *Bab 'Asal* refers
to a specific place, another Arabic wor(l)d written in roman script, followed
by its partial translation into French: *porte*, then *rue sentimentale* with rever-
berations of *éducation sentimentale*. *Bab 'Asal*, although it is not immediately
translated into French, is transcribed into French. *'Asal* is not translated into
French until the next page when the narrator describes the noncorrespon-
dence between the name and its referent: "un étage à l'autre, de la villa, de la
senteur fraîche et matinale des fleurs printanières à cette âcre odeur de pisse
qui est loin du nom ('asal égale miel) qui la désigne" (pp. 15–16). (One floor
to the next, from the country house, from the fresh morning savor of spring
flowers to the acrid smell of piss far from the name [*'asal* means honey] that
designates it.) Realism of urban life, modernism of the aesthetic of decay? It
is rather a comment on signifiers, on the rupture between idioms whose co-
habitation inaugurates the signifying system of the novel.

Indeed, the next sentence begins with the sentence fragment "Prime rup-
ture." The nominal rupture of the signifier: *'asal* (honey) is expressed by the
French translation *pisse* (urine). The linguistic rupture, not on the level of sig-
nifier/signified but rather in the relation between signifiers in different lan-
guages that are supposed to be equivalent. This primordial rupture establishes
the narrative as a writing of passage between incongruous worlds: "Prime
rupture. Comme de hantise, le portail vert rouge blanc du hammam où ma
mère m'emmenait enfant: devant ce spectacle indélébile, corps nus, femmes
grosses, retenues de violence qui parfois éclate querelle de seaux. Et le sang
coule" (p. 16). (Primal rupture. Like a child's fear, the green red white door-
way of the hammam where my mother used to take me when I was a child:

before this indelible spectacle: nude bodies, pregnant women, kept from violence that sometimes explodes in a quarrel of pails. And blood flows.)

Meddeb's *Talismano* is the story of a simulation of origins: "Le je engage avec lui l'histoire: ces ans qui ont imprégné ma naissance, mon origine, mon enfance" (p. 57). (The "I" is staked with history: these years that impregnated my birth, my origin, my childhood.) "Origin" is posited as multiple, nomadic and thus not equivalent to its definition as singular. "Home" is at once Tunis, French thought, Arabic language, Soufi mysticism, and the historical origin of the Maghrebi novel as rupture with tradition as the novel begins with allusions to European traditions of the *roman d'apprentissage*. Also present is the mythic notion of uninterrupted origin:

> tabernacle où brille, ô ténébres, ô prestigieuse armoire, l'arbre généalogique qui assure l'ascendance bédouine, l'origine chérifienne, sahrawîe, Saqiat al-Hamra, pérégrination des ancêtres. L'agréable sensation qui te lie à jamais racines te coagulant sédentaire faussaire car le désir te projette vers de tels aïeux nomades, vers le mythe. (p. 17)
>
> (A tabernacle in which there shines, O shadows, O prestigious closet, the genealogical tree that assures bedouin ascendency, the cherifian, Saharan origin, Saqiat al-Hamra, the peregrination of the ancestors. The agreeable sensation that ties you forever roots coagulating you sedentary forger for desire projects you toward your nomad ancestors, toward myth.)

Traditional mythic genealogy is one among several and not the only or final origin. Insisting on plurality of origins (or the genealogy of the self) has a revolutionary effect of describing the uncontainable but ethical national subject. A Tunisian citizen, impossible to circumscribe, defies the orientalist vision of himself as the sly Easterner: "à rectifier définitivement le consensus orientaliste en éliminant de son organisme le virus de l'espionite" (p. 57). (Definitively to rectify the orientalist consensus by excreting from its organism the virus of a mania for espionage.) The effect is a revolt that liberates the self from French and Tunisian categories of identity: "à jeter bas le masque du mimétisme" (p. 57). (To throw to the ground the mask of mimicry.)

This analysis of Abdelwahab Meddeb's *Talismano* mobilizes Deleuze's, Foucault's, and Barthes's vocabularies. These vocabularies of analysis are influences that constitute the multiple genealogy of the writer. The multiplicity of idioms displayed in this novel is less pertinent than the way in which these idioms are used through a style of redundancy and repetition to create a metamorphosis. This expression of identity through metamorpho-

sis, through the minoritarian use of French and the displacement of Arabic into the French, is articulated through the author's bi-cultural voice. The self is represented as positive space inhabited by negative space, the self in metamorphosis, the subversive, "barking" self.

Chapter 2

▼▼▼▼▼▼▼▼▼

Other Voices, Other Spaces

Although the Moroccan novelist and short-story writer Mohamed Choukri (b.1935) writes in Arabic, his narrative consistently deploys a multitude of foreign languages. For example, his first novel, *Al-Khubz al-hafi*, was published in English and French translations before being published in its original Arabic. As I will explain, Spanish, Berber, French, and English work on the Arabic of this novel, and Arabic looses its aura of originality since it was heavily inflected by these other languages. All versions—each translation being an entirely new invention of the story—form essentially multilingual texts. Each version also includes Spanish dialogues as well as a silent mother tongue of Berber in the background. In addition to the polylingualism of the writing and publication processes, the text's diegesis mobilizes the multilingualism described in the introduction to this volume. Foreign languages are an integral part of the very fabric of this novel about contemporary life in Tangiers. Characters speak in and comment on different languages. The protagonist struggles to reconcile his inherited Berber identity as well as Islamic and Moroccan idioms with Western idioms and cultural references.

The subject of this chapter is twofold. First, the publication and production of the text constitute inherently polyglot processes. Secondly, a "diasporic" thought is articulated within the text itself through the narrative's departures into fields of Western modernism as well as Christian theology in a sort of narrative homelessness. Theological (Muslim and Christian) verticality is undermined in favor of this vagabond, exterior, and horizontal conception of the home space. The diasporic use of language produces a novel critical of the environment in which it was produced. Using this technique of multilingualism, the novel effectuates a critique of postcolonial Morocco and a critique of conservative forces within the Arabo-Islamic literary tradition. A response to this repressive social and literary space is described in another context by Wadi Bouzar as the creation of a "surplus-space." Bouzar writes:

Plus le malaise politique, économique, sociale et culturel est grand, plus un espace globale est en crise, plus les espaces que la société offrent ou concède à la majorité de ses members sont des espaces subis. Les sujets ne sauraient alors se satisfaire de leurs espaces de souvenance ou de leurs espaces de vie, ils aspirent à d'autres espaces, comme si des espaces subis exigeaient toujours un plus: des espaces-plus. L'espace-plus est l'espace que désirent, que découpent, que désignent, que se représentent que disent les sujets eux-mêmes. Cet espace n'est pas celui des appareils politiques et administratifs des Etats nations. . . . L'espace-plus est lié à la vie intime des sujets.[1]

(The greater the political, economic, social, and cultural sickness, the more the global space is in crisis, the more the spaces society offers or concedes to the majority of its members become "spaces of subjection." Subjects are not able to satisfy themselves with their spaces of memory or their spaces of life, they aspire to other spaces, as if "spaces of subjection" demands a surplus: surplus-spaces. Surplus space is the space that subjects desire, divide, draw, represent, and speak to themselves. This space is not that of the political and administrative instruments of the nation-state. . . . The surplus-space is tied to the intimate life of the subject.)

This chapter will describe the strategies used in this narrative to create a surplus-space. Through the literary form of a polyglot novel, a new space is invented.

The Multilingual Publication

The author, Mohamed Choukri, came to Tangiers from the Rif Mountains during a time of drought and widespread famine. Instead of leaving for Europe, Choukri remained in Morocco, learned how to read and write in Classical Arabic and construct literary narratives about what he knew best—life in Tangiers as a poor migrant worker from the mountains. At least this was the subject of his first novel, *Al-Khubz al-hafi* (Casablanca, 1983), or *Le pain nu* (Paris, 1980), or *For Bread Alone* (London, 1973). All three versions of the story must be considered together, since they all constitute part of the same multilingual phenomenon. The first version was published in English, based on Paul Bowles's transcription from Choukri's oral testimony in Spanish, French, and some Moroccan dialect.[2] Choukri has stated that the story was initially presented to Paul Bowles in four languages, Classical Arabic (the language in which the manuscript was written), Moroccan colloquial Arabic, Spanish, and French, and then translated into and published in a fifth: English. Choukri stated in an interview:

> It took us, Paul Bowles and I, two or more days to translate one chapter into English. Meanwhile, I would finish the following chapter. I used to dictate to him in Spanish (which he spoke well) and sometimes a French sentence would save the day. As for the claim made by Bowles that he translated directly from colloquial Moroccan, it is an outright lie. I recall using a few colloquial words, and I do not mean to sound condescending about the colloquial language that Paul Bowles was only slightly familiar with. As for myself, I am incapable of writing in colloquial Arabic as I am ignorant of its aesthetic qualities.[3]

The Arabic version was being written at the same time, and in relation to, the English version that was being simultaneously produced for publication. In addition, the Arabic version must be considered as being a relation of translation from Berber, his native language that is continually mentioned in the narrative as the unheard, spoken maternal language. It was a necessary movement of translation from his native Tarifite, since Berber dialects are, for the most part, not written. In this way, each of these versions, including the Arabic "original," has been constituted in relation to the other languages.

Seven years later, Tahar Ben Jelloun's French translation was published in Paris. Instead of translating from the published version, the translator used Choukri's original and yet unpublished Arabic manuscript. In a kind of reversal of authority, the French translation of the original soon came to be considered the authoritative version. Demonstrating the hegemonic power of the French language (in the context of France–Maghreb relations), only after the French publication did an Arabic version finally find a publisher in Casablanca. The French edition served as a new "original" for the publication of the Arabic version, masquerading as a modern Francophone folktale. Having gotten the foreign inflection needed to become folklore, the menacing familiarity of the story in Arabic was temporarily suspended. Although it was initially refused in Morocco, a Moroccan printing press agreed to print the manuscript at Choukri's expense. Upon publication in Arabic, the novel produced outcries from its widespread Moroccan readership. The initial refusal of the Moroccan publishers and presses to publish the narrative and the subsequent disapproval of the readership are based on a reading of the Arabic version that has continued to haunt it up to the present day. Although this novel has received widespread acclaim in the West and among some liberal scholars in the Middle East, it has remained the subject of literary controversy and considerable disdain. Many critics who read the text in Arabic consider it pornographic and wish to exclude it from the canon of Arabic literature. The content of the text—homelessness, prostitution, poverty, drinking, and so on—is an affront to the sacred character of the Arabic language

in which it is written. The main problem emerges from the association of this language with the word of God. I will return to this subject below.

Because of the sacred nature of the Arabic written word and the degraded subject matter, the novel went into a sort of linguistic exile. It is as if the novel needed to travel to London, then to Paris, in order to then return to Morocco for its Arabic incarnation as a folkloric translation from French and English texts. It could not be accepted as an original Moroccan story. This three-headed, monstrous quality of travel is what allowed for its survival. Although Choukri himself did not migrate to foreign lands, nor did he write about characters who migrated to foreign lands, his first novel's publication enacts migration, return, and essential multilingualism.

The publication of the original Arabic text (singular) is plural: English, French, Arabic, and Berber. Being almost an orphaned text with no clear genealogy, the novel does not bear the name of a publishing house, but simply the name of the printing press that printed out the pages. Choukri himself is listed as the publisher, since he financed the printing. Unlike other works in translation, there is no original version. Is it to be called *Le pain nu* (first widely read version), or *Al-Khubz al-hafi* (first written version), or *For Bread Alone* (first published version)? Predictably, the Roman script library records for the novel have conflicting entries. The Library of Congress catalogue entry for the Ben Jelloun translation indicates the name of the author as Choukri and on the same page spells it Shukri, a Romanized transcription of the Arabic pronunciation. This inconsistency occurs on most of the entries. The English version is classified as Choukri's biography, whereas Ben Jelloun's translation gives the subtitle *récit autobiographique* (autobiographical narrative). The Arabic text is catalogued as fiction, probably imitating the French classification. There is no original classification of the text to indicate its fictional or nonfictional status. Likewise, contemporary Moroccan readers consider it biographical, testimonial, or fictional according to their opinion of the novel.

Arabic and Berber: Idioms in Tension

One of the reasons that the book has been viewed as threatening is that the production of *Al-Khubz al-hafi/For Bread Alone/Le pain nu* effectuates a disruption of an ideologically defined linguistic hierarchy. Choukri's novel flattens the linguistic hierarchy that categorizes Tarifite (his native language), standard Arabic, Spanish, English, and French in relation to one another. Although these languages are present in varying degrees in many Moroccan novels, Choukri's deploys them in a particularly urgent and critical way.

All of these languages occupy strictly defined social positions in Moroccan society, Berber being at the bottom of this sociolinguistic hierarchy. Choukri's native language is Tarifite, one of three Amazigh (Berber) lan-

guages spoken in Morocco, the other two being Tamazight and Tachelhit.[4] Tarifite is spoken in the Rif, the mountainous northeast portion of Morocco. These Berber languages are depreciated in relation to spoken and written Arabic and European languages, partly due to their exclusively oral expression. (Berber publications have recently begun to appear due to Berber movements that have emerged in Morocco and, more violently, in Algeria.) The Berber language is even lower on the linguistic hierarchy than colloquial Arabic, which is also an oral language, since the latter takes precedence over the former in any context outside the immediate Berber family or community. Berberophones speak other languages (colloquial Arabic, Spanish, or French) in order to communicate outside their geographical region, even among speakers of other Berber dialects. In addition to its orality, Berber languages—historically spoken by rural communities—are devalued because being not associated with urbanism, material prosperity, and modernization. The novel's narrator explains the prejudice against mountain Berbers: "Ce mépris du Riffain frappe aussi celui qui est descendu de la montagne. La différence c'est qu'on considère le Riffain comme un traître et le montagnard comme un pauvre type" (p. 19).[5] (This disdain for the people from the Rif hit also he who comes down from the mountains. The difference is that those from the Rif are considered traitors and the mountain dweller a fool.) This perception of the Berbers and their languages is evident throughout the novel. Riffains are portrayed as not only foreign but also inferior. The other boys from Tangier say of the narrator:

> —C'est un Riffain. Il est arrivé du pays de la famine et des assassins.
> —Il ne sait parler arabe.
> —Les Riffains sont malades et partout où ils vont ils répandent la famine.
> —Même leurs animaux sont malades.
> —En tout cas, nous ne mangeons pas leurs bêtes. D'ailleurs elles les rendent encore plus malades.
> —Oui, quand meurt une vache, ou une brebis, ils la mangent quand même. Ils mangent de la charogne. (pp. 18–19)

"He's from the Rif. He came from the country of assassins and famine."
"He doesn't speak Arabic."
"The people from the Rif are sick and wherever they go they spread famine."
"Even their animals are sick."
"In any case, we don't eat their livestock. They make them even more sick."
"Yes, when a cow dies, or a goat, they eat it anyway. They eat carcasses."

From this passage it is clear that the Arabic speakers consider Berbers to be lower than themselves.

The hierarchy is expanded to include the literary Arabic of the original text. Berber dialects and colloquial (spoken) Arabic are depreciated in relation to written, Classical Arabic, which is respected as the language of the Quran. Classical Arabic occupies a sociolinguistic position of prestige. It is a written form, and is above all a sacred language. It is used exclusively by an elite community of Quranic scholars and the educated classes of the Arab world. Classical Arabic carries the association with the transcendental and the mythical, corresponding to an expansive symbolic space. This transcendental quality of the language connects Morocco to other Arabo-Islamic countries and thus also embodies a geopolitical dimension: "Enfin, sur le plan supranational, l'arabe standard représente à la fois la langue mythique de la communauté islamique et la langue référentiaire de la communauté arabe."[6] (Finally, on the international scale, standard Arabic represents both the mythic language of the Islamic community and the referential language of the Arabic community.) Classical Arabic unites Moroccans with the rest of the Arabo-Islamic community and the *Umma*, the community of Muslims.

Some Berber speakers have come to consider this conflation of Moroccan national identity with the rest of the Arabic-speaking world as an oppressive, colonial imposition of the Arabic language upon local Berber identities. This is one main reason why Berbers have objected to considering the Arabic language as the official language defining Moroccan identity. The Moroccan linguist Ahmed Boukous has described this sociolinguistic hierarchy established between languages spoken in Morocco in the following way:

> les langues non-maternelles, l'arabe standard et le français, occupent des positions privilégiées dans la hiérarchie des usages linguistiques, alors qu'y sont dépréciées les langues maternelles, l'amazighe et l'arabe dialectale. . . . L'on est ainsi en présence de deux paradigmes, celui des langues fortes, celles qui représentent un capital symbolique important et qui procurent à leurs détenteurs des profits substantiels, et celui des langues faibles.[7]
>
> (The nonmaternal languages, standard Arabic and French, hold the privileged positions in the hierarchy of linguistic usage, whereas the maternal languages are depreciated, the Amazigh and Arabic dialects. . . . We are in the presence of two paradigms, that of the strong languages, that represent a symbolic capital and gains for their users considerable profit, and that of the weak languages.)

In Morocco, maternal languages share the characteristics of their orality and locality. Each language resonates with a certain type of space, a modality

developed out of the dialectic between geographical space and the symbolic power of a given language.

This movement between local (Berber) and expansive (Classical Arabic) languages forms a hybrid and critical literary effect. In the literature of Arabophone Berbers, use of many different languages constitutes a migration between symbolic places. While Berber languages are spatially limited to a certain region, and in the imagination often to a village or household, standard Arabic has the characteristic of being perceived as limitless and omnipotent and corresponds to a territorially imprecise space. In his investigation of the conceptions of space among the illiterate around Marrakesh, Mohamed Boughali shows the contrast between the daily conception of space limited to the home (the workplace, a sister's house, the well, the hospital, the public oven) and the limitless, transcendental space of the *Umma*, a community that coheres via the language of the Quran. This example shows how each language becomes associated with a conception of place: Berber (the limited village space) and Classical Arabic (limitless, vague space of the *Umma*). Boughali directly addresses the perception among illiterate villagers of the space of the *Umma*. It is through religious ceremony that the individual gains a wider, if imprecise, perception of the space around him:

> En effet, nous pouvons, à juste titre, nous demander quelle est la nature exacte de l'espace qui pourrait éventuellement correspondre au sacré théologique de la *Umma* et quelles en sont les limites réelles. Il convient de faire remarquer qu'à ce niveau, la notion d'espace devient diffuse. Plus le sacré auquel est intégré l'individu outrepasse les limites de la ville, ou du village, plus il devient imprécis.[8]
>
> (Effectively, we can ask ourselves what is the exact nature of the space that could correspond to the theologically sacred *Umma* and what are its real limits. It is worth pointing out that at this level, the notion of space becomes diffuse. The more the individual is integrated into the sacred, going beyond the city or the village, the more its space becomes imprecise.)

Written Arabic and initiation into the *Umma* have the characteristic of extending beyond the local community and link the initiate to an international, or, in the case of Classical Arabic, imprecisely conceptualized international community. The shift from Choukri's Berber mother-tongue to the Classical Arabic in which he wrote *Al-Khubz al-hafi* represents a spatial movement from the specific, restricted space of the oral to the diffuse sacred of the *Umma*. The negotiation between these linguistic positions (Berber and Arabic) constitutes the strategy for the minoritarian writer to participate in a public literary discourse. To turn once again to the work of Michel de

Certeau, in his *La prise de parole* (The capture of speech) he writes: "restituer le récit des pratiques quotidiennes et des trajets anonymes cachés dans l'epaisseur du tissu social."[9] (To restore the narrative of everyday practices and the anonymous trajectories that are hidden within the thickness of the social fabric.) It is this shift from Berber to Classical Arabic that allows for the restoration of this hidden trajectory.

Due to the marginal position of the site of textual production (Berber in relation to Arabic) and the country of origin (Morocco in relation to France), a new linguistic, subjective space is forged in the novel. This deployment of multilingualism is what distinguishes Choukri's essential relation to multilingualism from other Moroccan Francophone or Arabic-language writers. His position of double marginality, both with relation to the West and within Morocco, intensifies the political essence of minority writing and the metamorphosis of these relatively major languages.

Spanish

Linguistic shifts between Berber and Arabic are compounded by textual movements into European languages and spaces. Crossing over into the Spanish territory and language does not produce a radical shift, but rather intensifies an internal multiplicity. The linguistic border is frequently crossed and opens up the Moroccan space to the northern Mediterranean. Rather than composing a homogeneous power-block, the frequently mentioned Spanish soldiers contribute to the agitated, decentered narrative territory of the novel. Spanish is part of the vibratory movement that mobilizes the narrative's drive and narrator's movements around the city. The narrator, Mohamed, passes several days wandering the streets of Tangier selling the Spanish newspaper *Diario de Africa*. He was selling *"Diario de Africa*. Nous déménageâmes. J'aidais ma mère au marché. Je criais face aux clients espagnols: Vamos a tirar la casa por la ventana, Quien llega tarde no come carne" (p. 39). (*Diario de Africa*. We moved. I helped my mother at the market. I screamed in the faces of the Spanish clients: "We're going to have a blast! Come one come all, the early bird gets the worm! He who comes late eats no meat.") Spanish comes in as a molecularizing force, breaking centered populations and their territories. The openness of the city of Tangier to the Atlantic Ocean, the Mediterranean, Spain, and the rest of Europe is here rendered in Spanish as the fishermen shout ashore: "Eh! Chico! Ven aqui! Solo es una broma! Ven! Toma otro pan" (p. 80). (Hey! Kid! Come here! It's only a joke! Come! Take another loaf of bread.) This is one of many examples of the spatial and linguistic plurality of the text. The Spanish language, widely spoken in Tangiers, denotes wandering between Morocco (here) and Spain

(there). "Entre le marché et les rues étroites de la médina je mendiais, ou tout simplement, je chapardais" (p. 23). (Between the market and the narrow streets of the medina I begged, or simply stole.) *Marché* (meaning "market") is a French version of the Arab *souq*, differentiated by its Cartesian order relative to the *souq* situated in the *medina*, meaning "city" in Arabic and signifying the Arab part of the North African city in French. *Chaparder* is a word brought onto the Algerian territory by the Spanish military in the mid-nineteenth century: it became slang for "to steal"; the Spanish word becomes a way for the wandering Riffain to steal and make his way from place to place, eating en route. The migrating Spanish word *chapar*, having moved from the north to Africa and then back into the French language, allows him to move from point to point through the heterogeneous space of the city: "Certaines nuits, je dormais au café, sur les bancs, et d'autres je trouvais refuge dans la boulangerie espagnole" (p. 29). (Certain nights I slept at the café, on the benches, and other nights I found refuge in the Spanish bakery.) Words create paths of flight, and space becomes *édentée*, un-*eden*ed, like the "un-edened" genitals of the not-so-striking girl Monat whose "déchirure s'ouvrait comme une bouche édentée" (p. 32). (Rip opened like a toothless mouth.) Repeated flights from point to point within national languages and territories mark the narrator's incessant crossing of borders. The diasporic movement of leaving the home is actualized in the home territory. This is inherently a critique of colonial invasion and an inherent commitment to Moroccan determination.

Homelessness

The portrayal of homelessness in the novel is part of a social critique, a statement of a forced linguistic, spiritual, and cultural homelessness. This homelessness is represented in part by the multilingualism and flattening of linguistic hierarchies that recreate the Moroccan space. A similar subversion of hierarchy is effectuated in the register of theological spaces. The leveling of hierarchical spaces and languages proves to be a contesting of his society's worldview. Migration or diasporic movement seems to have made its home in Morocco during the protectorate and after. The narrator of *Le pain nu* is homeless, mostly in Tangier, and never attached to a particular language or place. Despite the narrator's homelessness, or perhaps because of it, the notion of an *original place* is continually imagined and interrogated. The home—be it a toponym—is always figured between quotation marks and thus puts into question the validity of the notion of an original place, of paradise—the utopian place. The superimposition of life in Tangier onto images of paradise performs a dismantling of hierarchical spatial orders. The ghetto

and paradise are superimposed in a subversive gesture. The events recounted in the novel resemble what one would imagine hell to be like: infanticide, famine, rape, chaos, and so on. Strangely, images of heaven and paradise recur in the novel. The moral standard that establishes the hierarchy between heaven and hell is leveled. Conservative, moralistic critics are inclined to interpret this as a pure attack on religion; other critics will see it as a text's description of rural migration via the symbolic terrains available to its author.

The narrator's series of flights within and between cities represents the multiple levels of homelessness: "'Tu es en fuite?' 'Oui'" (p. 78). ("Are you in flight?" "Yes.") Tetouan seems to be home: "'D'où es-tu?' 'De Tétouan'" (p. 85). ("Where are you from?" "From Tetouan.") Walking along the *avenue d'Espagne*, Mohamed is picked up by an elderly gentleman who asks him where he is from: "'Il me demanda si j'étais de Tanger.' 'Non, je suis de Tétouan'" (p. 82). ("He asked me if I was from Tangiers." "No, I am from Tetouan.") But in other contexts he is alternately from the Rif and from Tangier. "'D'où es-tu?' 'Je suis Riffain'" (p. 78). ("Where are you from?" "I am Riffain.") "'Et ou dors-tu?' . . . 'dans la casbah la route de Ben Abbou'" (p. 119). ("Where do you sleep?" . . . "in the casbah on Ben Abbou street.") To escape the questionable propositions of a stranger met outside the train station, Mohamed invents an uncle and a home on a street in Tangier: "'Veux-tu dormir chez moi?' Je le regardais. Son visage n'était ni sincère ni innocent. Cette bonté était suspecte. 'Non. Merci. J'ai un oncle qui habite Aïn Keteouet. Je vais chercher sa maison et dormirai chez lui'" (pp. 81–82). ("Do you want to sleep at my house?" I looked at him. His face was neither sincere nor innocent. This generosity was suspicious. "No. Thanks. I have an uncle who lives at Ain Keteouet. I'll go look for his house and sleep there.") At other times he is from nowhere, or anywhere. "'Où dors-tu?' 'Dans la rue. N'importe où'" (p. 81). ("Where do you sleep?" "In the street. No matter where.") These flights are not just actual but also conceptual. Mohamed constructs his narrative/home as the situation unfolds. Gilles Deleuze writes: "La carte est affaire de performance."[10] (The map is a matter of performance.) This invention of space is how the individual reinterprets historically defined boundaries.

Leveling Theological Hierarchies

I have shown how linguistic hierarchies are disrupted and how a new, horizontal, and open trajectory is traced. In a similar way, a theological hierarchy comes into question in this seemingly simple narrative. The narrative includes and then rejects a theological worldview that upholds a vertical structure of meaning. The text's superimposition of a sociolinguistically

sacred field (Classical Arabic) in relation to degraded spaces (prostitution, street life) is in direct contradiction with the accepted symbolic norm. The Islamic principle of transcendence that determines a vertical production of meaning is present in the novel, but only to be seriously put into question. Signs of God (*âyat*), of which language is one manifestation, reveal a theophanic space that moves from above to below, since meaning and signs are given to us by God:

> Avec le terme *âya*, l'on relève l'usage fréquent de verbes ou substantifs qui dénotent ce movement du 'haut' vers le 'bas' tels que *nazzala* et *anzala* 'faire descendre.' Une relation verticale s'établit donc entre le fidèle et Dieu, la créature et le Créateur, et impose une structuration de l'espace et un cadre particulier à la communication: la transcendance d'Allah.[11]

> (Along with the term *âya*, we detect the frequent use of verbs and nouns that signify a movement from "high" to "low" such as *nazzala* and *anzala*, to "descend or to go down." A vertical relationship is thus established between the faithful and God, the creature and the Creator, and imposes a spatial structure and a particular framework on communication: the transcendence of Allah.)

In the space of Choukri's novel, this transcendence, or verticality, is horizontalized through a movement of flight between home and foreign cities and a sacred language touching the profane realities of life.

The superiority of the high or the divine is subverted through a compression of the Islam/Christian spatial dichotomy and a revaluing of the real, the base. Cultural excursions into Christian references effectuating a collapse of the religious division between *dâr al-Islam* (land of Islam) and *dâr al-kufr* (land of disbelief). In a rejection of these religious borders, the text moves across theologically defined spaces of high/low (heaven/hell) and sacred/profane (Arabic/French, *halal/haram*).

This crossing occurs when Biblical notions of theological space are deployed not as oppositional arguments but as a way to write about Muslim spaces. *Le pain nu* begins with the expulsion of the narrator from his homeland, the Rif Mountains. The narrative continually suggests the possibility, then the impossibility, of a promised land, pointing to a Biblical reference and a meaningful, primordial rupture. It appears that the family is moving from a fallen, condemned homeland to a promised land: "C'était le temps de la famine dans le Rif. La sécheresse et la guerre" (p. 11). (It was a time of famine in the Rif. Drought and war.) The family leaves a poor, desperate, oppressive land: the Egypt–Israel mythic paradigm. Mohamed, the narrator, is promised a better life after the family's departure from the Rif; mountains

of bread are promised in the unknown new place: "Nous émigrerons à Tanger. Là-bas le pain est en abondance. Tu verras, tu ne pleureras plus pour avoir du pain. A Tanger les gens mangent à leur faim" (p. 11). (We will emigrate to Tangier. There the bread is abundant. You will see, you won't cry for bread anymore. In Tangiers the people eat their fill.) The protagonist discovers the illusory character of the promised land: "A Tanger, je ne vis pas les montagnes de pain qu'on m'avait promises. Certes, dans ce paradis on avait faim mais on n'en mourait pas comme dans le Rif" (p. 12). (In Tangiers, I didn't see the mountains of bread that I had been promised. Certainly, in this paradise we were hungry, but we didn't die from it like we did in the Rif.) Thus at one moment, geographical borders have been crossed and mythic space has been superimposed upon a stronger image of the conditions of the poor in contemporary Morocco.

The notion of paradise is continually debunked through superimposition onto the real and infernal life in Tangiers. Early on in the text, the narrator abandons (or is abandoned by) the notion of the origin, paradise. Especially in the initial and final lines of the text, the question of paradise is posed: "Pourquoi Mon Dieu avions-nous quitté notre pays, notre terre? Pourquoi les autres ignorent-ils ce qu'est l'exode?" (p. 20). (Why my God have we left our country, our land? Why do the others not know what is meant by exodus?) The narrator wonders: "Qu'est-ce qu'il y a au paradis?" (p. 17). (What is there in paradise?) Theological explanations and systems of reason seem arbitrary and absurd to Mohamed; when he asks his mother why God does not help them in their poverty, her response does not seem to convince him: "Mais pourquoi Dieu ne nous donne-t-il pas un peu de chance comme aux autres?—Dieu seul sait. Nous, nous ne savons rien. Ce n'est pas bien d'interroger Dieu. Lui sait. Nous, nous ne savons rien" (p. 16). (But why does God not give us a chance as He does for the others?—God alone knows. We know nothing. It's not good to ask God questions. He knows. We know nothing.) His mother is speaking in the logic of Islam where all meaning comes down from above, from the all-knowing Creator. This logic seems to fall on deaf ears as the narrator continues to search for a new, subjective order to the world.

The questioning of God's existence in the first part of the novel is consistent with the ambivalent representation of paradise in the novel. Paradise is manifest in it both as a possible, fantastical space and as a false promise associated with the supposed absence of God. After his brother's funeral he asks his mother about the relation between God and death:

> Quand je demandai à ma mère: 'Mais pourquoi l'homme meurt?,' elle me répondit: 'Parce que Dieu le veut.' 'Mais où vont-ils après?' 'Au paradis ou en enfer.' 'Et nous deux?' 'Au paradis si Dieu le veut.'

'Qu'est-ce qu'il y a au paradise?' 'Tu poses trop de questions. Quand tu seras grand tu comprendras tout.' (p. 17)

(When I asked my mother: "But why does man die?" She answered me: "Because God wishes it so." "But where do they go afterwards?" "To paradise or to hell." "And us?" "To paradise God willing." "What is in paradise?" "You ask too many questions. When you grow up you'll understand everything.")

As Mohamed enters into the Tangier cafe life of *kif* (marijuana) and drinking, he wonders: "Est-ce pour çela que nous venons au monde? Ah, non! Il y a l'enfer et le paradis. Du moins c'est ce que m'a dit ma mère" (p. 29). (Is this why we came into the world? Oh, no! There is hell and heaven. At least that's what my mother says.) Mythic spaces are thus compared to the reality of life in Tangiers. This questioning of the Islamic order of space and logic, especially because the text is written in Classical Arabic, remains shocking and unacceptable to many readers from the Arabic-speaking world.

One way in which the narrative migrates back and forth between Moroccan and European (also Christian and Muslim) sociospaces is through a whole series of conscious or unconscious references to Saint Augustine. He in never mentioned directly, but the allusions to his life and work already indicates a transgression of the modern dichotomies: north–south and Christian–Muslim. Saint Augustine was a Christian living in a predominantly Muslim North Africa. Tracing the Augustinian narrative, *Le pain nu* can be read as a testimony to the narrator's childhood carnal pleasures. The narrator seems to walk in the Christian saint's footsteps, thus creating an ironic, even multiple-subject position vacillating between north and south—between Christian and Muslim territories. Where Augustine writes from an experience of conversion and moral rejection of his trespasses, Mohamed (the fictional character) describes his debauchery as a positive force associated with writing, and the novel ends with the narrator beginning to write. Through the narrator's mimicry of Saint Augustine he migrates to Christendom. Through this difference with respect to Augustine he elaborates a critique of his home space in Morocco.

In the first of the novel's two garden scenes, Mohamed is caught stealing pears. This resembles an unconscious reiteration of Saint Augustine's theft. Saint Augustine recounts the stealing of the pears in order to show the existence of God and the impurity of human desire. He thus establishes the dichotomy between the fallen state of man and the necessity of regaining his original purity before the fall, in the Garden of Eden. Augustine's vocabulary signals confession as a discourse of synthesis, a moral position justifying the passage from a fallen state to a state of repentance:

Il y avait un poirier près de la vigne de mon père, dont les poires n'étaient ni fort belles à la vue, ni fort délicieuses au goût. Nous nous en allâmes, une troupe de méchants enfants après avoir joué ensemble jusqu'à minuit. . . . Et nous nous en revînmes tout chargés de poires, non pour les manger, mais seulement pour les prendre.[12]

(There was a pear tree near my father's vine whose pears were neither very beautiful nor very delicious. We went, a group of mean children, after having played together until midnight. . . . And we came back loaded down with pears, not in order to eat them, but just for the pleasure of taking them.)

The Augustinian discourse can be seen as a synthetic returning where the text functions as a primary space of moral rectitude.

In a similar scene of stealing pears from the garden, the narrator of Choukri's novel, Mohamed, tells us: "Notre voisin possède un poirier très riche. Je passais des heures à observer ses fruits. Un matin il me surprit en train d'essayer de cueillir une belle poire, la plus belle, avec un roseau. Il me traîna par terre" (p. 19). (Our neighbor has a very rich pear tree. I spent hours looking at its fruits. One morning he caught me trying to steal a beautiful pear, the most beautiful, with a branch. He dragged me to the ground.) As in Saint Augustine's *Confessions*, the young thief is locked up and punished for his transgression. But instead of realizing his fallen state, Choukri's narrator reenacts the transgression of touching the forbidden fruit.

Following the theft and the transgression of having touched the tree, the first of many erotic fantasies swells in the narrator's imagination: he spies on the proprietor's daughter from his place of punishment. In a second garden scene, the notion of an original, pure land is suggested and then dismissed. The passage begins:

Un matin, je montai sur le figuier et je vis Assia à travers les branches. Assia, ce devait être la fille du propriétaire de ce jardin. Elle marchait lentement vers le bassin. Elle va peut-être me voir et prévenir son père, un homme qui ne souriait jamais, tel mon père qui, par sa violence, devait ressembler à bien d'autres hommes. (pp. 30–31)

(One morning, I climbed the fig tree and I saw Assia through the branches. Assia, she must be the landlord's daughter. She walked slowly towards the pool. Perhaps she will see me and tell her father, a man who never smiled, like my father who, with his violent behavior, resembles many other men.)

In this scene, Mohamed perceives a naked girl for the first time, suggesting the first sensation of Adam and Eve's nakedness. The text reads: "Le corps nubile dans sa nudité révélé. Assia restera dans ma mémoire. Image fugitive

et initiation visuelle" (p. 32). (The nubile body revealed in its nudity. Assia will remain in my memory. Fugitive image and visual initiation.) Along these same lines, Mohamed feels guilt, for he fears being seen seeing and touching. The narrator alludes to God's punitive presence indirectly, through his father: "Mon père c'était Dieu, ses prophètes et ses saints réunis. Quelle terreur!" (p. 71). (My father was God, his prophets and his saints all together. How terrible!") The allusion to the tree of knowledge, and by metonymy, to the Garden of Eden, and the taboos associated with these places engender an identity of desire and not morality, drive (movement) and not stasis. The narrator continues to transgress moral and cultural boundaries. The Rif does not become the original land in the mythical sense, and there is no possibility of a promised land or a redemption.

The Augustinian aesthetic could be described as mimetic, while Choukri's text performs a fragmentation of space and flattening of meaning. This distinction can be understood in the following way:

> In terms of most communication theories and common sense, a map is a scientific abstraction of reality. A map merely represents something that already exists objectively "there." In the history I have described, this relationship was reversed. A map anticipated spatial reality, not vice versa. In other words, a map was a model for, rather than a model of, what it purported to represent.[13]

The map of Tangier that is traced in the narrative creates a diasporic future for the narrator. This doubling of space, as opposed to the mimetic role of the map, is common to both Mohamed Khaïr-Eddine's novel *Agadir* and Choukri's writing about their home cities. As in Khaïr-Eddine's novel, there can be no objective map in Choukri's, for there is no objectivity to physical spaces that continuously cross into one another. The maps of the cities described in the text are created and shaped according to the narrator's subjective drives. The map is not realistic, but created according to the image of the space described by Bouzar as the "surplus-space."

Transforming spaces of oppression into spaces of surplus in Choukri's text is clearly thematized. The characters experience their home as a space of subjection and constantly flee into imaginary and transgressive spaces. In order to create this spatial multibelonging, the narrator travels between opposing lands in three instances: the Garden of Eden versus the fall, *dâr al-Islam* versus *dâr al-kufr*, Egypt versus Israel. The way of describing space in sacred texts assumes a synthetic space of morality, which is similar, in its verticality, to the sovereign authority that establishes state territories. In this text, on the other hand, these spaces are no longer in opposition to one another, but rather conflate and become part of the new subjective space.

This novel is an example of what we have termed the "Arab avant-garde" in its experimental and challenging incorporation of exterior cultural references, languages, and narratives to tell its story. The critical aspect of the narrative is easily discerned: the text is critical of hegemonic tendencies both inside and outside the North African territory. Despite so many critics in the Arab world who wish to silence this text because of its cruelty (in the sense defined by Artaud) and raw sensibility, it remains a significant contribution to the corpus of contemporary Moroccan literature. The value of this text is in its migratory, contestatory conceptual wanderings that ironically stay within the home-space of Morocco. In its perceived hostility towards Moroccan (and Islamic) culture, this novel exposes a daily reality of many people who live in a state of poverty and urban nomadism. Critique is productive, and this novel adds to the world's knowledge of the multifarious layers of symbolic and real experience of Moroccans. Idioms of the Other (French, English, Spanish, Classical Arabic, and Biblical references) are mobilized to allow for publication of this narrative, which might not ever have been published in its exclusively Arabic form. Use of these multiple idioms allows for the contemplation and reconfiguration of the home space while resisting a nostalgic return to an authentic origin, to a prelapsarian paradise. In Choukri's case, this use of other idioms also entails traversing the barriers drawn by the Arabic literary arena. Foreign use of European languages—English, Spanish, and French—performs a minoritarian displacement, decentering the power of Western languages. However, the local deployment of Arabic by a Berber writer can also be considered "minor" within the context of Morocco, where Arabic established a relation of dominance with respect to Berber. Working back and forth between so-called "tradition" (associated with Classical Arabic) and so-called "modernity" (associated with Western languages) loosens the restrictive space that these categories create. These new porous surfaces or borderlines allow for movement and a new way of participating in both types of being. "Multiple belonging" (to cite Wadi Bouzar) provides a possibility for previously unrecognized and contestatory experiences to become public.

Choukri's text marks the migration from a limited linguistic space of Amazigh—his maternal language spoken in the home and within a limited geographical space. His writing enacts a movement into the expansive social space of Classical Arabic, a sacred language uniting the vast, even geographically unlimited space of the *Umma*, and then into the European linguistic spaces of English, Spanish, and French. Choukri represents the peasant's migration through literature, passing through the sites of cultural legitimacy located primarily outside of Morocco. This linguistic migration and the sociospatial migration it operates is the creative principle for the voice of dis-

content. *Le pain nu* is about the home city of Tangier and the narrator's father's house, filtered through the spaces of Tangier, Tetouan, the Rif, and the languages of Francophone Tahar Ben Jelloun, the Anglophone Paul Bowles, and, most distressingly (for many), the sacred language of the Holy Quran. The multilingual process by which the text came into existence is one aspect of this novel's diasporic thought. It is through this "diasporic" use of cultural and linguistic borders that the author articulates his critique and vision of the homeland.

What I here call "diasporic thought" is not far from what Homi Bhabha calls "enunciative practice." Both serve as strategies for subjugated perspectives to emerge into the public discourse. Bhabha shows that the survival of subjugated cultures depends on the shift from the notion of the subject as epistemological site to the subject as enunciative practice. This latter notion of practice is the operative principle in the production of Choukri's literary text. Bhabha explains:

> If culture as epistemology focuses on function and intention, then culture as enunciation focuses on signification and institutionalization; if the epistemological tends toward a *reflection* of its empirical referent or object, the enunciative attempts repeatedly to reinscribe and relocate the political claim to cultural priority and hierarchy (high/low, ours/theirs) in the social institution of the signifying activity.[14]

Bhabha goes on to describe how this interstitial process of signifying—writing as a dialogic process between cultural sites high and low—opens up the new cultural spaces in which "objectified others may be turned into subjects of history and experience."[15] In Choukri's novel, one sees precisely this practice of multiple enunciative sites and the ideologically constructed oppositions by which his social critique is registered: France–Morocco, sacred–profane, classical–contemporary, literary–real. These elements are indeed distinct; we do not want to conflate these categories, but rather will stress that by superimposing them, or traveling across their borders, Choukri's text radically disturbs the political claims to power from which his characters have been excluded. All critics of Mohamed Choukri's novel have challenged the "irreligious" transgression of those borders, especially the use of the sacred language to express a so-called vulgar reality. Crossing those borders allows for the critique of poor migrant workers' conditions in mid-century Morocco, a condition lived by the author as well as the character in the text.

Chapter 3

▼▼▼▼▼▼▼▼▼

Ruin and Affect

Despite differences in time and space, the critical preoccupations of the Algerian novel *Vaste est la prison* written by Assia Djebar (b.1936) are not far from those of the Tunisian and Moroccan narratives described in the previous chapters. Indeed, the question of the relation between internalized Western idioms and Arabo-Islamic idioms of cultural expression remains an inescapable problematic shared by artists, novelists, historians, and critics of North Africa. Djebar's novel describes the painful experience of being exiled into the language of the Other while always seeking to rediscover her native Arabo-Berber language and identity. The paradox foregrounded by this novel is that the more the narrative traces the historical writing back towards this origin, the further the protagonist is thrust into exile, for all the historiography is written in French. In this novel, the mutual determination of fiction (the personal, the intimate, the affective) and the historical (collective, "the objective") remains inextricable while scientific discourse tries to wrest them from each other. Djebar's novel shows these two types of narrative discourse to be entwined. This relationship between *histoire* (history), which, in the case of Algeria, was largely written by French historians and artists who worked under colonial patronage, and *histoires* (stories), which concern individuals and their private lives as Algerians, is central to our inquiry.

Djebar was born in Algeria and educated in Algeria and France. She has published many novels in the French language including *La soif* (1957), *A Sister to Scheherazad* (1987), *L'amour, la fantasia* (1995), *Vaste est la prison* (1995), and short stories including *Femmes d'Alger dans leurs appartements* (1980). She has also made two films: *La Nouba des femmes du Mont-Chenoua* (1979) and *la Zerda ou les chants de l'oublie* (1982).

In addition to her talents as novelist and film-maker, Assia Djebar is also an accomplished historiographer. Many of her novels (with the marked exception of her first, *La soif*) include chapters piled high with researched archival material from pre-Islamic North Africa, nineteenth-century colonial

expeditions, and other material that contribute to a renewed articulation of Algerian history. During the time required to digest the historical material informing her writing, I have become entangled in the prickly relationship between these punctilious and erudite historical chapters and the tender stories of passion and heartbreak that frequently preoccupy the female protagonists. The tenor of these thematic partners (collective versus individual histories) seems so radically out of tune in the novel that one must wonder why they are continually paired. Why and how do tales of fantasy, madness, and unrequited love set in late twentieth-century Paris or Algiers consistently bump up against such a sustained historical erudition?

Many critics have speculated on the meaning of such an obvious yet apparently mysterious relation between historiography and intimate fiction. According to Sonia Lee, in her "Daughters of Hagar: Daughters of Muhammad," Djebar investigates the relation of the Prophet Muhammad with his daughter Fatima in order to make a statement about Islam's original protective posture vis-à-vis women. Lee interprets Djebar's authorial intentions in *L'amour, la fantasia* in the following way:

> Djebar seems to feel that Muhammad's legendary love for Fatima should have served as a model for Muslim fathers, an opportunity to improve their society, and to act upon the wisdom of the Koran. But instead of listening to their heart, they chose to perpetuate the law of their fathers, thereby yielding to their desire to preserve male prerogatives.[1]

It is altogether possible that Djebar is arguing against the "dispossession of Fatima" as the origin of the contemporary Muslim woman's dispossession.

Another critic, Patricia Geesey, interprets Djebar's use of historical figures as self-inscription into a legacy of female transmitters in what she calls a "reconstructive project."[2] The notion of a "reconstructive project" is important in many contexts where history was written by a colonial intelligentsia, and the problems with "reconstructing" will be examined below. Yet another literary critic, Anne Donadey (1993), puts forward the legitimizing function of historical research as a form of support for fictional autobiography. This position is defensible to the extent that Djebar's first novel, *La soif*, was widely criticized by Algerian writers and freedom fighters of the late 1950s for its lack of historical and political *engagement*. In a recent study of *L'amour, la fantasia*, John Erickson argues that Djebar's retelling of the French colonial conquest of Algeria, through its technique of citation of French historiography and incorporation of new perspectives, parodies and thus subverts the colonial posture as site of knowledge and authorial voice. Along the same lines, and in reference to *Loin de Médine*, Erickson writes: "Djebar's goal in

looking at these male-authored histories is to first uncover women's obscured presence and then highlight their voices in the construction of early Islamic historiography."[3]

Indeed, new historiographic accounts like Djebar's, especially ones that reiterate tales of women, Berber tribesmen, and other previously underexamined stories, can be read as a reorientation or even dismantling of Western historiography. A critique of historiography (both European and Islamic) is produced through a constructed continuity of the woman storyteller and the contemporary Algerian historiographer/biographer. The need for rewriting Algerian history of the colonial period does not come into doubt here. Djebar's use of history in *Vaste est la prison* articulates not the Algerian history one may anticipate, but the effect of an inescapability of the narrator's French subjectivity in the recounting. In this novel, the contemporary self (the narrator/archivist/writer) is conditioned by a symbolic "captivity" within the French literary and intellectual traditions.

This incarceration is indicated by two elements of the narrative: the thematic element of feminine sentiment and the impossibility to access an Algerian past other than through the French referent. The first element in fact emerges out of the second, for it is the French literary tradition that produces the condition and possibility for representing such an unabashed feminine affect. Djebar's mention of the twelfth-century legend of *Tristan et Iseut* is but one appearance of the French literary tradition, of which she is perhaps an inheritor, and indicates the importance of French literary discourse in her access to "the ancestors": "Ô aïeul au visage enfoui en terre et que, plus problablement, je rejoinderai faute de cet amour final, de cette passion jusqu'à la mort que je quête-car il n'y a pas d'Iseut en Islam."[4] (O ancestor, whose face is buried in the earth, most likely I shall meet you again for want of this final love, this passion to the point of death that I seek. Because there is no Isolde in Islam.)[5] Thus the fatal passion of French medieval literature ignites the passion for the "real" Algerian past whose simulation will be continually pursued and recreated within the narrative.

History and Affect

The first part of *Vaste est la prison* narrates an unconsummated adulterous love affair that ruins the narrator's marriage. The second part recounts the history of archeological research into the writing on a ruined Berber tombstone in Dougga (situated in Tunisia, about a hundred miles from ancient Carthage). The first part has one thing in common with the rest of this lengthy and curvilinear narration: *ruin*. The narrator's heart and marriage are fragmented, pulverized, torn to bits. The archeologists and linguists involved

in the investigation, that spans several centuries, seek to decode the Lybico-Berber language engraved on the ruins of the Dougga mausoleum. Both the ruin of the heart and the stone's fragmented materiality allow for a stylistic coherence of dismemberment and a sentiment of mourning. Yet rather than the political or historical *arguments* that critics tease out of Djebar's fiction (critique of Western historiography, incorporation of untold stories into official representations of Algeria, and so on), it is the incendiary effect produced by the gathering of historical bits that becomes the subject of my inquiry.

I will once again turn to Michel de Certeau, who has written extensively on the writing of history and historiography. The difference between "official" historiography and the historiography of *Vaste est la prison* has everything to do with the foregrounding of passion, possibly the effect of a spatial disorder that is described by Michel de Certeau in *L'écriture de l'histoire* (The writing of history) where he analyzes Freud's *Moses et Monotheism*. De Certeau writes of the Freudian interplay between the inaugural moment (separation as object) and the moment of writing: "La fiction freudienne ne se prête pas à cette distinction spatiale de l'historiographie où le sujet du savoir se donne un lieu, le 'présent,' séparé du lieu de son objet, défini comme 'passé.' Ici, passé et présent bougent dans un même lieu, polyvalent."[6] (The Freudian fiction does not lend itself to this spatial distinction of historiography in which the subject of knowledge is given a place, the "present," separated from the site of his or her object, which in turn would be defined as a "past." Here, past and present move in the same polyvalent place.)[7]

Similarly, Djebar's narrative puts forth a mechanism of passion, fueled by an internal division, at work in the collecting of information about the lost maternal language that precludes a simple rewriting of Algerian history *alongside* the personal history of an Algerian writer. *Vaste est la prison* can be considered as a continuation of the initial move in *La soif*'s fictional autobiography: a testimony of inaugural separation from her so-called mother language and culture of origin. What consistently burns throughout Djebar's writing, including *Vaste est la prison*, is a fiction of wounds or melancholy. Melancholia, according to Freud's "Mourning and Melancholia" (1915), is characterized as an extension of narcissism where identification functions as the primary motivation for object choice. The absence of the object, instead of simple mourning, produces a curious affective state. The creative manifestations of such a loss may resemble the double bind that I will describe below.

The abundance of affect in *Vaste est la prison* provides a new perspective on bits of history, and the excavations of crumbling sites of memory in the novel. Again, de Certeau's commentary on Freud's *tradition mosaïque*, his mosaic tradition or the fragmented narrative of Moses' original *separation*

from the Egyptian space as inauguration of Hebraic identity serves our pur-
pose here: "Le *lieu* d'où Freud écrit et la *production de son écriture* entre dans
le texte avec l'objet dont il traite. Comment une légende réligieuse se forme-
t-elle? Comment le Juif est-il devenu ce qu'il est? Qu'est-ce qui construit une
écriture? Les trois questions se combinent."[8] (The *place* from which Freud
writes and the *production of his writing* enter into the text with the *object* that
he is taking up. How does a religious legend take form? How have the Jews
become what they are? What is it that builds a writing? The three questions
are combined.)[9] The inaugural separation from the mother tongue in
Djebar's fiction becomes the original condition of writing. The way the love
story unfolds and is represented demonstrates the protagonist's separation
from a traditional Algerian girlhood. Similarly, separation as a condition of
identity finds at once its proof (female desire) and simulacrum (inability to
possess the object) in the relationship to the desired young man in *Vaste est
la prison*. The break-up then reopens and recreates the wounds of this sepa-
ration. It is because of the narrator's distance from her Algerian heroines, not
because of her proximity to them, that these figures are summoned from
their graves. Identification with the culture of origin is *staged* in order to
reenact the history of being cut off.

The narrator's dialogue with such heroines as Aïcha, Fatima, the Berber
princess, and others is clearly staged as a testimony of exile into French. This
difference operates (in the surgical sense of "incision") on the contemporary
self as a primordial scene that is simulated by the heartbreaking, extramarital,
and impossible love affair with the man she calls her "maternal cousin."
Berber identity is alluded to in this part of the story in a conversation with
the lover whom she fantasizes is her (Berber) mother's nephew: "Vous seriez
plutôt le fils de mon oncle maternel! Vous savez bien, la branche paternelle
compte pour l'héritage, et donc pour les mariages d'intérêts, tandis que la
lignée maternelle, par contre, est celle de la tendresse, des sentiments, de . . ."
(p. 41, ellipsis in the original text). (You might be the son of my maternal
uncle, though! You know that the paternal branch is what counts for inheri-
tance, and consequently, in a marriage for money, whereas the maternal line
is, on the other hand, the line of tender emotions, affection, and . . . [p. 40
in the English translation].) The young man in question (whose mother is
Berber but who confesses to feeling more like a *pied-noir* than a Berber)
stands in as the desired maternal lineage, a desire continuously mediated
through the French writing and linguistic tradition.

In her "Acting Bits/Identity Talk," Gayatri Chakravorty Spivak opens an
investigation into the subaltern autobiography with a brief reflection on Dje-
bar's novel *L'amour, la fantasia*. Spivak's commentary on subaltern narration
through autobiography renders suspect any speech adducing "identity as

origin" when it is built upon the sum of the parts of a collective history. "The origin of identity" is reconsidered here as a *stage* that is set by the autobiographer in order to underscore the importance of the *rupture* with history that characterizes the subaltern autobiography. An identity posited in symbiosis with historical continuity ("identity of origin") becomes countered rather by a *staged* bit of identity against which an incision is marked through prose. Narrative cutting of the self from an a priori *staged* character allows for the contemporary writer to emerge not to "fill the gaps" of history, but as a writer spinning a text that, to the contrary, is rife with gaps, pocked with holes, and decomposed by its bits. This reading seems to gloss *Vaste est la prison*, since the dominant aesthetic and affect is crumbling, reduced to bits of culture and a ruined identity.

The mausoleum is a site of mourning, of precolonial memory reduced, through Western scientific endeavors and excavations, to a pile of bits and pieces. This historiographic endeavor, in its archeological manifestation, amounts to simulating and producing the lost origin through French strata (archival documents) as opposed to constructing a self that "gets along" perfectly with history and with the privilege of literacy. Acting bits, according to Spivak, rhetorically shuttle back and forth between the "original" self and the mourning self who fails to consummate a seamless relation with sites of origin.

Such a reading complicates the interpretation that Assia Djebar's historiography *adds up*, or fills in the lacunae, or includes minoritarian or oral testimonies within the dominant cultural space of French historiography or, more broadly, of Western thought. The *adding up* of minoritarian identity fits rather neatly the notion that recovery is possible. Perhaps the savvy writer plays with such desires and expectations of her readership. However, the narrative clearly displays the problems at stake in the archeology: Djebar shows that inherent in the recovery process is the division or incision within her own subjectivity. The well-documented and meticulously recounted history of the 136 B.C. monument in Dougga represents an ambivalent relationship to the commodification of identity, at once inside and outside an economy of *supplementing*, to the historical documentation of the Berber king's mausoleum. Inside this *supplemental* economy, the history of the Lybico-Berber language inscribed upon the beloved and dilapidated sepulcher serves to edify the French metropolis that, contrary to common belief, the Berber language has ancient manifestations of a written form. French is thus enriched by the presence of an Arabo-Berber Francophone writer. In addition, the rewriting of history in the writing of the self is consistent with critical positions about Western writing on the Orient and North Africa. On the one hand, one could interpret this as an effect of conformity or acquiescence in writing. To take this possibility one step further, the insertion of the staged

authentic self into the literary market perhaps acts out the reader's very desire to oppose French narratives of/*on* Algeria, thus underscoring the continued commodification of subaltern identities by Western thought.

On the other hand—and this is the interpretation that I would like to advance here—historical documentation can be deployed by virtue of its very powerlessness to recover or adopt an orphaned self exiled in the hexagon (France). The bits of history, neither essential nor evacuated, simply lend their materiality for the expression of "cutting" that constitutes the autobiography-in-fiction. Spivak writes that

> this [citing or cutting] is not postmodern practice. There is none of that confident absolute citation where what is cited is emptied of its own historical texting or weaving. This is a citing that invokes the wound of the cutting from the staged origin. I harmonize with Djebar here: autobiography is a wound where the blood of history does not dry.[10]

History forms a composite shaping of the autobiographical self in bits and shards whose hinges never seem to meet. The effect is not a remodeled self, a smooth, subversive hinging with Algerian storytellers, but rather the performance of the "acting bits" composed by the separation between the Francophone writer and the culture of origin. A closer look at the seams that are strained or torn between the Algerian- and the French-writing selves will demonstrate the main object of this literature as, not a historical or identity reconstruction, but rather the separation from a clearly staged, original Arabo-Berber identity.

Discovering the Lost Letters

The first character in the narrative to discover the tombstone is a Christian convert to Islam, Thomas of Arcos (b.1565). This erudite wanderer, who spends several years as a slave in Tunis, happens upon the tombstone in the mid-seventeenth century. He copies the writing that he sees inscribed upon it. The "double writing" has been shrouded in mystery for centuries. Thomas of Arcos is unable to identify the ancient languages he has transcribed, but assumes one may be Punic. He gives the text to a specialist in Eastern languages, Abraham Echellen. Unable to immediately identify the writing, Abraham takes a copy of the inscription and goes back to Rome to study the text. This is the last we hear about both Abraham and Thomas of Arcos. Thus we hear about two ancestors in the genealogy of the Algerian Berber narrator: "Thomas, entre deux rives, entre deux croyances, sera le premier transmetteur d'une inscription bilingue dont le mystère dormira encore

deux siècles" (p. 128). (Thomas, between two shores, between two beliefs, will be the first one to transmit a bilingual inscription whose mystery will lie dormant for two more centuries [p. 130].) The affinity between Thomas of Arcos and the narrator provides the first evidence of her writing's inaugural separation from the Berber language and culture as opposed to the thesis of recovery and continuity.

Two hundred years after Thomas of Arcos, and just prior to the French invasion of Algiers in 1830, the next "ancestor" emerges from the Italian court. Count Borgia of Naples, impassioned with archeology and the classical period, decides to take leave of his lovely wife Adélaïde and travels to Carthage. Arriving in Tunis, he meets a Dutch engineer, and they both follow the path of their predecessor, Thomas of Arcos. Borgia describes the ruins of Dougga in the letters he sends back to his wife in Naples, and includes in these letters dispatched across the Mediterranean the faulty interpretation that the double inscription is written in "*punico e punico-ispano*." Borgia dies suddenly upon his return to Naples, and his wife, wishing to publish his travel narratives, gives the manuscript to a Frenchman, who in turn sells it to the National Museum in Leiden, where the manuscript lies undisturbed until 1959.

A few years after Borgia's description of the ruins, in 1832, Lord Temple of Britain makes an archeological excursion to North Africa. His description of the Dougga mausoleum is slightly more precise than the others: he quickly recognizes that one of the languages is Punic and the other is some sort of "old African" language. He accurately dates the monument at around the last years of Punic Carthage, circa 146 B.C. This account is published upon the lord's return to London.

This same lord returns to the site a few years later with a Danish cartographer whom he met at an archeology conference in Paris, and the two of them go together to the sites around Carthage. The English consul in Tunis, becoming aware of the value of the Dougga site, decides to sell it to the British Museum. Unfortunately, the local authorities under Turkish domination had little desire to conserve their Carthaginian patrimony and allowed the British consul to take control of the monument. Consul Thomas Reade has the monument broken into pieces, marking the beginning of the end for the Berber alphabet; parts of the scattered alphabet are packed up and shipped to London—the only evidence of the "ancient African" language is transported in pieces from the pillaged site of Dougga to the British Museum. This destruction occurred in the midst of the French invasion of Algiers.

Under the French Protectorate, the ancient ruins of Carthage were the property of French archeologists and European historians of the classical period. Around the turn of the century, a certain L. Poinsot undertook the

reconstruction of the Dougga mausoleum. The only thing that could not be reconstructed, that was lost forever in its original form, was the (double) inscription upon the tombstone. Also during the nineteenth century came Gésénius, M. de Saulcy, Honegger, and Célestin Judas, who all attempted to decode the language of the stele. The latter managed to approximate the 23 letters of the Berber alphabet based on his predecessors' transcriptions. The reconstruction of the alphabet was not certain; the initial written form of the language remains unknown because of its fragmented, ruined form: "cet alphabet . . . devenu ensuite indéchiffrable jusqu'au milieu du XIXe siècle, en somme jusqu'à ce qu'une stèle de sept lignes ait été transportée au British Museum, laissant dans son sillage un champ de statues brisées et de colonnes abattues" (p. 145) (this alphabet . . . which then became indecipherable until the mid-nineteenth century, in short until a stele with seven lines on it was carried to the British Museum, leaving in its wake a field of broken statues and felled columns [pp. 147–48]). Other traces of the lost alphabet were discovered on ancient edifices by Scholtz (in 1822), Pacho (in 1827), and Walter Oudney, who identifies the language as that of the Tuaregs. At around the same time, the bey Ahmed, a Berber ruler under Ottoman-controlled North Africa, included in his Arabic text a few lines written in the Berber alphabet.

Throughout the hundreds of pages of this archeological history, of which only a thumbnail sketch is provided here, a desire circulates. The narrator gropes about for knowledge of the mother tongue, for an ancient, prelapsarian, original script and erudition: "Oui, combien sommes-nous, bien qu'héritiers du bey Ahmed, des Touaregs du siècle dernier et des édiles bilingues de Dougga, à nous sentir exilés de leur première écriture" (p. 150). (Yes, how many of us are there who, although the heirs of the bey Ahmed, the Tuaregs, and the last century and the *aediles*, bilingual Roman magistrates in charge of the monument of Dougga, feel exiled from their first writing? [p. 152].) The narrator/protagonist stages the fantasy of the Berber origin reiterated through the narratives constructed by her Turkish, Tuareg, and European predecessors. Movement toward the origin—the Berber alphabet and history—at the same time pushes her away from the object of her desire, finding herself each time assimilated into the curious inquiries of her scholarly European predecessors. The desire to recover the unrecoverable produces melancholia that in turn generates the compulsion to return to the place of birth. Apropos the displaced mother tongue, the child returns to find herself in another language. The sacred origin is, as Derrida writes

> si intérieur qu'elle ne fût même plus en position de protester sans
> devoir protester du même coup contre sa propre émanation, qu'elle
> ne pût s'y opposer autrement que par de hideux et inavouables

symptômes, quelque chose de si intérieur qu'elle ne vienne à jouir comme d'elle-même au moment de se perdre en se retrouvant.[11]

(So intimate that it would no longer even be in the position to protest without having to protest, by the same token, against its own emanation, so intimate that it cannot oppose it otherwise than through hideous and shameful symptoms, something so intimate that it comes to take pleasure in it as in itself, at the time it loses itself by finding itself.)[12]

The historical narrative becomes "subject" to its object of inquiry: the relation of exile from the mother tongue. What remains is a residual sentiment of separation from that desired origin effectuated by the very idiolect by which she attempts to recover it. This movement toward the Berber language becomes movement away, precluding a point of origin, since the point of departure is always switching places with the point of arrival:

> "Fugitive et ne le sachant pas," me suis-je nommée dans ton sillage
> Fugitive et le sachant, désormais
> La trace de toute migration est envol
> rapt sans ravisseur
> ligne d'horizon inépuisable
> S'efface en moi chaque point de départ
> Disparaît l'origine
> même recommence. (p. 347)
>
> "Fugitive and not knowing it," I called myself.
> Fugitive and knowing it, henceforth,
> The trail all migration takes is flight,
> Abduction with no abductor,
> No end to the horizon-line,
> Erasing in me each point of departure,
> Origin vanishes,
> Even the new start. (p. 359)

Failed Infidelity

Close examination shows that reconstituting the shards of history does not heal the wounds of separation. Left, however, is the invitation to retrace the rift between the bits of the staged self and the writing self in mourning. The story of the mausoleum illustrates a sentiment in the present. Part 1, which tells the story of the love affair, is titled "L'effacement dans le Coeur" (What is erased in the heart) and mirrors the title of part 2, "L'effacement sur la Pierre" (Erased in stone), in which the narrator recounts the history of

investigations into the mausoleum. The heart and stone become mirror images of each other, both symptoms of the replacement of the (irreplaceable) mother tongue. The melancholy that runs through part 1 enacts the sorrow and loss of the language on the ruined mausoleum. The narrator finds bits of research and a pile of crumbled stone. The imaginary search for continuity with the mother language testifies to the affect of rupture, separation, and ruin of the present. This is the flame for which the narrator gathers bits of (her) history.

Affect exists in this story/history as melancholy, as the inability to recover the Other, the beloved, and the "Other" original self. In the initial pages of the novel, at the end of the love affair, the narrator begins to tell her story. In an epiphanic moment she wakes from a deep sleep. The protagonist compares herself to the ruins of Dougga: "Dans ce déblayage de ruines, le visage de l'autre, pendant treize mois, me parut irremplaçable. Il se ranime devant moi à l'instant où j'écris, probablement parce que j'écris" (p. 26). (For thirteen months, in this excavation of ruins, the face of the other had seemed irreplaceable to me. He springs back to life before me the moment that I write—probably because I am writing [p. 26].) The heart in ruins gathers memories of the lost loved one just as the historian gathers bits of the Berber mausoleum in part 2. Writing is the expression of the incarceration within the monolingual culture that separates her from the mother tongue. "Vast is the prison crushing me" (p. 234), she writes, unable to continue writing the ancestral Berber dictum, "Meqqwer lhebs iy inyan" (p. 242). The protagonist tells her husband of her failed infidelity. The ensuing scene reproduces the landscape of the ancient Dougga ruin, the narrator becoming Thomas Reade, British consul in Tunis as she fantasizes dismantling feverishly and splaying about the broken bits: "Une rage me secoue: tout briser, tout casser, ici dans cette demeure—les lampes, les livres, les verres, tout mélanger en débris, en ruines, en pierres, en miettes" (p. 84). (I am shaken with rage: Break everything! Shatter it all! Here in this apartment—the lamps, the books, the glasses, trash everything together in a pile of ruins, stones, shards! [p. 84].) Relationships of repetition and simulation are established between the heart, the beloved, and the mausoleum.

In part 2, the mausoleum is referred to as "*le stele.*" "*Stèle,*" from the Greek, signifies a place where one inscribes commemoration. This word, used countless times in the archeological documentation, appears for the first time on page 49 where the narrator wonders how to erect a sepulcher (*stèle*) around the site of memory where she met her beloved. "*Stèle*" is used to describe the reconstruction of the lover's memories as she mourns the death of this affair. The memory, like the stone, is always prey to dilapidation and crumbling: "Peut-être que ma mémoire, pour lutter contre l'insi-

dieuse, la fatale corrosion, tente de faire surgir en stèle quelque chose comme 'la première fois.' Quand, pour la première fois, ai-je vu cet homme, ou plu-tôt quelle première image a déclenché mon premier émoi?" (p. 49). (Perhaps my memory, to battle against its own insidious, fatal dissolution, is attempt-ing to raise some stele like a mark "for the first time." When was the first time I saw this man, or rather, what is the first image that triggered my first emotion? [p. 48].) The obsessive act to assimilate with the sacred, original law is repeated with the image of the beloved and the reflection of the sep-ulcher. Both become at once purely idealized, coveted, and recovered only as an ethereal shadow, impossible to possess but at the same time captured as fragile, dusty rock—as easily broken and as tender matter.

In this sense, and contrary to many critical opinions, these stories from the past are not resuscitated as a supplement to the hegemony of the French literature and history on Algeria. The novel is a commentary on the prob-lems of resuscitating, of recovering, of rewriting Algerian history. The narra-tor rather manifests the fears of her own forgetting. She refers to her life as a fracture. She reiterates the fracture in order to remember that the origin, the place of birth, the maternal language has indeed been substituted:

> Non, ne m'enserre que la peur paralysante ou l'effroi véritable de voir cette fracture de ma vie disparaître irrémédiablement: si par hasard je deviens soudain amnésique, si demain je suis renversée par une voiture, si j'agonise sans préparation un prochain matin! Vite tout transcrire, me rappeler le dérisoire et l'essentiel, dans l'ordre et le désordre, mais laisser trace pour dix ans encore . . . dix ans après mon propre oubli. (p. 50)

> (No, I am only gripped by the paralyzing fear, the actual terror that I shall see this opening in my life permanently disappear. Suppose it were my luck suddenly to have amnesia; suppose tomorrow I were hit by a car; suppose some morning soon I were to die! Hurry! Write everything down, remember the ridiculous and the essential; write it, orderly or muddled, but leave some record of it for ten years from now . . . ten years after my own forgetting.) (p. 49)

The text is created as one creates a sepulcher, in fear of the disappearance of memory, in order not to forget the ones who have taken the story/history to their graves: "Les morts qu'on croit absents se muent en témoins qui, à travèrs nous, désirent écrire!" (p. 346). (We think the dead are absent but, transformed into witnesses, they want to write through us [p. 357].) This predicament (where moving toward the origin shifts her away from it) man-ifests itself on many registers: "Non en quelle langue, ni en quel alphabet—celui, double, de Dougga ou celui des pierres de Césarée, celui des mes

amulettes d'enfant ou celui de mes poètes français et allemands familiers?"
(p. 346). (Not in some language or some alphabet? Not in the double one
from Dougga, or one of the stones of Caesarea, the one of my childhood
amulets, or the one of my familiar French and German poets [p. 357].)
Communication with the dead, instead of healing the rift of historical sepa-
ration, communicates a wound, an incision still wet with blood: "Comment
inscrire traces avec un sang qui coule, ou qui vient juste de couleur. . . . Mais
avec le sang même: avec son flux, sa pâte, son jet, sa croûte pas tout à fait
séchée? Oui, comment te nommer Algérie" (pp. 346–47). (How can one
inscribe with blood that flows or has just finished flowing? . . . But with
blood itself: with its flow, its paste, its spurt, its scab that is not yet dry? Yes,
how can one speak of you, Algeria? [pp. 357–58].)

The Monocle

The question that haunts the novel is how to name Algeria and how to
write about the Algerian self who speaks and writes in French: "Oui com-
ment te nommer, Algérie. . . . Je ne te nomme pas mère, Algérie amère" (p.
347). (Yes, how can one speak of you, Algeria? . . . I do not call you mother,
bitter Algeria [p. 358].) The autobiography as the invention and naming of
the self is captive within the situation of exile, the French language, within
the French archival material, within the space of the metropolis. Bits of his-
tory cut the self as they are gathered within the French idiom, as Derrida
shows:

> Il serait alors *formé*, ce je, dans le site d'une *situation* introuvable,
> renvoyant toujours ailleurs, à une autre chose, à une autre langue, à
> l'autre en générale. . . . En tout cas il n'y avait pas de je pensable ou
> pensant avant cette situation étrangement familière et proprement
> impropre (*uncanny*, *unheimlich*) d'une langue innombrable.[13]
>
> (This *I* would have formed itself, then, at the site of a *situation* that
> cannot be found, a site always referring elsewhere, to something
> other, to another language, to the other in general. . . . At any rate,
> there was no thinkable or thinking *I* before this strangely familiar
> and properly improper [*uncanny*, *unheimlich*] situation of an un-
> countable language.)[14]

The constitution of the self during the autobiographical act is continu-
ous with separation from the mother tongue and what has become (in the
writing) "native" images of the self. Djebar makes her case that recognition
is the constitutional act of the fictional autobiographical text in which the
French language displaces the mother tongue. The writing in French is not

a choice, but the situation of captivity within the magnetic force of the emblem of military power, the hexagon, France: "J'écris pour me frayer mon chemin secret, et dans la langue des corsaires français qui, dans le récit du Captif, dépouillèrent Zoraidé de sa robe endiamantée, oui, c'est dans la langue dit 'étrangère' que je deviens de plus en plus transfuge" (p. 172, emphasis in original). (I write to clear my secret path. I write in the language of the French pirates who, in the Captive's tale, stripped Zoraide of her diamond-studded gown, yes, I am becoming more and more like a renegade in the so-called foreign language [p. 177].) She *is* (only) in the "foreign" language. This reference to the first Algerian literary character transforms her into a traitor, "elle devient transfuge," who moves over to the side of the enemy. The notion of a reunion of the self with the past through a historical "hole-filling" appears via a reading from the hexagon: "*Telle Zoraidé, la dépouillée. Ayant perdu comme elle ma richesse du départ, dans mon cas, celle de l'héritage maternel, et ayant gagné quoi, sinon la simple mobilité du corps dénudé, sinon la liberté*" (p. 172, emphasis in original). (*Like Zoraide, stripped. Like her I have lost the wealth I began with—in my case, my maternal heritage—and I have gained only the simple mobility of the bare body, only freedom* [p. 177].) The maternal language, the culture of origin, no longer exists unless in fragments through French monolanguage/monocle (an apposition that will be elaborated below).

Scott Durham's discussion of the culture of the simulacrum is useful in this instance. Durham comments on Jean Genet's *Un captif amoureux* (Prisoner of love), a title curiously fitting to Djebar's protagonist: "In this culture, as we have seen, the liquidation of a sense of palpable historical ground provokes a 'passion for the real,' a nostalgia for the lost original points of reference which can then, of course, only be simulated or reconstructed."[15] If any identification is possible, we read it through the reiteration of loss felt in the state of captivity within the French language.

This situation of the writing-self is here distinguished from the situation of the "double inheritance" described by writers like Abdelwahab Meddeb and Abdelkebir Khatibi. The hegemonic force of the colonial language upon the mother tongue obviously differed in Algeria, Morocco, and Tunisia. Derrida traces the difference in his *Le monolinguisme de l'autre* (Monolinguism of the other) where Khatibi's bilingual heritage, or *Amour bilingue* (Love in two languages), is contrasted to the double interdiction of the Algerian context. The systematic linguistic takeover by the French produced a monolingualism (as ideology of the French language) in the Algerian writer expressing the impossibility of writing other than in French. The paradox (of Djebar's fictional autobiography) is articulated in: "*Oui, je n'ai qu'une langue, or ce n'est pas la mienne*" (emphasis in original).[16] (*Yes, I have only one language but it is not mine*).[17] The paradox that proliferates in Djebar's narrative

gathering of historical "identity bits" is that these bits of the self will never amount to or approach her maternal language or culture. Rather, she moves further and further away and realizes her writing as this incarceration. History is gathered as a testimony of dispossession, to an irreversible erasure, to a returning within the Other language as the only language. The constitutional makeup of writing the self in French is the exclusion of the self as other than Francophone: the folly of the law is well-expressed by Derrida: "On ne parle jamais qu'une seule langue . . . (oui mais)—'On ne parle jamais une seule langue.'"[18] ("We never speak but in one language . . . [yes but]— 'One never speaks only one language.'")[19]

The third part of *Vaste est la prison* consists of a film script and the description of the making of the film set in Algeria. During this process, the narrator's I/eye cannot help but take the perspective of the French metropolis. Again, Derrida's *Le Monoliguisme de l'autre* is strikingly pertinent: "La *métropole* la Ville-Capitale-Mère-Patrie, la cité de la langue maternelle."[20] (The *metropolis*, the City-Capital-Mother-Fatherland, the city of the mother tongue.)[21] The identification in the French-Algerian fictional autobiography is defined by the impossibility of not looking at what one never was, but at the same time the necessity of a perspectival difference from the colonial eye. In other words, the object of ocular consideration is the ungraspable staged self, the maternal and original self: "La femme arabe apparaît endormie, image quasi traditionnelle au foulard rouge, image insaisissable" (p. 173). ("The Arab woman seems asleep, an almost traditional image of her wearing a red scarf, an elusive image" [p. 178].) The fantasmatic identification with the Algerian-Woman-as-Other repeatedly marks (remarks, and thus writes) the incarceration within French ideology as the only, but Other, language: "Une émotion m'a saisi. Comme si, avec moi, toutes les femmes de tous les harems avaient chuchoté: 'moteur'" (p. 173). ("I was gripped by an emotion. As if all the women of all the harems had whispered 'action' with me" [pp. 178–79].) The narrator's Otherness with respect to the covered woman is formalized by the medium of literary representation. Here, this is manifest in the "film-script" narration. The narrator makes a film. Her monocular eye (I), the lenticular I, marks the paradox of identification through difference from the Algerian woman: "Corps femelle voilé entièrement d'un drap blanc, la face masquée entièrement, seul un trou laissé libre pour l'oeil . . . c'est elle soudain qui regarde, mais derrière la caméra, elle qui, par un trou libre dans une face masquée, dévore le monde" (p. 174). ("A female body completely veiled in a white cloth, her face completely concealed, only a hole left free for her eyes. . . . Suddenly she is the one looking, but from behind the camera, she is the one devouring the world through a hole left in the concealment of a face" [pp. 179–80].)

The tradition is seen through the eye/I of the One—the monocle and the

vision from the other side of the Mediterranean. She sees *what she never was* by way of looking at the Frenchman looking at the Arab woman on the film set: "Julien, l'ami qui se veut, pour moi, photographe, prendra des photos de plateau à la prochaine pause. Dans le remue-ménage de ce démarrage, il fait nuit, il fait froid, je pourrais me sentir seul. Mais non. L'homme regarde sa femme, image lointaine, dormir et je le regarde la regarder" (p. 174). ("Julien, the friend who is supposed to be my photographer, will shoot some pictures of the set during the next break. It is dark, it is cold amid all the commotion of getting started, and I could feel alone. But no. The man is looking at his wife, a distant image, as she sleeps, and I look at him look at her" [p. 179].) Again, the French literary discourse mediates an identification with the simulacrum of the absent self: the Algerian woman, with Algerian stories. There is always the Frenchman, a figure resembling a monocle, through which the narrator establishes her "I" (monocular perspective), establishes her attraction to/separation from the Arabo-Berber woman. In reference to the covered (monocular) woman on the film set, the narrator speculates: "Ce trou, son seul dard vers l'espace" (p. 175). ("This hole is the only lance she has to throw out toward space" [p. 180].) The "incarceration" of the Algerian woman whose vision is reduced and who flees the omniscient eye of the man and of the French tourist's camera is reversed in the narrator's perspective. The narrator, the Francophone writer, because of her difference from the desired Other/Object, desires or identifies with the camera-eye. Yet she marks her difference with regard to the French voyeur: "Ce regard artificial . . . cette fente étrange que les touristes photographient parce qu'ils trouvent pittoresque ce petit triangle noir à la place d'un oeil, ce regard miniature devient ma caméra à moi, dorénavent" (p. 175). ("This artificial gaze . . . this strange slit that the tourists photograph because they think it is picturesque to have a black triangle in the place where an eye should be, this miniature gaze will henceforth be my camera" [p. 180].)

The narrator traverses the Mediterranean to film her home village, to simulate a return to the maternal space, the origin, and a recovery of the maternal language. The mother figure and birthplace become objects of an obsessive and mediated return. The back-and-forth motion mobilized between the narrating self and the child born into a maternal language bears three fricative traits: it is fictional, French, and fantasmatic. The irreplaceable—because sacred and biological—origin, the Berber language of the mother, is inaccessible. Wandering through the northern Algerian landscape in preparation for the filming, the narrator clearly articulates the relation to the mother tongue as a foreign tongue: "J'ai rendez-vous avec l'espace. Celui de mon enfance, et de quoi d'autre . . . peut-être de cette fiction à créer. Quatre heures de l'après-midi: je ne pense même pas à Camus et à son

étranger" (pp. 219–20). ("My rendezvous is with this space. It is the space of my childhood and of something else . . . perhaps the space of this fiction to be created. Four o'clock in the afternoon: not even Camus and his *étranger* come to mind" [p. 225].) The way in which the "union" with the birthplace is rendered makes it clear that a separation, a replacement of the mother tongue, is complete and can only be accessed by way of fiction: "Cet espace, au vrai, me ressemble. Ainsi, me dis-je, commencer une fiction de film, lorsque l'espace qui lui convient est trouvé vraiment" (p. 220). ("This space, in actual fact, is like me. So, I think, begin a film story, when the space that is right for it is really *found* [p. 225, italics added].) The use of "trouver" (to find) instead of "retrouver" (to find again) is noteworthy. She does not rediscover this "original space," but rather seems to come upon it as if for the first time.

This novel produces a testimony to the problems of recuperating or re-covering Algerian history. The problem of North African historiography (and of subjectivity and writing) is that it necessitates a passage through the language, vision, and texts of the French invader. Even if the narrative's direction consistently thrusts toward the culture of origin before and during the colonial period, the movement is one of simultaneous removal. What is critical about this text is the warning it articulates. It can be read as a caveat, both to the writing self and to the reader. Access to subaltern histories is re-constituted as part of a process of mediation through the dominant dis-courses of the present. The danger, the novel seems to instruct, is to not take into account the almost inevitable confusion of perspectives within the com-posite (monocle) of the dominant culture. Instead of being an inhibition to historiographic writing on the colonial and precolonial periods, this personal account displays the complexity and necessity of the endeavor. The use of the forked idiom does not simplify the situation of negotiating history and identity. Rather, it reproduces it in all its complexity and continued resist-ance to a hegemonic articulation of the self.

PART TWO

THE VISUAL ARTS AND POLITICAL RESISTANCE

Chapter 4

▼▼▼▼▼▼▼▼▼

Film and the Mystic Image

Like literary narratives, the filmic production of North Africa can also use foreign languages and theoretical discourses as modes for critique of their country's cultural and identity politics. Both narratives and films can establish links between the moment of writing and their cultural history, mobilizing a critical usage of foreign languages. The Tunisian film-maker Moncef Dhouib (b.1952) uses film to reach back into legendary Tunisian culture through stories that take up Tunisian legends, mythic places, and mystical practices. At the same time, the films comment on a Western iconography that has been adopted by the state in order to homogenize national culture. In Dhouib's film shorts *Hammam D'hab* (The golden bath, 1985), *Al-Hadra* (The trance, 1990), and *Tourba* (The cemetery, 1995), the images struggle with a secularist image of Tunisia that has been deeply penetrated by a political process. Because they are not easily accessible for viewing, the films' summaries are located at the end of this volume in the appendix.

The Commodity-Image

A state-monitored, identity-forming image is being used in Tunisia to assure a sociopolitical transformation that was inaugurated with the coming to power of Habib Bourguiba in 1936 and continues in a state of crisis up till the present day. Through the use of this image, Tunisia has become a society of virtual freedom, a *trompe l'oeil* identification with the West. As John O. Voll explains in his article, "Saints, Sultans and Presidents," contemporary Tunisian society is in the midst of what he calls a "crisis of authoritarianism." The political failure, Voll explains, in modernist, secularist regimes like those of Bourguiba, and by extension Ben Ali, is signaled by a failure to bring about the democracy that their secularist agendas were ostensibly designed to produce.[1] Equally critical is the way in which this Western-oriented authority has brought about social and cultural disarray by effectively pitting one of the central cultural and identity factors of the population, Islam,

against its so-called democratic regime. What I have been interested in, keeping in mind this well-known sociopolitical configuration and historical juncture, is the way that images in and of Tunisia have been used to support the process of authoritarian political control and repression of orthodox, and especially political, Islam.

The economic and political power of the Tunisian government is buttressed by a certain image of Tunisian society. Images of a modern, rational, Western, open, democratic Tunisia are produced and disseminated by the official Tunisian state apparatus. What this image is concealing is a prohibition of any contact between politics and Islam. Islam cannot enter into the realm of political representation, and through a process of false association, suffers from a virtual ban on its visual representation. This image of openness assures political support from the West, and political acceptability in turn brings in hard currency, tourism, and foreign investment.[2] Indeed, the image of a secular Tunisia welcoming to tourists is generated by a carefully orchestrated politics and economy of the image. The Tunisian image, according to this standpoint, must be cleansed of any sign of Muslim identity if it is to remain acceptable for consumption.

The state image in Tunisia has come to be stripped of any aspect of the history and culture with which the Tunisian spectator at one time associated him/herself. Arabo-Islamic identity has been moved off-screen. This erasure is apparent not just in filmic and artistic production but also in the street and in people's practice of public life. For example, the quasi-interdiction of the *hijab* (or head scarf), through a visible or a more Althusserian police presence, produces the ideological *image* of Western-style freedom. This indicator of freedom is reproduced in the multiplication of female bodies, uncovered, free, and seemingly omnipresent. Although this appears to be visual and corporeal freedom, it is reinforced by the state for particular interests. In Tunisian society, forcing the image of the female body onto the public eye hides a control over the national, collective body. Many would argue that legal statutes affirm this feminine liberation. However, images of women, liberated or not according to Tunisian law, are being used to dissimulate a repressive political power. The self has been transformed into an image of the West in opposition to a strange and dead "oriental" past.

Objections to this political relation to culture cannot be voiced directly in such a context. However, they can be voiced and perceived through art, poetry, and images produced by Tunisian film-makers. Dhouib's film-shorts provide examples of how cultural production resists the "commodity-image" produced in Tunisia. These films, relying on the techniques of the filmic medium itself, disrupt the orientalist discourse that produces a deep opposition between the Tunisian "spiritual" past and the "modern" present. The

images in these films incorporate Islamic practice into the image, while deliberately sidestepping the dogmatism of the religion's orthodoxy. For example, in *Al-Hadra* (The trance), images of Soufi practice show the self in a state of worship, mystical trance, and loss of conventional social identity. The two main characters are from the elite ruling class and are shown as followers of a popular religious brotherhood. The story presents an image of the "national subject" that runs contrary to the state's official representation.

Images of Loss

Al-Hadra tells the story of a couple who, since their wedding night, remain unable to consummate their marriage. In the opening scene of the film, the bride is surrounded by other women from the family, being prepared for her wedding. The women are deliberating where they should apply the *harqoos*, a blackish dye made of clove paste traditionally painted onto the bride's skin. They finally agree to apply the perfumed paste in the shape of a flower behind her ear, on the nape of her neck. That night, the blindfolded husband searches to smell the *harqoos* in order to then consummate his marriage. His inability to smell it seems to be the cause of their problems, for he is unable to "see" his wife without the vision of his eyes. Years later, following his mother's advice, they go to the tomb of a saint—Saida Manoubia of the Chadlya Brotherhood—to find a cure for their misfortune. The husband, sporting a double-breasted suit and bow tie, is incredulous and regards the mystical practices as silly and primitive. After a series of activities in worship of the saint, the husband, still unwilling to believe, opens the saint's casket as if searching to disprove the existence of the saint through her lack of visibility. Indeed, the casket is empty. He brings the shiekh, telling him that there is no saint, that their worship is pure folly. Proof of her nonexistence is that he saw her absence with his own eyes. When he brings the shiekh, the husband is surprised to see the image of his wife in the casket. Shocked at the sight of his wife frozen in the saint's tomb, he looks at the shiekh, searching for an explanation. The shiekh tells him that now he will know how to love, the eyes of his heart having finally been opened. The man's incredulity is belied by the image of his wife's death.

What is enigmatic about this film is this ending. How did she die? Is she actually dead? Did the women of the brotherhood offer the wife as a sacrifice to the saint? Maybe she metaphorically dies in her worship of the saint. Perhaps he imagined the whole episode. It remains unknowable. The image, nonetheless, is of a normal person who appears to have been transformed into a saint. Her glowing face is superimposed upon the image of the saint and she is pictured lying in the saint's tomb adorned with her jewels (see fig-

FIGURE **4.1** *Al-Hadra*: lying in the saint's tomb.

ure 4.1). Ultimately, however, according to the information provided by the filmic narrative, a conclusive interpretation of the ending is impossible to establish. In direct contradiction to the official image, the woman's identity is difficult to insert into any narrative, whether nationalist, religious, or commercial. The image of her face is an event located outside of time and represents pure poetry—what Julia Kristeva describes as the explosion of the semiotic into the symbolic order. Kristeva described this sort of violent eruption of the *pulsion sémiotique* into the symbolic in *La révolution du langage poétique*. In this image, violence is represented through the ancient practice of saint worship. Poetic language, as Kristeva explains, contests the synthetic system of the historic narrative. In the same way, the poetic image of this woman's face at the end of the film forms a visual event that cuts into the seamless narrative of national unity. After this image, the characters will never be as they were. The filmic narrative is permanently disrupted and comes to a close. The credits roll on the backdrop of the man riding home on his carriage, seemingly unaccompanied by his wife.

The images of this film oppose the official image not simply because of its religious content, but rather because it does not function in the same way as does the official image. It does not represent its own capacity to accumulate political and economic power. According to the official economy of the image in Tunisia, pictures make money and at the same time *produce* new

identities. In this film, the image itself becomes one among many purification rites in the process of mystical worship. Dhouib's images point to something beyond themselves but, unlike the image that acts as a commodity, this extra-referentiality does not replace the spiritual (human creativity) with the material (profit). On the contrary, they remind the viewer of human spirituality. These images show the human body in a state of disintegration, emptiness, fusion, or even loss of consciousness, signifying a state of worship. The worship in this case can be through the intermediary of an object or worship of a saint. Love expressed for an object is not idolatry (as it would be considered within the orthodox framework), but rather another way of showing love for God. Dhouib's film-shorts represent the human being in a perpetual state of religious worship through bodily transformation into the sacred and loss.

This notion of loss is represented on many levels within these film-shorts. On the level of the narrative, meaning is elusive, enigmatic. In conventional narrative, meaning accumulates as the story progresses, but in these filmic narratives the viewer progresses toward a loss of meaning. In the enigma, meaning is elusive and seems to evaporate. Even if the reader/spectator assigns meaning to the film, one is left with a suggestion about the limits of man's ability to comprehend; the enigmatic ending contributes to a message about man's limited capacity to understand. For example, the incredulous husband who tells the shiekh that saint-worship is an illusion represents the doubtful believer. His arrogant incredulity is confronted by the undeniable image of the saint's miracle (*karamat*), and, by extension, God's work. Although he doubts, he is presented as a man in transformation from the profane to the sacred. The shot of the husband taking oil from the candle burning above the saint's sanctuary is itself a microcosmic image of the entire story line: progression of the body from the profane into the sacred (see figure 4.2). The combination of narrative enigma, the images of human bodies in worship, and saintly *baraka* (magical or benevolent powers) throughout the film all point to a deeply religious message. The film seems to say, even if you doubt: remember that you are ignorant of God's workings.

Another of the film-shorts, *Hammam D'hab* (The golden bath), is also clearly about characters and images that undergo a process of spiritual and physical loss. The human body is represented as a desiring, visually bound object that is transformed by the end into a purified, decomposing, and sacred object. In the beginning of the film, the contours of the human body are clearly defined and carefully put into focus. Human desire is circulating in a profane and lusty, if sublimated, relation between the girl who walks through the street on her way to the *hammam* (Turkish bath) and her

FIGURE 4.2 *Al-Hadra*: the husband taking oil from the candle burning above the saint's sanctuary.

beloved who works in his barber shop opposite the bath's entrance. They exchange illicit glances as she steps through the bath's door (see figure 4.3). Once inside, in a gesture of sublimation, she passes her chewing gum to him in a silver box via a servant. It seems that the illicit and base desires of the outside world go through a ritual process that is materialized in the image of the hot and running water of the *hammam*. She steps from the street (exterior, dirty, profane, illicit, and time-bound universe) into the cleansing world of the *hammam*. Like water turning to steam, her desire for the barber transforms into an indeterminate and mystical love.

 This particular *hammam* is closely associated with a legend that is transformed into a mystical experience through the techniques of the filmic image. The legend tells of a widowed mother and her beautiful daughter whose long black hair blends into the night. A mysterious and good-hearted man falls in love with the girl and desires to marry her. Testing the woman's and her daughter's virtue, he says that for a lock of the girl's hair, she and her mother can have the gold that is buried in the ground. He warns them that the gold belongs to a devil and they must only take it for the amount of time that it takes a candle to burn. They give in to their greed and keep grabbing at the gold, paying no mind to the candle that has burnt out. They completely forget about the honest man who wished to marry the girl and think

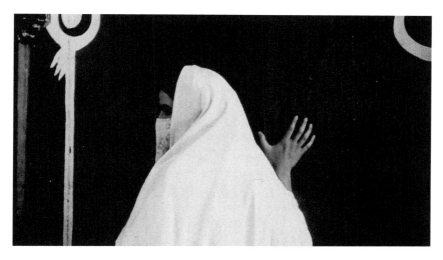

FIGURE 4.3 *Hammam D'hab*: exchanging illicit glances as she steps through the bath's door.

only of the gold he has offered them. As a punishment for their greed, the girl is swallowed up by the pit that has opened up in the earth. This myth is clearly moralistic in structure and warns that if you are greedy, you will miss good opportunities and might be led to a painful and horrifying death.

The legend is recounted to the beloved in the *hammam*. Through association with the images of the film, the legend is reinterpreted as a mystical tale. The girl who listens to this story (the "beloved") is also swallowed by a deep, black pit at the end of the film. However, the reasons are quite different: she seems to have reached a state of spiritual purity. Her purity does not lead her into a marriage but into a state of physical disintegration and invisibility—a sort of spiritual and physical state of bliss. The beloved goes through a transformation that can be likened to the mystical trance in which the body loses its control, contour, and form. This happens in a narrative progression that is like the mystical trance, or *hadra*. The beloved falls asleep in a small chamber of the *hammam*. All the other women leave, as does the man who tends the furnace, and the *hammam* closes for the day. The woman, presumably in a dream, wanders through the rooms of the *hammam* and enters one filled with candles. She hears a distant cry and sees an arm waving from below the floor. At the end, she slips slowly into a deep pool of thick opaque liquid. Her body, in this enigmatic scene, gradually disappears from view and becomes one with this seemingly endless pool, literally disappearing within the frame of the image. The mystical experience is represented in an image of physical disappearance. Images and legends of the past are thus

connected to the present through practices of spiritual worship. At the same time, the present, the here-and-now, is connected to the transcendental.

In *Hammam D'hab* as well as the other films, religious words and practices abound and are superimposed on a tentative and always shadowy human figure. As we observed in *Hammam D'hab* and *Al-Hadra*, the human being is represented in a state of transformation from profane into the sacred through ritual practice. The human being is always shown passing from spaces of the profane, and void of love, to spaces of spiritual purity and contemplation and love of God. These filmic images represent the imagined historical memory of the self as mystical and religious. Through sound and image quality, the image seems to remind us of God. Many sequences are superimposed with a sound track with verses from the Quran. The most frequent topoi in his film trilogy are those associated with spiritual and ritual purification such as the *hammam*, the mosque, *henna*, *harqoos*, and mystical-trance ceremonies. The deeply religious disposition of these films is initially sensed when one hears as the opening line of each of the three films: "*b'is-milallah*" (In the name of God), the first words of the Quran—words spoken before reciting the Holy Quran and words uttered by practicing Muslims before beginning an activity.

It must be said, however, that these images of religious practice, saint worship, and trance, although very deeply rooted in Islamic societies, are marginal with respect to orthodox Islam. A film that would seemingly be impossible to show in Tunisia was briefly allowed because, although very popular, it remains on the margins of what has been banned from representation. Indeed, many of the activities represented remain rejected and marginalized by orthodox Muslim groups and individuals. One scholar has written that

> [t]he other current of Islam is a more popular form, widespread amongst the population and deriving from a mystical tradition mingled with less orthodox beliefs. Belief in the powers of local saints, activities and festivals connected with their tombs, superstitious faith in curing barrenness or effecting marriage are deeply held, particularly in rural areas, and are frowned upon by the *ulema* (scholars) as unorthodox or even non-Islamic.[3]

It is the orthodox, and more specifically the political ambitions of religious orthodoxy that are forbidden within the Tunisian context. The films perform and represent a profoundly Muslim world through mysticism. This image of mystical Islam is not only useful in the Tunisian context, but also for the *Umma* as a wider community in crisis. The inclusion of unorthodox Islamic practices serves to counterbalance the emergence of fundamentalisms

gaining ground since the proliferation of the teachings of the Saudi scholar Muhammed ibn 'Abdelwahab.

The film-shorts all deal with mysticism or saint worship—what has been called "popular Islam." This must be made more precise, for saints can be divided into the categories of "legitimate," or hagiographic, and legendary or "popular" saints. This distinction between the so-called legitimate and illegitimate has been made by one specialist in the following way: "On peut distinguer d'abord—sans préjudice de classifications plus nuancés—deux sortes de Saints dans l'Islam: les saints 'populaires,' d'allure plutôt folklorique; les saints 'serieux,' subjects des hagiographies."[4] (First, we can distinguish between two types of Saints in Islam—without the prejudice of more nuanced classifications—the "popular" saints that look rather folkloric; "serious" saints, subject of hagiographies.) The saints and the mystical practices that are represented in Dhouib's films are part of the legendary, folkloric tradition. Even though the films are set in the late nineteenth century, the traditions are still practiced widely in Tunisia. I have differentiated between the "legitimate" and the unorthodox practices of worship, because the theory of the image applies differently to each. The unorthodox is open to play, art, and representation. Orthodox Islam banishes the representational image, whereas the images of *Al-Hadra*, *Hammam D'hab*, and *Tourba* produce an economy of the image that produce an effect of visual *loss*.

Sacred Topoi

It is not just the type of image that is oppositional. These films are resisting Tunisian state authority through their very content. The stories revolve around sites—places that have mystical and religious practices associated with them and are respected by those that visit them frequently. The places—the *hammam* in *Hammam D'hab*, the *zaouia* (religious hostel or house of worship) in *Al-Hadra*, and the cemetery in *Tourba*—all honor locations containing their own legendary characteristics. Legends provide an alternative to the nation's official historiography. In particular, the Soufi practices represented in *Al-Hadra* act in resistance to the Tunisian state by virtue of their total indifference to centralized authority. One commentator on Soufism in the Maghreb has written: "Ces saints populaires sont encore essentiellment des patrons locaux. Ils ont un territoire délimité, parfois même materiellement par des *kerkours*, tas de pierres, et sur lequel s'exerce leur influence."[5] (These popular saints are still essentially local patrons. They have a territory that is delimited, sometimes even by *kerkours*, piles of rocks, and upon which they exercise their influence.) Asserting power that is simultaneously local (the saint) and transcendental (Allah) is threatening to the

centralized and secular political order. The worship of the site, the *qoubba*, and the attraction of the saint's *baraka* are tied to places, thus taking away the authority embodied by the person of the *makhzen*, king, or in this case the president. The fables are part of a power structure completely separate from the centralized political administration that remains in a struggle to gain control over local authorities.[6]

But how do viewers respond to the filmic representation of these sacred topoi? Since there is virtually no distribution of Tunisian films that are not supported by the state, there is very little published criticism of these particular films. According to the Tunisian film-critic Hedi Khelil, these films and "these types of films" (films about what I call "sacred topoi"), are considered as self-orientalizing by Tunisian viewers. Khelil explains this point of view when he writes: "Lorsqu'on dit que le cinema tunisien 's'est maladivement confiné dans la Medina et le hamam,' . . . on fait désinvoltement fi de la verité des ces films et de leurs contenus."[7] (When it is said that Tunisian cinema "has closed itself up in an unhealthy way in the medina and the hammam," . . . one inadvertently disregards the truth of these films and of their contents.) If the Tunisian viewer is resistant to the representation of himself, it is not because he is not familiar with the *hammam* or even with the practices of saint worship or mystical trances; the Tunisian is not accustomed to *seeing* or visualizing his identity in this way. The Tunisian spectator is in a doubly strange position while viewing these films: the spectator discovers an uncanny relation of nonrecognition to such images that he knows as part of the spoken and unofficial historical memory. The sounds (chanting, the Quran), places (the *hammam*), and practices are familiar from photos, oral stories, and behavioral and linguistic traces in the older generations. All Tunisians, whether educated in France or not, know of the Saint Saida Manoubia, for example. However, such images have been inserted into a national identity division through the coercive presence of the official state image. If the spectator identifies with the images of the characters, he finds himself in a difficult state of protest against the ideological, commodified images of himself that have now been internalized. The spectator's inadvertent rejection of such representations of Tunisian identity leads us back to the problem imposed by the predominance of state-sponsored images. I will now return to that question.

Mysticism and the Political Field

In principle, mysticism has nothing to do with politics. Since mystics and members of saintly brotherhoods are not concerned with matters of this world, they ostensibly do not pose a direct threat to political control. For this reason, perhaps, the Tunisian government has sponsored such public per-

formances as Fadel Al-Jaziri's *Hadra*, which transforms just such a mystical ceremony into what, in the United States, might be called "performance art." However, historically, these practices *do* pose an indirect and perhaps more deep-rooted challenge to political power. John Waterbury has shown saint worship to be in opposition to centralized state control, writing: "Alliances of tribes, murabitin, and shurafa (plural of sharif) would often form in varying combinations to deny the sultan his revenues, or, occasionally, to put forth a contender for his title of *amir al-muminin* (Prince of the Faithful)."[8] Although his analysis concerns the colonial period, it has clear resonance with the social conditions of the contemporary Maghreb. Since the Tunisian president is standing on a decidedly secular political platform, saint worship is potentially even more oppositional than in a religious-political context such as in Morocco. It reinscribes and legitimizes power as *local* and *sacred* in total opposition to the secular state. These Soufi images oppose state control, which, as I explained at the beginning of this chapter, is directly oriented toward gaining Western approval and support.

The Doubly Banished Image

Muslim practices do not disappear simply because the state prohibits their political and visual representation. As we know, the repressed never ceases to exist but rather resurfaces in violent or displaced ways or, if unable to resurface, produces neurosis. I believe all of these have taken place in Tunisia: images of the Muslim self have both gone into hiding and have transformed into violent and displaced phenomena. This "displacement" is complicated by another level of prohibition and repression. It is well-known that Islam has an uncomfortable relation to mimetic representation, especially with respect to the human form. For this reason, a story that relies on the image cannot be situated in the center of hegemonic interpretations of Islam. In the case of the films I am investigating here, the spiritual image of the self has resurfaced in the form of mystical Islam for two interconnected reasons: one is related to power, as I explained above; the other reason is related to mimetic representation.

Through a film about mysticism, a critique of orthodox Islam can be articulated. Generally speaking, one is constantly reminded of the Islamic ban on the image while watching films from the Arabo-Islamic region. The region has a relatively recent filmic past. Film-makers primarily rely on the visual history of the West for past visual reference. To prevent the idol worship that was the practice of pre-Islamic Arabia, mimetic representation of the human being was effectively prohibited in Islam.[9] Although our central problematic in this book is not the debate about the admissibility of figurative representa-

tion and representational art in Islam, a few remarks on the subject are critical when considering the use of film within the context of Islamic societies. The act of image-making is superimposed upon a long history of opposition to the image. I will comment briefly on the history of this ban.

According to the *hadith* (sayings of the Prophet), Ibn 'Abbas described the Prophet's disapproval of images. The Prophet's distaste for representational images stemmed from their association with idolatry, pre-Islamic worship, and the Christian belief in the Holy Trinity. It is explained in the Quran that those who associate God with anything else will be punished. However, images seem to be allowed when they do not serve as objects of worship or represent things not allowed in Islam. Ibn 'Abbas was a cousin of the Prophet and lived with him for thirteen years. After the death of the Prophet, Ibn 'Abbas continued to gather information on various subjects of concern to Islamic thought and life. Before forming an opinion, however, he would ask no less than thirty companions of the Prophet. In the *hadith*, Ibn 'Abbas pronounced this judgment on the Prophet's opinion of images: "Abu Talha, a companion of Allah's Apostle and one of those who fought at Badr together with Allah's Apostle told me that Allah's Apostle said: 'Angels do not enter a house in which there is a dog or a picture.' He meant the images of creatures that have souls." [10]

Thus the representation of human beings was considered impure and the Prophet disapproved of the admiration of such images. However, the prohibition of images is not categorically stated nor is it prohibited in all cases and purposes. For instance, 'Aisha, wife of the Prophet, recounts that the Prophet allowed her and her friends to play with dolls that are clearly representations of the human form:

> I used to play with the dolls in the presence of the Prophet, and my girl friends also used to play with me. When Allah's Apostle used to enter (my dwelling place) they used to hide themselves, but the Prophet would call them to join and play with me. (The playing with the dolls and similar images is forbidden, but it was allowed for 'Aisha at that time, as she was a little girl, not yet reached the age of puberty.) [11]

What is important is that there has never been any absolute prohibition. Ibn 'Abbas, whose opinion was widely respected with relation to matters of the Prophet, was not categorical but always provided the most lenient interpretation. 'Ali Ibn Abi Taleb, the Fourth Caliph and cousin of the Prophet, frequently asked Ibn 'Abbas's opinion. He asked a Muslim from Basra, where Ibn 'Abbas was governor, about Ibn 'Abbas's rule of the population. The man from Basra reported that Ibn 'Abbas was tolerant and that his implementa-

tion of Islam was judicious and always generous. Thus neither the Prophet (Peace be Upon Him) nor Ibn 'Abbas imposed an absolute prohibition of the image. Images and statues that serve as substitutes for God are inadmissible, but not all images are prohibited for all purposes.

It is difficult to know to what degree artists consciously think about this history. However, one can glean some ideas from the images and sounds produced in a given film. Moncef Dhouib's films are infused with this prohibitive but flexible relationship to the image. Through his use of the medium of film, he reintroduces tolerance vis-à-vis the image in Islam. He is not representing Islam as dogmatic, but rather as a culture and religion that tolerates foreign elements and media. Although these films represent the self as Muslim, the image is located outside of hegemonic interpretations of Islam. What is extraordinary about these films is that they perform and represent a profoundly Muslim worldview, while inflecting this worldview with its own hybridity and marginality. The image of mystical Islam is a reformative gesture, shifting the image of Islam from orthodox to tolerant, popular, and heterogeneous.

The Mystical Image

The film-shorts make no direct reference to politics or even social issues. It is perhaps far-fetched, then, for our discussion of them to open onto a political situation. The reason for this is that Dhouib's films are not preoccupied with other films; their main struggle is with the "character" of the image. The tension is between two incompatible types of images: between the secular, ideological image and the image of the self as religious and modern. Thus, instead of comparing Dhouib's images to other, more commercially successful Tunisian films, my analysis concentrates on a contrast between two types of images that seem to be in a relation of tension in contemporary Tunisia. The official *commodity-image* that dominates most visual representations in Tunisia works to marginalize the image of *loss* and mysticism in Dhouib's films. The first critical gesture, then, is this resistance to the commodification of Tunisian identity through the image.

It is the second critical gesture of these films that is probably less obvious and perhaps more interesting. Using the filmic image to represent popular practices of Islam, Dhouib is disrupting the (Western *and* Tunisian) discourse that opposes "Western" materialist, technocratic culture to an invented, spiritualist, and mystical "East." The official use of the image effectively establishes an opposition between so-called Western values (materialism, profit, and commercialism) and so-called oriental values (mysticism, spirituality, and the immaterial). Objecting to this opposition, the films combine the filmic image ("Western") and Islamic practice ("Eastern"). The Western

discourse that establishes this dichotomy is well-known as "orientalism." The Tunisian version of this discourse opposes the gritty, dead, mystical, and oriental past with a "new Tunisia" in the form of modern, naturalized images. This highly charged opposition is put into question by the films that I am analyzing here. The objection is launched through the cohabitation of the elements that are supposed to be opposite: technology and spirituality, modernity and legend. Let us remember that like the French language, cinema is a Western medium and was brought to North Africa through colonial invasion and long-standing occupation. Even if he is working through this Western medium, a colonial and servile relation to the West seems to be the target of Dhouib's films. Indeed, precisely because he is working with film, he is shifting the dichotomous categories established by the colonial discourse. The use of film differentiates his representation from the perception of mysticism and local traditions as "authentic," "mysterious," and essentially strange. He uses this Western visual medium to produce an image of Tunisia that is clearly connected to the historical development of Tunisian culture and traditions. Because they fuse the local and the foreign, these films work to reject the dichotomies: technology/spirituality, Western/Eastern, present/absent. Dhouib reinvents tradition through the foreign medium without transforming his culture, via the photographic lens of the Other, into an object of folklore.

The film *Tourba* (The cemetery) provides a clear illustration of this point. *Tourba* is a film about a girl whose father dies, and for the entire forty days proscribed for mourning she is unable to shed a tear. She loved her father dearly and is troubled by her apparent lack of sadness at his death. Her mother curses her, and all the sisters, servants, and friends ostracize her for her cold and unfeeling response to the death. The father was a respected and noble man. He was also a member of an unnamed brotherhood and wrote many books about his worship and learnings. Because he died near the tomb of his saint, one of his disciples brought his corpse back to his home. The disciple tells the daughter that if she wishes to bring her father back to life, she must cry into and fill with her tears seven glass flasks. After the mourning period, she begins to cry and gradually fills the flasks. On the night during which she will fill the last one, she is crying at her father's grave in the cemetery. She hears a man moaning in the distance and runs to him. She finds the disciple, gasping for breath and dying from an unknown sickness. He begs her for water, as if with his last breath. Since she has no water, she goes to her box of tear-filled flasks and pours the tears, flask by flask, into his parched mouth. This is the end of the tale. The disciple taught the girl how to love. Through his learning of mysticism, he knows how to open the human heart.

If this were the only story in the film, it would remain a rather conventional filmic adaptation of a legend of mystical initiation. However, the story

is framed by a prologue and epilogue that add another dimension to the film. This dimension is that of the filmic lens. In the first sequence, before the story begins, the disciple enters on horseback the family estate through an arched doorway. He enters into the house led by one of the sisters, who does not recognize him although she met him during her father's forty-day wake and funeral. He enters into the mother's room and finds it strange that she does not recognize him, for he is the one who recently brought her dead husband's body back to their home. She seems puzzled and makes a remark in a way that indicates that her husband has been dead for a long time. Indeed, she is visibly and significantly older than she was at the time of her husband's death. The disciple asks the elderly woman where he can find her daughter, the girl that saved his life the night before in the cemetery. The mother replies that the daughter has been dead for twenty years. After this comment, the narrative of the main story begins. At the end of the film, after the daughter meets and saves the life of the disciple in the cemetery, there is a short sequence of the disciple exiting the estate on the back of the same horse. He has not aged, he is wearing the same clothes and rides the same horse. What happened to the twenty years between the time she saved his life and the time he goes to find her? Why was this twenty years perceived as only one day for the disciple? How can he exist in a parallel universe? There is a temporal enigma, a magical quality to the tale that is communicated uniquely through filmic techniques. The tale takes on its own trajectory much like the other two films in the trilogy. The message of the narrative is how the father, and more directly his disciple, show the girl this spiritual path, this *tariqa* or way. The flow of tears opens her heart and she is transformed into a person who saves the life of a dying man with her tears. It is a story of love—not romantic love but rather mystical love. The girl progresses from the profane to the sacred by way of a mystical opening—and this is created through the filmic medium.

The narrative's message is transformed by the intervention of the filmic medium. The film itself is not hidden and silent, but rather intervenes to show the legend as a form of mystical experience through its presence. The two sequences that frame the main story (the disciple entering and exiting the estate on horseback) could not have been represented through the traditional, oral mode of transmission. It is a specifically filmic temporal skip. The legendary, even the mystical, do not exclude a modern and foreign lens of the camera. The filmic image makes a strong statement of presence in the narrative structure and transforms an oral story into a new, filmic version endowed with its own dimension of meaning. The camera becomes the omniscient narrator, and the story is told from the perspective of this narrator, visible at the beginning and end, and then invisible during the telling of the main story.

The cohabitation of mystical practices and the Western lens of the filmic image produce a clear comment on the image in Islamic culture. It reintroduces the image not as a foreign and Western intruder, but as a medium capable of mingling with an ancient mysticism. In an interview that I conducted with him in September 2002, Dhouib stated that in this trilogy he was aiming to "nettoyer l'image de l'Islam" (clean the image of Islam).[12] Although he did not elaborate at length on this point, I have understood that these images do not clean the Islamic image of so-called "contamination" by the West. Rather, they reinvent an image of Islamic practice through two elements that have traditionally, and in this perspective unjustly, been banned in orthodox Islam: mysticism and mimetic representation. His images clean the Islamic image of fundamentalist interpretations that (as Abdelwahab Meddeb writes) articulate a false reinvention of the religious origin. According to these interpretations, the image, Soufism, and mysticism are unacceptable in Islam. The films propose another version of the origin, of the past, that is tolerant and inclusive of human representation as well as of popular forms of Islam.[13] By translating the past into the present via the Western medium of the cinematographic image, Dhouib reintroduces the image of an Islamic identity without returning to the solution of opposition to the West proposed by fundamentalists.

Although there is no French language or cultural references in these films, they critically deploy and foreground the use of Western media. Like the other works treated in this book, the incorporation of other languages (or idioms) is itself used as forward-looking political and cultural commentary. In this case, the filmic image makes itself quite visible as the medium of expression in tales of popular religious practices. This combination mobilizes a double critique: on the one hand, it comments on the dominant image of Tunisia that is controlled by the state; and on the other, its message is religious. Images of Soufi trances represent a loss of self, but on another level, the contemporary self lost to its historical identity. They present a reformed image of Islam: the image *should* be included in religious culture. Indeed, religious culture should be more tolerant, since from its origin the religion was strengthened by its tolerance. The films seem to ask the viewer to return to prayer, to saint worship. This message is a defiance of the modern image of the self that has now become second nature to viewers in Tunisia.

Moncef Dhouib's filmic images wrestle with the Western discourse defining Tunisian identity as either the same (Western) or the opposite (despotic and "strange"). The trilogy brings to the foreground, through the filmic medium, sacred cultural representations that are specifically Tunisian.

Post-Structuralism Avant la Lettre

Although France had long-standing cultural and economic interests in Egypt, French culture did not have the same, deep-rooted impact on Egyptian society as it did in the countries of the Maghreb. In Egyptian Francophone writing, the French language was not experienced as the major symbol of the colonial occupation. French was not imposed as the colonial language, thereby not producing whole generations of writers who were educated in the French language and inculcated with the values of French culture. For the Egyptian Francophone writer, unlike his Maghrebi counterpart, French culture did not become a major pivotal axis upon which postcolonial identity was negotiated after independence from Britain in 1956. Nonetheless, the French language *did* serve as a medium for critiquing Egyptian politics that sought to homogenize national culture. In addition, French was a language used by the cosmopolitan, intellectual classes and by the aristocracy who often spent some time in France for schooling or on diplomatic missions. An example of critical use of the French language is the avant-garde group *Art et liberté* (Art and Freedom). This group of artists and writers was inspired by the European avant-garde, and particularly the Surrealist movement in Paris. It adopted and transformed the principles of the Surrealist movement, applying these new principles to the art and politics of an Egypt on the eve of revolution.

One of the founding members of Art and Freedom, Ramses Younan (1913–1966), was a painter, essayist, critic, and translator. He came from a humble family of Minieh, Egypt, to study painting at the School of Fine Arts in Cairo, where he earned a diploma in 1933. After many exhibitions in Cairo during the 1930s and having published an essay on modern art in 1938, he became known as one of the most prominent figures in the Francophone literary and contemporary art scene in Egypt. His paintings were mainly nonrealist but figurative, especially before 1956 when he returned from France after an eleven-year stay. Younan's innovations, both in illustra-

tive "dreamscape" painting as well as in his abstract paintings after 1956, had a significant impact on the development of modern art in Egypt.

In 1939, along with the prolific Francophone poet and critic Georges Henein, Younan founded the group Art and Freedom in Cairo.[1] The artists of this group, and more specifically Younan and Henein, were responding to the art and theories of the French leftist avant-garde of the 1920s and '30s headed by André Breton and his Surrealist movement. Henein and Younan, along with painters Kamel El-Telmessany, Fouad Kamel, and several others, founded a group whose central focus was clearly inspired by the revolutionary spirit of French Surrealism. Their group photo mimics the famous one taken of the Surrealists, though notably omitting the French group's feature of the beheaded female dummy hanging from the ceiling. The group's early manifestos, exhibitions, and pamphlets appear to constitute no more than an Egyptian "bureau" of the Parisian Surrealist movement. That this is not the case becomes clear upon closer inspection. Their terrain of artistic and intellectual struggle remained to a large degree Egyptian. These intellectuals had contact with French culture and spent periods of residence in France, but always explicitly addressed the specific problems they faced as Egyptian artists.

Contrary to the claims of some critics who view Art and Freedom as a simple reproduction of the Parisian movement, it is clear that they maintained a critical perspective vis-à-vis Surrealism. Art and Freedom was initially constituted by a group of Egyptian modern artists as a reevaluation of the European Left based on a critique of the avant-garde. From its inception, the group published articles against the Italian avant-garde because of its fascist tendencies, and against the French avant-garde for its bourgeois compromises as well as its blind acceptance of communism. The Egyptian movement was founded as a form of resistance against a rising fascism in Europe and, perhaps more importantly, against the restrictions on artistic expression they felt were threatening their own society. The members wrote many articles during the 1930s critical of the fascism looming in Europe but always included, occasionally implicitly, the elements of religious and political repression they themselves were facing as artists in Egypt. Just prior to the inauguration of the group, Georges Henein verbally and violently protested against fascist influence on avant-garde art on the occasion of Marinetti's visit to Egypt during his lecture on art on 24 March 1938. Criticizing the paradoxes of the European avant-garde was a way for Egyptian artists to struggle for freedom on their own home front.

The members of Art and Freedom grew increasingly critical of Surrealism, particularly after the Second World War, and officially broke with the movement in a letter written by Henein to Breton on 26 June 1948. The group insisted on the total freedom of the artist, whether French or Egyptian. There

were abstractionists as well as figurative artists in the group, and one of its members even produced a realist film.[2] The group also wrote more directly about European and Egyptian politics and history as well as the economic problems it felt were crippling the creativity and general well-being of the Egyptian population. Its notion of freedom included an articulate discourse against the oppression of women, which was not the case for the Surrealists in Paris. Politically, the members of this group were closer to anarchism than to communism, although their political writings show an intense influence of Marxism, and their Trotskyite tendencies are evident from their concurrence with the Breton-Trotsky Manifesto and the FIARI (International Federation of Independent Revolutionary Art). However, they published many critiques of communism and of Marxism, notably Younan's "*Variations sur le Verbe couvrir,*" published in *La Part du Sable* in July 1947. From this overall anarchistic political tendency as well as its complete tolerance of different forms of artistic expression, in addition to the critique of the Surrealist technique of automatism (letting the unconscious mind direct artistic production) that is the subject of this chapter, we see that the Egyptian Art and Freedom group has only superficial resemblance to the Surrealists of Paris. In this way, the group's use of the "idiom" of French Surrealism was deployed to launch a critique of its own internal Egyptian cultural hegemony.

Problems of Working in the Cultural Interface

Ramses Younan's work, both visual and written, is not as well-known as one would expect considering the perspicacity of his vision. He was exiled from France for his support or failure to condemn the nationalization of the Suez Canal. Indeed, he was marginalized, and literally exiled, by Egyptian society because he was considered to be pro-Western. In a general way, the artistic avant-garde in Egypt during the 1940s and '50s was considered too Western to have been absorbed by the Egyptian culture of the time.

To begin, and as I have described in greater detail in chapter 4, representational art was traditionally forbidden in Arabo-Islamic societies. Although this prohibition remains part of the ideological backdrop for the artists of modern Egypt, at the time they were working the cultural taboo against figurative representation was being relativized. It was becoming accepted that the restrictions on representation were a matter of cultural practice and not, strictly speaking, stated in the sacred texts. Art historian and Islamic art specialist Oleg Grabar notes the insights of Sheik Ahmad Mohammad 'Issa from al-Azhar University, who states: "Le monde nouveau des Arabes musulmans avait rejeté les images non pas pour des raisons doctrinales, mais par refus de s'engager dans les discussions si complexes d'un monde qui prenait les images

trop au sérieux."[3] (The new Arabo-Islamic world had rejected images not for doctrinal reasons, but because of a refusal to engage in complex discussions taking place in a world that took images too seriously.) Many, but not all, of the members of Art and Freedom were Christian. They lived, however, in a predominantly Muslim society and could not have been immune to the restrictions imposed by that society—if not officially, at least restrictions felt as pressures via the civil society. Younan was precisely engaged in debates around theories of the image, and these debates were marginalized as part of Western cultural preoccupations. Indeed, Younan's Christianity and Francophone orientation were enough to isolate him from the mainstream and acceptable cultural debate, although he wrote and translated many texts into Arabic.[4] He was, in addition to his marginal identity, extremely radical in his views. From this weakened position, his critiques could not penetrate the monumental sacrality of the Word in the Arabo-Islamic culture. It is noteworthy that the intellectual impact of Art and Freedom publications in Arabic has been described as "un couteau sans lame auquel il manquerait la manche"[5] (a knife with no blade whose handle is missing).

Younan in particular was seen as a threat to the emerging Egyptian state, ironically because of his revolutionary ideas. He was responsible for the content of the radical journal *al-Majjalla al-Jadida* (The new magazine), founded during the 1930s by Salama Moussa and interrupted by the state in 1944.[6] The journal published articles on topics such as democracy, poverty, the arts, and Stalinism. Younan, and none of the other members of the group (for reasons that do not seem to be documented), was arrested in 1946 for his political activities and ideas. After his release he traveled to France, where he remained until the Suez Crisis. Then he was again exiled, this time from France, for refusing to criticize the nationalization of the Suez Canal on the French radio where he worked between 1952 and 1956. It would seem that a figure such as Younan is caught between the politically revolutionary, yet culturally conservative, Egypt and a still-imperialist France that was not yet willing to accept criticism, especially not from an Egyptian intellectual such as Ramses Younan.

Critique of Surrealist Automatism

In 1948, in Cairo, *La Part du Sable* published an astonishing dialogue between two Egyptian intellectuals. Ramses Younan and Georges Henein engaged in a dialogue that seems, at first glance, to be about how Surrealist automatic writing betrays its revolutionary project by returning slavishly to what Henein calls "une bourgeoisie du hazard" (a bourgeoisie of chance). In fact, the depth of this dialogue, inaugurated by Younan's unprompted and

explosive part of the essay, measures far deeper than expected into the origins of deconstruction of the image and anticipates debates in aesthetics that would take place in Europe during the two following decades. This dialogue, titled *"Notes sur une ascèse hystérique"* (Notes on an hysterical asceticism), concerns the relationship between truth and fiction and the ensuing problem of narrative forms and constructions of images. I hope to illustrate that Younan's theory of the image constituted a precocious and fundamental critique of the European avant-garde that was not merely quantitative but essential and revolutionary. This surprising insight on the part of Younan can be seen most clearly in the dialogue with Henein. Contrary to some critics' writing about Art and Freedom, I will explain here how the Egyptian avant-garde, and specifically this movement, was extremely critical of the European avant-garde from the very outset.[7] In her article, *"Le turath comme expression de la modernité dans l'art arabe contemporain,"* Silvia Naef claims that European modern art was simply appropriated in the Arab world in order to compensate for the "lost time" due to the Islamic culture's resistance to representational art. These modern aesthetic forms that were being appropriated, she states, were already out of date in Europe.[8] However, a much more complex relationship was developing between the European and Middle Eastern avant-gardes. For, as we will see below, Ramses Younan's writing, leading a general trend in the movement at that time, would constitute a critique of the European avant-garde at a very early stage.

Bourgeois Mythology

The critique was launched through the creation of a new mythology that destabilized the Surrealist and modernist aesthetics. Yet, the definition of Younan's mythology must be clarified immediately. Younan's articles *"La désagrégation des mythes"* (The disaggregation of myths) and *"Notes sur une ascèse hystérique"* (Notes on an hysterical asceticism) provide the most fruitful examples. The latter essay, explained in detail below, ends with the proclamation that after "tant d'essais d'interprétation" (what we need is a new mythology), ". . . une sorte de MYTHOLOGY DE CHAMBRE, en attendant la naissance—peut-être!—du Grand Mythe." (After so many attempts at interpretation, what we need is a new mythology, a kind of MYTHOLOGY OF THE BEDROOM, while waiting for the birth—perhaps!—of the Grand Myth.) This call for a new and "grand" myth must be situated in relation to another well-known definition of the myth, the form analyzed by Roland Barthes in his 1957 *Mythologies*. At this point it is worthwhile to reiterate Barthes's exact thesis in order to show the similarity between his and Younan's visions of the bourgeois myth. Barthes analyzes the

bourgeois ideological manipulation of a linguistic semiology—a deformation that produces the myth. He explains that the myth is a deformation ("métaphores détournées," or "deformed metaphors" in Younan's words) of the linguistic sign (composed of the signifier and the signified); the sign, emptied of its meaning, becomes simply an empty and useful form. This emptied form is then used (and this is where the ideological deforms the semiotic) in cooperation with a new signified, a concept (imperialism, a grammatical example) to form a new signification that is the myth. This process of deformation occurs precisely at the moment when the linguistic sign is separated from its meaning and attached to a new signified that is historically defined and ideologically charged. This ideological meta-language of the myth can be deciphered, and that is precisely what Barthes does, thereby losing its transparency. The production of meaning in the historical period dominated by the bourgeoisie, through analysis, looses its illusory character. We come to see how deformation of meaning produces ideologically charged messages.

In his essays of the late 1940s, ten years before Barthes published *Mythologies*, Younan anticipates the death of bourgeois mythological and transparent language. He writes as his concluding paragraph of the article "*La désagrégation des mythes*": "Ainsi, plus auncun artiste conscient de l'époque ne peut plus s'imaginer de demeurer au sein de la nature car celle-ci a perdu, à ses yeux, sa transparence, pas plus qu'il ne peut se satisfaire d'une vie dans le cadre illusiore des formes géométriques ou des métaphores détournées."[9] (In this way, no conscious artist can ever again imagine that he dwells in the breast of nature since nature lost, in his eyes, its transparence, nor can he content himself with a life in the illusory context of geometric forms or deformed metaphors.) The artist, in the wake of the demystification of the bourgeois symbolic, becomes once again, Younan writes in 1948, "à nouveau confronté aux cryptogrammes de l'univers, comme s'il en était revenu à son point de depart." (Once again confronted with the cryptograms of the universe, as if he had come back to his point of departure.) This is the innovation that thrusts the painter into a new vision of representation that we will find spelled out a decade later in Europe. When he calls for a new myth, Younan is not calling for the resuscitation of the form that would be later analyzed by Barthes. Younan, in a performative act of writing, precociously states the death of the mythological illusion: that the contemporary artist perceives the passage from "semiology to ideology" and "history into nature."[10] The contemporary Egyptian artist, according to Younan, has perceived and thereby produced the death of this deformation: "nature, in his eyes, has lost its transparence."

In another essay, "Beyond the Mind's Logic," Younan writes more

directly about the deformation produced by the bourgeois hegemony. His critique of the alienation endemic to capitalist societies is coupled with his remarks about the myth-making process. Younan claims that from capitalist myth-makers have emerged imperialists and dictators. The bourgeoisie "disfigured and manipulated instincts, and repressed emotions—that naturally search for pleasure—either through the trade race and competition, or through military songs and hysterical slogans that dictatorial and imperialistic governments drill into their people."[11]

The Myth of the False

In "*Notes sur une ascèse hystérique*" and "*La désagrégation des mythes,*" Younan is referring to the artists' role of creating and drawing on a new mythology. This new mythology will be the myth of the false and implies a deconstructive reconfiguration of the binary truth–illusion. The mechanisms will be different, for the categories upon which the bourgeois myth was constructed will in themselves be transformed. In the bourgeois myth, illusion was used in order to create a naturalized image of the real, which is in fact historically determined. Instead of illusion being at the service of a capitalist, bourgeois reality (narrative of truth and science), the new mythology will use illusion to uproot, challenge, and derange the state of things. Both reality and illusion begin to lose their identity as such and thereby disrupt the power structure that formerly organized their relationship within the bourgeois mythology.

The Surrealists, according to Younan, were part of the bourgeois mythology that he had so clearly identified and critiqued. Writing about visual arts and the poetics of the image, Younan engages a shift from one epistemology of the image to another. This shift signals a movement from the modernist dilemma in which the Surrealists eventually found themselves trapped. Surrealist artists were ostensibly caught up in the myth-making machine produced by the bourgeoisie. Younan's critique of automatic writing begins in his 1938 book, *Aims of the Contemporary Artist*. In this early text, he begins to identify the dangers of Surrealist automatism: "The art of these Surrealists is susceptible to dwindling into an artificial, deliberate art, the elements of which are produced by the conscious mind more than the imagination of the unconscious"; in other words, still within the ideological world conditioned by a bourgeois, scientific discourse of truth. Younan will depart from what he perceives as the mystifications of automatism and enter into a contemporary or poststructuralist theory of the image.

At this embryonic phase in poststructualism, Younan's main concern was personal and political. He was seeking to release the image from a totalitar-

ian reign of truth—a project that reached its most elaborate theoretical cul-
mination in Gilles Deleuze's work on cinema in *L'Image-Movement* and
L'Image-Temps. Younan's particular dismantling of the Surrealist's methods of
artistic production, despite his otherwise favorable posture vis-à-vis this
moment in the European avant-garde, bears a striking resemblance to
Deleuze's visual and philosophical analysis of the cinematographic image of
new-wave cinema.

In the dialogue *"Notes sur une ascèse hystérique,"* the artist's relationship to
reality comes under scrutiny. Both thinkers concur that the oppressive rela-
tion that continues to exist between truth and automatic art must be dealt
with in order to save the dignity and freedom of the artist. Henein writes (in
a beautiful, long parenthetical phrase that winds almost to the extent of its
own disappearance) about the "tragic" fate of automatism:

> (l'expérience automatique, grisante à ses premiers pas, impossible à
> poursuivre sans que se forme aussitôt une syntaxe et un vocabulaire,
> c'est-à-dire une bourgeoisie du hazard . . .) . . . Mais c'est le propre
> du comportement moderne de n'arriver à s'affirmer qu'en fonction
> des dilemmes. *Il est temps de rejetter Kafka.*[12]

> ([The automatic experiment, intoxicating from its first steps, impos-
> sible to pursue without forming a syntax and a vocabulary, that is to
> say a bourgeoisie of chance . . .] . . . But it's the nature of the mod-
> ernist comportment to only affirm itself by way of dilemmas. *It is
> time to reject Kafka.*)

To this extent, Henein and Younan agree, automatic writing leaves the artist
in the dilemma of his art falling back into the schemas where truth and fic-
tion are mutually working at each other's reification and ossification. Truth
remains the final judge of fiction's authenticity. The sovereignty of the artist
is once again sacrificed to the truth, leaving him alienated while his own
dreams have organized themselves against him.

Georges Henein's Narrative of Truth

If the two writers seem to agree on this much, what is noteworthy here
is that upon closer examination, Henein remains faithful to the Surrealist
mode that relies on an opposition between the essence of the independent
real and the reality of the dream. Georges Henein seems to stand in for the
old model of visual representation. Paradoxically, what has been interpreted
as Henein's radicalness in this debate[13] is actually a sign of his conservatism
wherein he "conservait et sublimait pourtant un idéal de vérité" (p. 195,
L'Image-Temps).[14] (Preserved and sublimated an ideal of truth [p. 149, *The*

Time-Image].)[15] His disappointment with the contamination of the dream narrative, the automatic creation, by the rules of "reality" leads him to call for the artist to plunge into "nothingness," *le vide*. This nothingness alone precludes any co-optation of the representation by the forces of interpretation and thus is the only way to protect the integrity of fiction of the human fantasy. What he is doing is effectively sacrificing the dream to protect its purity, its truth. The position of judgment remains intact—he opts for the exclusion of the false. Curiously, Henein's posture foreshadows the classical model of the cinematographic image elaborated by Deleuze. What Deleuze calls the "organic image or narrative" implies a certain relationship between the real and the imaginary. Like the "organic image," Henein's refusal of Younan's "apparitions" reinforces truth as the arbiter of fiction's authenticity, of fiction's "truth":

> Le régime organique comprendra donc ces deux modes d'existence comme deux pôles en opposition l'un avec l'autre: les enchaînements d'actuels du point de vue du réel, les actualisations dans la conscience du point de vue de l'imaginaire. . . . C'est une narration véridique, en ce sens qu'elle prétend au vrai, même dans la fiction. (pp. 166–67, *L'Image-Temps*)

> (The organic system will, therefore, consist of these two modes of existence as two poles in opposition to each other: linkages of actuals from the point of view of the real, and actualizations in consciousness from the point of view of the imaginary.) (p. 127, *The Time-Image*)

This "*narration véridique*" is what prompts the urgency with which Henein suggests the artist's flight into nothingness, for he aims to protect the truth, both of reality and fiction. Henein's position of judgment between what is true and that which is false in the representation of reality remains within the parameters of the classical form of representation that Deleuze describes as the "organic system" or "organic narration." In this system, the relationship between reality and fiction is one of opposition. The value of the dream, of the fantasy or lapsus, is determined by its relationship to reality, the object that remains independent of its description. Within this schema, Henein is criticizing automatic writing of having relegated the dream sequence and the representation of the fantasy to the ghetto surveyed by the guardians of truth. According to this "organic regime" that identifies, and thereby legitimates, the dream by opposition to an ever-present reality (truth), the truth again triumphs, since it is the judge of fiction's authenticity. This "organic narrative" that depends on the sensory-motor and establishes the veracity of the dream by opposition to the truth, or reality, indeed

constitutes the dilemma out of which the artist must escape as if from a prison or camp.

Henein opts for emptiness, nothingness, instead of the dream that he mourns as "false," paradoxically because it succumbs to the habits of reality. He cries out that our words, freed through the mechanisms of the unconscious, have been enslaved by the verbal mechanism—these words have betrayed us. In "Notes" he writes: "La parole est une plaie dont on ne peut se défendre que par un grand silence noir." (The word is a wound from which we can only defend ourselves by way of a great, black silence.) Truth for Henein must be found in emptiness, the nonspace beyond language and mimesis. The only existence that we can call authentic is that which cannot be named. Always to rediscover the dictatorship of the bourgeois order, Henein is fighting within the truth–falsity binary.

On the other hand, Younan, in a radical gesture, seeks to remove the authority that truth wields over fiction, the dream, the virtual. He writes: "je suis amené à FAIRE L' AMOUR AVEC LES APPARITIONS . . . cela passe sur un plan précaire, suspendu quelque part dans le vide. Pas de ciel, pas de terre, pas de dictionnaire." (I am inclined to MAKE LOVE WITH APPARITIONS . . . that takes place on a precarious plane, suspended somewhere in the void. No sky, no earth, no dictionary.) This is the inaugural statement that incites Henein's objections. At Younan's call "to make love with the apparitions," Henein stands up for duty as if called upon to control the border between reality and dream. These separations must be controlled in order to prevent contamination of their discrete identities. For Henein, the only way to prevent contamination between reality and the dream (a contamination that would deprive the dream of its identity) is to lapse into silence, emptiness. We must not give in to formulas of going beyond the self, of facile, one-penny solutions, says Henein, and recognize the supreme rights of EMPTINESS, of that which cannot be named: "Seul ce qui n'a pas de nom existe." (Only that which has no name exists.) Fear of contamination forces Henein to abandon the human dream. He has more confidence in the colonizing power of the bourgeois reason than in the visions of fantasy. This is Henein's concluding sentence to the debate, and his strength in this polemic is finally his weakness. That which he claims so triumphantly in this desire for radicalness is precisely what encloses him in the realist epistemology of the image, where truth remains the arbiter of artistic and, ultimately, human freedom.

The Crystal Image

Ramses Younan claims that the artist must create myths to produce the downfall of the bourgeois mythology. Instead of seeking to sacrifice the

dream to save it from "falsification," he sets out to discredit truth, to dislodge truth from its immovable authority over fiction. In "Dreams and Truth" he writes: "If we put aside the enchanting girl that all the philosophers have been searching for in vain, the 'truth' means nothing but the 'facts' of the society in which we live, these facts are not static."[16] (This could be taken as a pointed critique of the Surrealists, who are known for their use of female forms for projecting their aesthetic and philosophical "discoveries.") Younan's project in many of his essays is the creation of a new mythology. In "*La désagrégation des mythes*," Younan sings the praises of the mythological:

> Une mythologie veritable . . . détermine la position de l'homme par rapport à l'existant, par rapport aux forces, cachées ou manifestes, de l'univers. Elle lui rélève son origine et son destin. Elle lui désigne sa voie et ses fins. Elle interprète ses rêves, répond aux désirs de son coeur, de son esprit, de son imagination.[17]
>
> (A veritable mythology . . . determines man's position in relation to the existing, in relation to forces, hidden or manifest, of the universe. It rises from his origin and his destiny. It draws his path and his destinations. It interprets his dreams, responds to the desires of his heart, of his mind, of his imagination.)

The essential role of the myth for the artist's freedom and for the individual's fulfillment continues to condition Younan's arguments and creations. His praise of the "false," of the mythical, displaces the truth as judge. Through a vivid, pulsating, and omnipresent mythology, explains Younan, the artist continues to create: "Au sein des mythologies, se cristallisent les symboles, prend forme de l'expression artistique."[18] (In the midst of mythologies, symbols crystallize and take the form of artistic expression.)

In many ways, Younan anticipates the Deleuzian crystalline image: the universe in which neither truth nor falsity exists, just *la puissance du faux*, the power of the false, of the fictional. Deleuze describes/theorizes this new regime in a poetic language that deserves ample citation here. In the crystal regime:

> L'actuel est coupé de ses enchaînements moteurs, ou le réel de ses connexions légales, et le virtuel, de son côté, se dégage de ses actualisations, se met à valoir pour lui-même. Les deux modes d'existence se réunissent maintenant dans un circuit où le réel et l'imaginaire, l'actuel et le virtuel, courent l'un derrière l'autre, échangent leur rôle et deviennent indiscernables. C'est là qu'on parlera le plus précisément d'image-cristale: la coalescence d'une image actuelle et de son image virtuelle, l'indiscernabilité des deux images distinctes. (pp. 166–67, *L'Image-Temps*)

The actual is cut off from its motor linkages, or the real from its legal connections, and the virtual, for its part, detaches itself from its actualizations, starts to be valid for itself. The two modes of existence are now combined in a circuit where the real and the imaginary, the actual and the virtual, chase after each other, exchange their roles and become indiscernible. It is here that we may speak the most precisely of crystal-image: the coalescence of an actual image and its virtual image, the indiscernability of two distinct images. (p. 127, *The Time-Image*)

Younan describes precisely this shift in the relationship between the real and fiction. The authority of the real over the fictional (that the real makes fiction what it is) changes. The true and the virtual are not opposed, but are *incompossibles* (p. 171, *L'Image-Temps* [p. 131, *The Time-Image*]). That is, different possibilities that would have emerged from different planes of time exist at the same time. The reign of falsity opens the creative flow. Younan's new mythology is the mythology of the false where the impossible, the virtual, is true. Younan writes: "Le secret était dès lors divulgué et tous ceux qui ont des yeux pour voir savent désormais que la vérité et l'illusion sont une seule et même chose, que les sirènes et les chevaux ailés ou ces arbres pourvus de poitrines sont le plus fidèle miroir de ce qui se passe dans l'esprit de l'homme."[19] (The secret was henceforth divulged and all those with eyes to see knew that truth and illusion are one and the same thing, that sirens and winged horses or trees without chests are the most faithful mirror of what happens in the mind of man.)

In a similar way, Deleuze, in describing the poetic cinema that developed from the 1960s, explains that it is not a new separation between reality and fiction that is carved, but rather the new relation between them. One discovers fiction liberated

du modèle de vérité qui la pénètre, et retrouver au contraire la pure et simple fonction de fabulation qui s'oppose à ce modèle. Ce qui s'oppose à la fiction, ce n'est pas le réel, ce n'est pas la vérité qui est toujours celle des maîtres ou des colonisateurs, c'est la fonction fabulatrice des pauvres. (p. 196, *L'Image-Temps*)

([from] the model of truth which penetrates it, and on the contrary to rediscover the pure and simple storytelling function which is opposed to this model. What is opposed to fiction is not the real; it is not the truth which is always that of the masters or colonizers; it is the story-telling function of the poor.) (p. 150, *The Time-Image*)

This is precisely the call of Younan, that the freedom of the artist resides in his departure from the relativity of falseness: falseness itself, illusion itself is the uncompromised power of his creation.

In this new mythology, neither the real nor the imaginary reigns over the other. Younan writes: "Et peu importe que les mythologies s'enracinent dans la réalité, ne serait-ce que de façon ténue, ou qu'elles soient pur produit de l'imagination. L'important est qu'elles comblent en nous un vide et soient source de lumière et d'inspiration."[20] (No matter whether myths are rooted in reality, even slightly, or are pure products of the imagination. The important thing is that they fill a void within us and be a source of light and inspiration.) Henein praises *le vide* or nothingness that would be the only remaining site of truth, because emptiness could remain pure. In contrast, Younan reclaims the sovereignty of the illusion that will fill the void created by life in a scientific, dehumanized society. A similar reference to Nietzsche's glorification of the will is present in Deleuze: "il n'y a que du devenir, et le devenir est la puissance du faux de la vie, la volonté du puissance" (p. 185, *L'Image-Temps*). (There is only becoming, and becoming is the power of the false of life, the will to power [p. 141, *The Time-Image*].) According to Younan, the power of the artist will emerge from his role as myth-maker. Younan's notion of the artist in his new myth of the false corresponds to Deleuze's description of the filmic relation of the crystalline image. Deleuze writes: "C'est le devenir du personnage réel quand il se met lui-même à 'fictionner,' quand il entre 'en flagrant délit de légender.' Et contribue ainsi à l'invention de son peuple" (p. 196, *L'Image-Temps*). (It is the "becoming" of the real character when he himself starts to "make fiction," when he enters into "the flagrant offense of making up legends" and so contributes to the invention of his people [p. 150, *The Time-Image*].) Here, in the Younan–Henein dialogue "*Notes sur une ascèse hystérique*," Younan describes the same value of the "false." In his search for a new myth, he enters into the world of the crystalline image produced there where the real world does not exist. Younan's initial statement to "FAIRE L'AMOUR AVEC LES APPARITIONS" reminds us that he is speaking in an entirely different register in which creativity and freedom are actualized through a new relation of falsity to reality. To "make love with apparitions" is to create, in the "true" sense, through the reflexive simulation between the objective and subjective.

The artist thrusts off the oppressive, colonial presence of truth that formerly gave legitimacy to his dreams. The sovereignty of the "social fabulous," of the collective apparitions in all their falseness, in their glorious fakeness, will liberate society through the artist. In all of his writings, Younan, differing from Henein, insists on the people's dreams as true in-and-of-themselves: "Une mythologie qui fut source de lumière et d'inspiration pour des âmes affligées, altérées, en proie à toutes les formes du doute, de la confusion et de l'angoisse que suscite cette époque."[21] (A mythology that was the source of light and inspiration for afflicted and impaired souls, assailed by all the forms of doubt, of confusion and anxiety that this epoch creates.)

Forty years later, Deleuze would use these same conceptual terms to describe Picasso:

> Bref, le faussaire ne peut pas être réduit à un simple copieur, ni à un menteur, parce que, ce qui est faux, ce n'est pas seulement la copie, mais déjà le modèle. Ne faut-il pas dire alors que même l'artiste, même Vermeer, même Picasso, est un faussaire, puisqu'il fait un modèle avec des apparences. (p. 191, *L'Image-Temps*)

> (In short, the forger cannot be reduced to a simple copier, nor to a liar, because what is false is not simply a copy, but already the model. Should we not say, then, that the artist, even Vermeer, even Picasso, is a forger, since he makes a model with appearances.) (p. 146, *The Time-Image*)

The difference we perceive between Henein's and Younan's positions represents a significant split in perspective during the following two decades. *Mythologies* seems to reflect back on the divergences of the Younan–Henein discussion. Barthes explains the uselessness of opting for silence in order to escape the myth of the ideological (Henein's position). According to Barthes:

> The subversion of writing was the radical act by which a number of writers have attempted to reject Literature as a mythical system . . . it is well known that some went as far as the pure and simple scuttling of the discourse, silence—whether real or transposed—appearing as the only possible weapon against the major power of the myth: its recurrence.[22]

This is what Henein was suggesting through his position in the "Notes." The idea of the new myth based on falsification (Younan's position) is also discussed by Barthes, who explains: "Truth to tell, the best weapon against myth is perhaps to mythify it in its turn, and to produce an artificial myth."[23] Indeed, the only way for the artist not to be subject to the bourgeois mechanism of mythification—the trap Surrealism got caught in, or at was least accused of being caught in—is to state the truth of illusion, of the dream, what Deleuze calls "*la puissance du faux*" or the "potency of the false."

The importance of Ramses Younan's insights into what we now know as poststructuralism may not be self-evident. Younan's work as a writer and painter deploys French idioms of the avant-garde and incipient theories of poststructuralism in order to reorient the cultural trends of Egypt. His critical use of foreign languages both decenters the hegemonic French (the so-called First World) and brings to task internal cultural hegemony within Egypt by questioning its restrictions on self-expression. Some art historians

have claimed that the Middle Eastern avant-garde mainly appropriated Western art of the period in order to compensate for a cultural taboo against mimetic representation, and that the forms being appropriated were already "out of fashion" in Europe. In fact, upon closer inspection, these Egyptians, with Younan as arguably the most important example, were innovating and transforming the idioms of the European avant-garde prior to critique on the part of the Europeans themselves (such as Tel Quel in the 1960s, for example). The significance of this observation does not lie in "who did what first" on a linear time-line of modern art; rather, we are pointing to an early manifestation of a critical use of European idioms in a sociocultural context that was particularly hostile to an European presence. In so doing, Younan remains firmly committed to the project of reforming Egyptian cultural production. This critical posture within North Africa has particular resonance at our current juncture in history (early twenty-first century) when the view of "the West" from within North Africa is equally resistant and oppositional.

The Art and Freedom group of Cairo inflected and problematized Western art of the period, introducing a new, local iconography as well as theoretical considerations that emerged from a social, political, and religious context that the French, for example, were not grappling with. Even more interesting is the way that this reworking and critique of the Western avant-garde produced an internal development in art and aesthetic theory in Egypt. For example, following the disillusionment with French intellectual and artistic tendencies of the 1930s and '40s, Younan and other Egyptian artists who were influenced by him turned to abstract art. The abstraction of these years was a development that incorporated the freedom of the imagination, of the individual that was fought for so militantly by the Surrealists. The new abstract art also established a relation to previous abstract Egyptian art that was both new (introducing the dream, desire, the individual into the picture) and ancient. The abstraction of most traditional Egyptian art would now be endowed with the spirit of the unconscious and with the drives of revolution that previous forms of abstract Egyptian art did not necessarily express.

Younan's paintings' use of French visual iconography neither add to the French artistic hegemony (since he is critical of it) nor does it contribute to an internal Egyptian hegemony that completely marginalized Western art for the reasons described in this chapter. The work of Younan constitutes a "discussion" between artistic trends in France and the Arabo-Islamic world. This discussion within his work is what makes it worthy of our attention and rediscovery.

PART THREE

URBAN SPACE IN NARRATIVES OF RETURNING HOME

Chapter 6

▼▼▼▼▼▼▼▼▼

The Forked Idiom

Abdelkebir Khatibi (b.1938) was trained as a sociologist at the Sorbonne in Paris from 1958 to 1964. In the late sixties, his work focused on French sociology in Morocco, notably the *section sociologique* established in 1919 as part of the French colonial administration. Khatibi has written on the penetration of the European social sciences in Morocco and the necessity and modes of reinterpreting scientific discourses during the postcolonial period. Later, in the 1970s and '80s, he turned to literary production and has published several novels, including *La Mémoire tatouée* (1971), *Le livre du sang* (1979), and *Amour bilingue* (1982). He has distinguished himself as a literary and cultural critic, especially in Moroccan and Maghrebi literary studies with his books *Le roman maghrébin* (1968), *La blessure du nom propre* (1974), and *Maghreb pluriel* (1983). Perhaps the most compelling aspect of Khatibi's literary production is the way he combines the poetic and social scientific. His prose expresses the subjective and poetic responses to sociological transformations. *La Mémoire tatouée* in particular tells the story of the ways colonialism transformed Moroccan spaces and the way characters reflect on the spaces of their childhood. This intermingling of the social scientific and literary is what has drawn me to the following analysis of *La Mémoire tatouée*.

Khatibi's autobiographical novel *La Mémoire tatouée* provides a virtual "around-the-world" literary tour, a merry-go-round narrative experience. The itinerary narrated in the story takes the reader from El Jadida to Marrakesh, Paris, Combloux, London, Sophia, Cordoba, Stockholm, La Havana, New Delhi, Berlin, and back to Morocco. In between these places there are additional visits to Essaouira and a small village in the Atlas Mountains. The itinerary is not easily extracted from this complex narrative. The itinerary is curvilinear—places inhabit and cross over into one another. Links can be made to the Algerian novelist Réda Bensmaïa's text that begins: "1962–64, Algiers, 1964–71, Aix-en-Provence, August 1968, Switzerland [the Lenk Valley], 1971–88, Algiers, Aix-en-Provence, Algiers, San Francisco, London, Minneapolis, Lyons, Minneapolis, Paris *at all times*."[1] As in Bensmaïa's

account, Khatibi's novel combines each sentence/place with a double that is always marked by the shadow of the Other: "Belle illusion est le retour au pays! On ne revient jamais chez soi, on retombe dans le cercle de son ombre" (p. 145). (Beautiful illusion is the return to one's homeland! One never comes home, but one falls into the circle of one's shadow.) Although the narrator's travels trace a passage from Morocco to the "Occident" and back to Morocco, both places remain in quotations because they constantly inhabit and refer to each other. This passage between Morocco and the West is contained in each sentence, marking the importance of space for the telling of the autobiography.

La Mémoire tatouée engages the production of space both as a mode of understanding a social transformation and a poetic writing about childhood memories. It seems evident that within the arena of current cultural theory an increasing interest in space is due, perhaps, to the changes in this register within our internationalist, late-capitalist orientations. Space is felt to be an effect of compression, and, in a general way, spaces are getting closer, overlapping with greater ease; the specificities of spaces and their cultural practices are decreasing rapidly. We take an interest in space because we feel that it is disappearing. This current evolution of perception and critical inquiry toward space has been considered here in light of a problem of the social production of space that emerges from a specific dynamic relative to postcolonial Morocco.

Conceptions of space in postcolonial Morocco are heavily inflected both by memories of colonialism and the modernist epistemologies that constituted its logic. Writing in French is alone a testimony to this fact. Yet, as Khatibi's early work demonstrates, novelists are not the only Moroccan writers to use the French language. Many disciplines such as sociology and anthropology use French as a vehicular language, as do many Moroccan business and administrative institutions. The colonial period brought with it a whole slew of modernist discourses of knowledge: anthropology, sociology, cartography, urbanism, and so on. These academic disciplines were inscribed in the space of Morocco, both physically through the constructions and transformations of cities that obeyed foreign notions of space, and intellectually, for the practice of these disciplines in Morocco are inflected by the conditions of their implantation during the colonial period. The imposition of modernist, Western thinking (namely, the modern novel and disciplines of sociology, anthropology, and cartography) in Morocco becomes an integral part of local epistemologies and cultural expressions in the wake of colonialism. Khatibi's novel about a man returning to his native city is deeply involved in producing a "de-colonized" vision of his home space.

The colonial conditions of spatial transformation of the Moroccan city and the change in cultural practices can be traced throughout the colonial

period. This transformation has been investigated by many urbanists, historians, and anthropologists. Michael Gilsenan's *Recognizing Islam* outlines the effects of colonial transformations of space on practices of Islam. I have taken as true that: "The problem (of the French colonial power) was to fix, to group, to pin down in space, to define within boundaries of law, property, territory, and symbolic classification these elusive social groups."[2] Gilsenan continues to point out the relationship between ideology and space as a crucial form of colonial control, quoting Captain Vaissière who, in 1863, said in regard to land policy in Algeria: "It [land control] is in effect the most efficient war machine that can be imagined against the indigenous social condition and it is the most powerful and fruitful instrument which can be put in the hands of our colonists."[3] What Gilsenan shows is the evolution from tribal, precolonial social formations and practices to the practices of these same peoples in a colonial division of space that benefited a capitalist economic system and maximal colonial exploitation. Gilsenan's main thesis, at least with respect to North Africa, is that the organizing potency of the sacred, which prior to the colonial period conditioned spatial divisions and cultural practices within spaces, was radically diminished as a result of colonial urban transformation and land divisions. These are some of the reasons that I have read Khatibi's novel as a novel about coping with postcoloniality through a creation of a new space.

Discontent with the protected space of the medina and with the suffocating rigidity of the French city or *ville nouvelle*, the narrator of this autobiographical novel searches for a new space. The eventual destination is a "nonspace," which is much like the "surplus-space" that *Le pain nu* created for the narrator of that story. This "nonspace" is thematized in Khatibi's narrative as a space of the desert, what Deleuze and Guattari call "les espaces lisses du type desert."[4] (Smooth spaces of the desert variety.) Indeed, the desert will be described at the end of the novel as a mythic, liminal, livable space. The poetic or scriptural analogue to this desert space is the tattoo.

The Medina

The first place the narrator experiences as a child is the *medina*, or the old part of the city that existed before the arrival of the French. In the beginning of the narrative, the narrator's memories of his childhood are filled with joy and innocence. The memories of El Jadida take on a spatial quality in their descriptions of the streets of the medina: "Je me rappelle la rue, plus que mon père, plus que ma mère, plus que tout au monde" (p. 20).[5] (I remember the street, more than my father, more than my mother, more than anything else in the world.) Although the place is not named, the descriptions clearly indicate that the action is taking place in the *medina*. The serpentine forms of the

streets, the proximity of the terraces, the women hiding their faces yet peer-
ing out from behind dilapidated doors, the uneven height of the houses all
indicate that the description is of the *medina*. The narrator remembers the joy
and excitement he felt as a child running and playing in the streets of the
medina: "La rue me prenait, je me faufilais dans le labyrinthe où tout pouvait
jaillir: des chats errants, des yeux de femmes entre les portes ou près de la mai-
son" (p. 32). (The street took me over, I threaded my way through the lab-
yrinth where anything could spring up: stray cats, the eyes of women between
the doors or near the house.) These elements are archetypical of the space of
the medina. "Je traverse mon enfance dans ces petites rues tourbillonnantes,
maisons de hauteur inégale, et labyrinthe" (p. 32). (I'm crossing through my
childhood in these little whirling streets, houses of unequal height, and the
labyrinth.) But this early period of happiness, protected in the womb of the
medina, gives way to a more complex vision of the home-space.

As the narrator wanders through his native neighborhood he reflects on
two spaces that were formative for him as a young boy: the school and his
father's house. These places paved the way for his introduction into language
and the symbolic systems of his society. The Quranic school and the father's
quarters are remembered as two sociospaces within the *medina* that are struc-
tured by a traditional and patriarchal ideology. Memories of these places are
bitter, widening onto a general rejection of the values inculcated there. As
opposed to a narrative that would thematize returning home as a return to a
mythic Arabo-Islamic identity, this novel creates a critical distance vis-à-vis
Islamic culture in a representation of these spaces as closed, polarized, or
rigid—at times even repressive. Descriptions of the father's house demon-
strate the author's questioning of religious articulations of postcolonial iden-
tity. According to this narrative, the liberated consciousness must resist the
temptation to automatically return to traditional Islamic social organiza-
tions, or what is known as "sallafism." In this sense, the actual home (the
father's house) is rejected, since it represents religion's authority over the
individual. The layout of the father's house indicates the patriarchy sanc-
tioned by Islamic laws and customs: "[Mon père] habitait dans le Coran, en-
touré de sa famille ou de ses fidèles" (p. 17). (My father lived inside the
Quran, surrounded by his family or by his believers.) Paternal authority—
oppressive for the young narrator—is represented through the description of
the home. The parents are not given possessive articles: not *my* mother and
my father, but rather *the* mother and *the* father, thus emphasizing their role
as authority figures within a society structured by Islamic values: "Passons un
instant à la maison par le même chemin parabolique. Le père dormait seul,
en haut; la mère, en bas, dans une chambre à part. Entre les deux, ma cohab-
itation avec les frères et la bonne" (p. 33). (Let's stay for a moment at the

house via the same parabolic path. The father slept alone, upstairs; the mother, downstairs, in a separate room. Between the two, my shared room with my brothers and the maid.) The father is never described with affection, but rather as an authority figure associated with the religion and submission: "Devant le père je pliais l'échine, me conformais à un rôle d'esclave complice" (p. 31). (In front of the father I submitted, I conformed myself to the role of a complicitous slave.)

The paternal authority reduces the child to a muted existence: "L'image choc de mon père est comique: marche dans la rue, lui rigide, entre ciel et terre, m'écrasant de sa taille, et moi trottinant en silence" (p. 16). (The image of my father is comic: walking in the street, him, stiff, between the sky and the earth, squashing me with his height, and me walking along in silence.) The description of the father and the paternal space is a clear rejection of his religious upbringing. Submission to God's will, the primary posture of Islamic faith, is described as slavery, suffering, and oppression. In the father's room we find the family's treasure chest, valuable furniture, jewels, and an image of Mecca—the geographical point that organizes the Islamic spatial imagination: "Au fond de la chambre paternelle, cette armoire grandiose, avec glace oblongue et striée, fermée à clef . . . bijoux, chiffons bariolés ou vieille monnaie, et derrière tout, une bague avec une petite boule en verre: La Mecque!" (p. 33). (In the back of my father's bedroom, this grandiose armoire, with its oblong and striped mirror, locked . . . jewels, patterned cloth or old coins, and behind it all a ring with a small glass ball: Mecca!) The father's space becomes a miniature version of the wider Islamic community.

Much in the same spirit as the paternal space, the Quranic school is described in terms of being a closed, molar, and patriarchal space. Days spent at the Quranic school are described as "journées d'un temps linéaire, réduites à un espace limite où le cercle des enfants prisonniers de leurs corps se refermait autour d'une divinité sadique" (p. 31). (Days of a linear time, reduced to a limited space where children, their bodies imprisoned, formed a circle around a sadistic divinity.) Like the father, the *fqih* has total authority because of his pretended proximity to God: "Le fqih, patriarche très proche du bon Dieu par sa barbe et son autorité" (p. 31). (The *fqih*, patriarch close to God by virtue of his beard and his authority.) This figure is also described without affection and the narrator dreams of escaping: "Sous le regard méprisant du patriarche. . . . Criant face au mur, je rêvais de fuite" (p. 31). (Under the gaze of the patriarch. . . . Crying facing the wall, I was dreaming of flight.) The spaces that are traditionally sacred in the Islamic tradition—the mosque, the father's home, Mecca, the Quranic school—become repressive places and the narrator will seek new spaces of freedom.

At first, escape will take place through the streets of the *medina*. The nar-

rator remembers that to flee the oppressive atmosphere of the Quranic school, the narrator takes flight in the streets of the *medina*—first in his imagination, then actually running out into the streets. The street initially feels like an oppositional, subversive space relative to the hierarchical worlds of the Quranic school and the paternal home: "Je me débinais au moment de la prière, on me traita de voyou; je retrouvai la tactique de la rue" (p. 32). (I would scram at the times of prayers, they treated me like a thug; I discovered the tactics of the street.) The streets of the *medina* will be the beginning of the narrator's entry into a de-ideologized, rhizomatic space. The space of the *medina* seems at first to allow for escape from the paternal authority and flight to an uncontrolled territory.

As it turns out, the medina is not completely free from territorial divisions and the marks of colonial violence. As the narrative advances, the *medina* is increasingly regarded as antagonistic and always inhabited by the Western division of space. What appeared to be the free and resistant street is revealed to be part of a political shaping of the so-called "native" city. The narrator seems to comment on Lyautey's colonial policy of protection that consisted of preserving the authenticity of the *medina* in the name of difference—an essential difference that supported the discourse of protection. In his book *Lyautey et l'institution du Protectorat français au Maroc 1912–1925*, Daniel Rivet explains that spatial segregation and authentication of local culture formed part of a project of conquest.[6] As both Rivet and Paul Rabinow (in *French Modern*) describe in different ways, the ideology structuring the colonial division of space is the separation of people according to ethnicity, a separation of colonizer from the colonized. Rabinow discusses the effect of ethnic apartheid that was represented as a respect for indigenous practices. Ironically, then, the urban structures of the *medina* that remain intact in Morocco owe their existence in part to this colonial desire to separate space and peoples. This policy of differentiation through conservation of the "native" space and practices comes out in the novel both directly and implicitly. Khatibi writes quite directly here of the colonial conception of the Moroccan city: "On connaît l'imagination coloniale: juxtaposer, compartimenter, militariser, découper la ville en zones éthniques, ensabler la culture du peuple dominé" (p. 46). (We know the colonial imagination: to juxtapose, to compartmentalize, to militarize, to cut up the city in ethnic zones, and run aground the culture of the dominated people.) The narrator's memory of the *medina* is irremediably trapped within this binary spirit that is characteristic of the colonial division of space.

In a more indirect way, the description of the *medina* reveals the narrator's consciousness that the medina's authenticity is part of colonial urban policy. The streets of the *medina* remain associated with colonialism, since

being "protected" by it, thus remaining structured within a binary opposition. A Cartesian, geometric space (the French city) opposed itself to the *medina*—labyrinthine, serpentine, and dark. The realization of this binary creates a deculturation, a break in the continuity of history. Khatibi writes: "En découvrant son dépaysement, ce peuple errera, hagard, dans l'espace brisé de son histoire. Et il n'y a de plus atroce que la déchirure de la mémoire. Mais déchirure commune au colonisé et au colonial, puisque la médina résistait par son dédale" (p. 46). (Discovering its culture shock, these people wandered, haggard, in the broken space of their history. And there is nothing more atrocious than a ripping in one's memory. But it is a ripping shared by the colonized and the colonizer, since the *medina* resisted by its daedalus.) This resistance through space, however, in the image of traditional and immobile city space, is falsified by the colonial project of domination through preservation and authentication of difference. This is the "intellectual penetration" that Christopher L. Miller discusses in "Nationalism as Resistance and Resistance to Nationalism in the Literature of Francophone Africa." The relationship between politics and urban spaces is visible in the poetics of the literary narrative. The streets of the *medina* prove not to be a place of revolution, but rather another broken, sickening version of the alienated home. The narrator's home, even proximity to this home, provokes disorienting experiences of space; first the narrator experiences immobility, then trembling and vertigo: "A quelques mètres de la maison familiale et en une fraction de seconde, le vide m'envahit, se perd la mémoire, éclaire d'une immobilité définitive. Cloué dans l'espace, j'hésite à avancer" (pp. 20–21). (A few meters from my home and in a fraction of a second, emptiness took me over, memory is lost, a flash of definitive immobility. Nailed in place, I hesitate to go forward.) The return home is vertiginous, provokes anxiety, space freezes. This effect bears no resemblance to the comfort of nostalgia. Returning home is not associated with rediscovering familiar people, friends, family, but rather the sensation of recognizing that one's home has always been politically reconstructed as an authentic space of the Other, although it appears, physically, intact and authentic.

The *Ville Nouvelle*

In the French-built *ville nouvelle* (literally, "new city") the layout of the streets reproduces the French ideal of urban order. The narrator, wandering through the French city, reflects on the Cartesian shape of the French park that was: "arrangé—m'a-t-on dit—selon la phrase cartésienne, claire comme la clarté et pure comme la pureté, balancé selon la métrique de l'ordre militaire" (p. 44). (Arranged—so they told me—according to the Cartesian sen-

tence, clear as clarity and pure as purity, balanced according to the military order.) The spatial characteristics of the new city are described in relation to the colonial invasion and creation of the French city. Creation being an attribute usually associated with God, the colonizer is, ironically and with a certain amount of disdain, shown to be associated himself with a new deity: "'Il faut créer des jardins rationnels, des villes géométriques . . . il faut créer des Paradis sur terre, Dieu est mort, vive le colon.' Voici la parole du colon dessinant la ville comme une carte militaire" (p. 45). ("Rational gardens and geometric cities must be created, we must create Paradise on earth, God is dead, long live the colonizer." This is the word of the colonizer drawing the city like a military map.)

Traveling through Marrakesh, the narrator remembers entering into the Franco-Moroccan school system. In the French school, the narrator remembers bearing witness to the miraculous creation of the dichotomous world that structured his childhood imagination. In the classroom, simulating the cartographer's role in the colonial project, the geography teacher magically made the world appear with the movements and measurements of his wand: "Par un coup de baguette, jaillissaient des montagnes, habitées de mots étranges, chantants. Montagnes interrogées, soumises à quoi?" (p. 75). (With a simple waive of his wand, mountains sprung into being, inhabited by strange, singing words. Interrogated mountains, but subjected to what power?) The geography teacher has situated himself at the center of the universe he has just created: "[P]lanté au centre de l'univers, il surveillait les passages, extrêmement complexes, des fleuves et rivières, mesurait, vérifiait" (p. 75). ([P]lanted at the center of the universe, he surveyed the extremely complex passages of rivers and streams, measuring, verifying.) The colonizer, seen here through the school teacher, polices his geopolitical domain. The colonial imagination, control, and division guarantees the sovereignty of the geographer. The teaching of Moroccan geography in the Franco-Moroccan school has the effect of erasing the spatial memory of the Moroccan student. The narrator's memories of his native country are described as "un espace détatoué" (p. 75) ("un-tattooed space"). He reimagines this space as a product of a ruptured history: "Oui, arrière aux plaines, aux plateaux, arrière au désert où la mort même perdait la mémoire, place au royaume de la géographie" (p. 75). (Yes, behind in the fields, in the plateaus, in the desert where death itself lost its memory, place in the kingdom of geography.)

The question of colonial historiography is raised through the memories of the history class in the French school. The narrator's history was silenced. Mirroring a larger social phenomenon experienced by colonized populations, the student in this narrative feels the dominant European culture becoming "the inside" in relation to an "exterior," nameless Moroccan his-

tory: "Cela ne changeait rien à notre culpabilité, on se sentait des enfant conçus en dehors des livres, dans un imaginaire anonyme" (p. 58). (That changes nothing of our guilt, we felt like children conceived outside books, in an anonymous imaginary.) Entrance into the French school creates a separation between French culture and Moroccan culture, dichotomized because the latter was rendered nonexistent. As if interiorizing the French perspective, the narrator seemingly and momentarily comes to appreciate the effects of his French education. This education was not religious, although it was imposed. But it was imposed on his religious culture, a culture he has already rejected as oppressive. Indeed, because of his French education, he became trilingual: "A l'école, un enseignement laïc, imposé à ma religion; je devins triglotte, lisant le français sans le parler, jouant avec quelques bribes de l'arabe écrit, et parlant le dialecte comme quotidien" (p. 54). (In school, I received a lay instruction, imposed on my religion; I became trilingual, reading French without speaking it, playing with a few fragments of written Arabic, and speaking dialect on a daily basis.)

Khatibi's writing is deeply shaped by the effect of the colonial language on the maternal language and its "unnaming" of his childhood experience. As if to contradict his previous sentence, the experience is negative, neutralizing the oral and lived history. The price of this "civilizing" education was the effective obliteration of symbolic access to his childhood and past: "Mon enfance, ma vrai enfance, je ne pourrai jamais la raconter" (p. 59). (My childhood, my true childhood, I will never be able to tell it.) The interiorization of linguistic discipline grafts the history of the French language—the normalization of the French language by the French Academy during the seventeenth century—onto the body of the colonial subject: "Chacun est le flic de ses mots, ainsi tourne la culture" (p. 58). (Each person polices his words, and so culture evolves.) French is learned in fear, fear of making a mistake, and for this reason the Moroccan students of Franco-Moroccan colonial schools speak and write French flawlessly: "[L]a main s'habituant, par peur, à courir dans le désordre. Comme inceste miroitant, cette peur devant l'écriture, peur d'être dévoré par elle" (p. 55). (Out of fear, the hand got used to running amidst the chaos. Like a shimmering incest, this fear of writing, fear of being devoured by it.)

Producing an effect of multiple reflections, the narrator's reading of French literature conjures images of Moroccan landscapes. Camels, the desert, and tribal clusters are imagined with readings of classical French literature. In the student's mind, French culture reflects the silenced, erased desert landscape: "Dans les plaines arides de Corneille. . . . J'imaginais des chameliers. . . . A la fin de chaque pièce, chacun receuillait ses morts, moi je fichais 'la tribu des mots,' puis attendais" (p. 85). (In the arid plains of Cor-

neille. . . . I was imagining camels. . . . At the end of each play, everyone gathered together their dead, me I posted "the tribe of words," then waited.) In the Francophone Moroccan novel in general and in this novel in particular, space and writing are both chiasmic forms—both with relation to each other, and each with relation to Moroccan and French territories. The spaces, the *medina-ville nouvelle* and Morocco-France, are in a relationship of chiasm, the description of one always being the shadow of the other. Likewise, the relationship between the interior space of the native language and the exteriority of the French language is reversed: French is taken in as the mother tongue, and the Moroccan space is projected onto the outside. Space and writing are alternately Moroccan and French. Within a text that simulates the narrator's movement through space, there is a chiasmic doubling of literary and cultural references.

The French colonial school transforms his vision of Moroccan life, which is now irrevocably seen through a new perspectival lens. Morocco becomes a miniature of itself, a tiny bounded space. The country is made ridiculous; the Moroccan observer sees his own culture through the eyes of the Frenchman unfamiliar with Moroccan culture. The text reads: "Certes, le Maroc, dans ces textes, sous la forme d'un joyeux folklore, tuniques blanches, babouches vif écarlate. . . . Etonnés par cette image de nous-mêmes, nous gloussions, un peu honteux. . . . Car l'histoire était ce chevalier fougueux, envolé dans l'espace d'une miniature" (p. 59). (Certainly, Morocco, in these texts, in the form of a joyous folklore, white tunics, bright yellow slippers. . . . Surprised by the image of ourselves, we clucked, a bit ashamed of ourselves. . . . Because history was this ardent cavalier, disappearing into the space of a miniature.) The narrator perceives the process by which culture is reproduced and perceived as folklore by the colonial subject. In retrospect, he associates the lunch served at the French *lycée* with a crusade. The arrival of the meal at the boarding school is likened to the conquest of land: "Le plat arrivait, en croisade, dans le pays des exiles" (p. 68). (The dish arrived as a crusade in the country of exiles.) The revolutionary, decolonizing gesture of this narration is to be found in the perception of the home space and language as part of a spatial strategy. To decolonize in this novel (subtitled *Autobiographie d'un décolonisé*) is to extract oneself from the vision of a Morocco "protected" by the French.

Indeed, the narrator throws off the illusion of "protection" of Moroccan space in favor of a mixed and baroque folding of itineraries over and upon one another. In the perception of the young narrator, the colonial spatial binary—*medina-ville nouvelle*—is intertwined and confused with a sexualized difference. The space of the Occident becomes a desired woman, mimicking the colonial gesture of conquest of the Orient: "Bel Occident, déflo-

rer ta nature, sauter sur tes zones interdites et attraper les petits poissons rouges frétillant dans ta matrice" (p. 46). (Beautiful Occident, to deflower your nature, jump on your forbidden zones and catch the little red fish wriggling in your womb.) Because of this sexualized perception, not unlike the narrator of *Le pain nu*, the narrator of *La Mémoire tatouée* continually crosses over from one space to the other, seemingly seeking a final satisfaction and release from wanderlust: "Un pas de plus et tu es embarqué dans la zone interdite, le terrain sacré du conquérant" (p. 45). (One step more and you are setting off onto the forbidden land, the sacred terrain of the conqueror.) This consciousness that the world of his childhood was divided into twin and rivaling worlds leads the narrator to seek an alternative space for reflection. It is the repeated act of passage from one to the other space that leads him to the space of the nomadic consciousness, the bedouin desert.

The Tattoo

The narrator dispels the anxiety produced by spatial division through the creation of a mythic imaginary space. Seeking a space of writing outside of the written word, reliant as it is on the binaries he felt as a prison, he finds the abstract semiotics of the tattoo. The tattoo is a mythic semiotic system associated with a time and space that he only knows through reference to pre-Islamic times and the bedouin life of the desert. The movement of signs within space, the reduction of the sign to a series of points, releases the sign from its meaning while passing through a semiotic system and cultural practice originating in the pre-Islamic period. In his essay *Tatouage: écriture en points*[7] (Tattoo: A writing in points), Khatibi provides an ethnographic study of the Moroccan tattoo. He emphasizes that the script of the tattoo is a pre-Islamic form, even if it continued to be widely used as a cultural practice after the revelation of the Quran: "Le Coran est silencieux au sujet du tatouage, mais un hadît' dit explicitement: 'Maudites sont la tatoueuse et la tatouée.' Le tatouage devient aussi grave que l'usure."[8] (The Quran is silent on the subject of the tattoo, but a *hadeeth* explicitly reads: "Cursed are the one who tattoos and the tattooed." Tattoos become almost as serious a crime as repaying a debt with interest.) As in Abdelwahab Meddeb's novel *Talismano*, the rearticulation of pre-Islamic forms of writing at once returns to archaic knowledge and dislodges the modern, critical consciousness of the postcolonial writer.

Khatibi describes the pre-Islamic sign of the tattoo as a desubjectifying sign, linked to a new kind of subjectivity: "Disons-le tout de suite, le tatouage en tant que jeu graphique est à l'encontre d'une certaine métaphysique de l'être . . . le géométrisme entraîne de son côté la défiguration du

sujet. Un simple motif décoratif concourt à ruiner délicatement la dialectique sujet/objet."[9] (Let us say it right away, the tattoo as a graphic "I" is against a certain metaphysics of being . . . the geometry brings along the deformation of the subject. A simple decorative motif works towards delicately ruining the subject/object dialectic.) The critical element is located in an expression of cultural continuity that resists traditional religious identifications that the author rejects as culturally retrograde. This sign offers him a self-conception outside the spatial binaries that he experienced in both Islamic and colonial spaces. Khatibi continues: "En échangeant une écriture sacrée contre une écriture en points, on risque de détruire la hiérarchie sacrée des signes. Hiérarchie ordonnée par la logographie, qui relève d'une décision divine, d'un discours transcendental."[10] (Exchanging a sacred writing with a writing of pointillism, one risks destroying the sacred hierarchy of signs. A hierarchy organized by logography that comes from a divine decision, from a transcendental discourse.)

Throughout the novel, places are increasingly "whitened"—the negative of the blackening color of the tattoo. The creation of a nonantagonistic space in the writing of the tattoo will be the reinvention of a livable "home" in the desert as a space for writing. Khatibi's narrative traces movements from the childhood descriptions of home into the streets, into a vertiginous shift to the space of purity—mythic "whiteness" that can be compared to a revolutionary, epiphanic event. The semiotics of the abstract sign, or the decoration, refers (paradoxically, since an abstraction does not *refer*) to the tattoo. The tattoo is explored in *La Mémoire tatouée* as a pre-Islamic cultural phenomenon, a signifying mark outside the sentence, as Homi Bhabha writes.[11] The abstract mark of the tattoo is also outside Islam and outside the colonial invasion. This vibratory movement of the tattoo is the way in which memory of the home city is reimagined, hence the title *"the tattooed memory/ memoire."* The writing (*mémoire*) is associated with the pointillism of the tattoo. To liberate the individual from a troubling spatial division that shaped the narrator's childhood, the memory is articulated in terms of the tattoo—evoking both the semiotics and literary history of the tattoo.

The narrator passes through a tattoo-writing that retraces pre-Islamic poetry, a mythic return to a pre-Islamic poetic associated with nomadic desert dwelling: "Me saisit la même fascination devant toute Bédouine tatouée. Quand celle-ci ouvre la main ancestrale, j'épouse ma fixation au mythe" (p. 13). (I was enraptured by the sight of a tattooed bedouin. When she opens her ancestral hand, I wed my obsession with myth.) In the first lines of the novel there is already a reference to pre-Islamic poetics of the desert. Critics have asserted that in pre-Islamic poetry there is a relation of analogy between writing, the tattooed hand, and nomadic desert dwelling. Writing is said to

be an activity of interpreting the disappearing home, the tribal camp
disappearing with the effects of the wind on the desert sand. The traces of the
camp are likened to the tattoo. In *L'auteur et ses doubles*, Abdelfattah Kilito
explains this relationship among the desert space, the tattoo, and the poet:

> Le regard suit le tracé du campement comme il suivrait les lignes
> d'un tatouage ou les signes d'une écriture. . . . Le campement, le
> tatouage et l'écriture ne présentent pas un dessin clair et net; aussi le
> poète est-il avant tout un déchiffreur de traces effacées ou à peine
> visible. Il doit lutter contre l'oubli, contre cette "terre poudreuse."[12]
>
> (Vision follows the trace of the camp site as it would follow the lines
> of a tattoo or the signs of a writing. . . . The camp site, the tattoo,
> and writing do not present a clear and easily distinguishable design;
> also the poet is above all a decoder of erased or barely visible signs.
> He must struggle against forgetting, against this "powdery earth.")

The traces on the sand are like the tattoo, both being forms of writing that
struggle against forgetting. At the same time, the tattoo is juxtaposed with
the desert traces, the latter being ephemeral and the former being indelible.
We find these same elements of likeness and contrast in *La Mémoire tatouée*.
Khatibi's writing struggles against the disappearance or forgetting of the
dwelling, the precolonial city. It traces these almost-forgotten spaces with the
points of the pre-Islamic writing (tattoo). Khatibi writes: "Le tatouage a l'ex-
ceptionnel privilège de me preserver" (pp. 13–14). (The tattoo has the
exceptional privilege of preserving me.)

Returning to the desert and the script of the tattoo marks a mythical and
genealogical return to the poetry of the desert. The archetypal desert poet of
love is Imru' ul-Quays, who wanders through the desert mourning the lost
of his beloved Layla. The image of the bedouin poet dying of passion in the
desert is unmistakably a reference to Quays. As if writing over the traces of
Quays, Khatibi's text reads: "Je meurs de passion folle . . . dis: ma plume s'en-
vole au choc des ruines de sable, que tremble le terre!" (p. 166). (I'm dying
of mad love . . . say: my pen is disappearing from the shock of the sand ruins,
how the earth is trembling!) These reflections on the desert reveal a return to
a previous literary period that marks the genealogy of the Arabic writer.
Poetry becomes associated with nomadism, belligerent bedouin culture, and
the space of the desert. Conscious of his fantasmatic association with
bedouin culture, the narrator says of himself: "Croit-il rebondir avec les
Bédouins par-delà les siècles, vers la horde de poètes poignardés de dos, roy-
aumes et plumes de roseau d'un parchemin?" (p. 166). (Does he think of
himself as among the bedouin from centuries past, towards the hordes of
poets stabbed in the back, kingdoms and reeds of a parchment?)

Previously divided between one space and another, the narrator finds peace and clarity in the space of the desert. Through the poetics of the tattoo, the narrator achieves a new level of self-consciousness that is both clarity and loss, a blinding light that becomes a completely white visual field as if caught in a sandstorm. Contemplation of the tattoo in *La Mémoire tatouée* functions as a space of purity, the only place in which the antagonism of the alienated identity, the dialectical ontology of the colonial situation, is not operative. The semiotics of the desert, of the tattoo, marks the critical and perhaps romantic gesture of this novel's trajectory.

The desert as a mythical, romantic space refers to the lost mother, harkening back once again to Hagar, the mother of Ismaël. The playfulness of the narrative provides a new form of "protection"—this time protection *from* the West, not protection *by* the West: "Certes, Occident, je me scinde, mais mon identité est une infinité de jeux, de roses de sable, euphorbe est ma mère, oasis est ma mère, je suis protégé Occident" (p. 173). (Certainly Occident, I am divided, but my identity is an infinity of games, of desert flowers, euphoria is my mother, the oasis is my mother, I am protected Occident.)

Chapter 7

▼▼▼▼▼▼▼▼▼

The Fault Line

Mohamed Khaïr-Eddine (1941–1995) was born in Tafraout, Morocco, into a family of Berber merchants. He studied in the French *lycée* of Casablanca and discovered his passion for French poetry, notably Lautréamont and Rimbaud, at an early age. He dropped out of school and moved to France in 1965, taking jobs as a manual laborer while at the same time contributing to literary publications such as *Preuves*, *Lettres Nouvelles*, *Temps modernes*, and *Présence africaine*. He moved back to Morocco in 1979 after having published many articles, five novels, plays, and two collections of poetry. His publications include: *Agadir* (1967), *Corps négative, suivi de Histoire d'un bon Dieu* (1968), *Soleil Arachnide* (1970), *Moi l'aigre* (1970), *Le Déterreur* (1973), *Ce Maroc!* (1975), *Une odeur de mantèque* (1976), and *Une vie, un rêve, un peuple, toujours errants* (1978). In addition to these, he continued to publish many literary texts following his return to Morocco, including *Résurrection des fleurs sauvages*.

In the author's first novel, *Agadir*, the destruction of space leads to a transformation and quasi-destruction of the main character's identity and ability to write. In his last novel, *Légende et vie d'Agoun'chich*, this fragmentation gives way to a clairvoyant description of those lost spaces and disappearing practices. Both novels trace the history and effects of the imposition of the French language and culture on Moroccan spaces. As each of the literary texts in this book does in a different way, these narratives mourn the lost civilization. In the two novels *Agadir* and *Légende et vie d'Agoun'chich* (1984), the lost home is mourned and there seems to be no possibility of a return.

The present investigation concerns Khaïr-Eddine's double critique of internal conditions of political repression as well as external occupation (the protectorate) that contributed to the physical and symbolic ruin of southern Moroccan traditions. In a comparison between the novels *Agadir* and *Légende et vie d'Agoun'chich*, distinctions can be made between ways in which contact

with the West is portrayed. In *Agadir*, both the home space itself and the discursive potential for representing cultural identity undergo a radical disruption. In this novel, storytelling in any conventional way becomes impossible except in a troubled and ruptured poetic form. Neither scientific descriptions nor legendary narratives are viable ways of representing the home space. However, in *Légende et vie d'Agoun'chich*, Khaïr-Eddine finds recourse to traditional legends in order to tell his story. These novels show the pain of desiring one's culture of origin yet being definitively estranged from it. *Agadir* shows that the rupture of the earth will prevent the storytelling itself and the narrative will fuse with its object, the crumbling space of the town. For purposes of clarity I will begin with a presentation of the last novel, which portrays the problem with less pathos and more metadiscursive intervention.

Légende et vie d'Agoun'chich

Seventeen years after the publication of *Agadir*, Khaïr-Eddine's writing circles around very similar preoccupations. The relationship between Moroccan culture and the earth, the destruction of the south by foreign invasion, and the difficult project of cultural recovery all take central roles in both novels. Khaïr-Eddine's *Légende et vie d'Agoun'chich* shows how a mode foreign of cultural expression has come to replace the traditional forms in Morocco's southern regions. Unlike in *Agadir*, there is a certain critical distance vis-à-vis this modernization that allows the author to trace and represent the process of cultural obliteration more clearly.

In *Légende et vie d'Agoun'chich*, traditional forms of cultural expression (both artistic and everyday life) emerge from the human relationship to the earth. The author writes: "Cette culture ne se donnait pas comme un apprentissage au sens scolaire, mais comme un travail de patience et de méthode qui consiste à nourrir le cerveau de l'enfant de légendes symboliques tout en lui faisant connaître les beautés diverses et immédiates de la terre."[1] (This culture did not present itself as learning in the scholarly sense, but as a work of patience and method that consists of nourishing the child's mind with symbolic legends while at the same time making him aware of the diverse and immediate beauties of the earth.) Thought itself relies on the geological to form its images; thought is linked to earth masses; and thoughts are described as "lieu(x) où la géologie et la métaphysique se mêlent en de multiples images" (p. 18). (Places where geology and metaphysics combine to form a multiplicity of images.) Cultural expression is described as an effect of space. Using the example of the *souq* or the market, I will show how the space and architecture form central sources for traditional expressions of cultural practice.

The *Souq*

The *souq* has been described as the element that has structured the Arab city since the Ottoman period: "Les *souks* . . . sont, en définitive, la principale *raison d'être* de l'agglomération."[2] (The *souks* are the principal and definitive *raison d'être* of the urban hub.) This is also true in the Maghreb where the *souq* structures the space of the city and creates a zone of economic and social activity. Jacques Berque describes the spatial organization around the Maghrebi *souq*: "Certes, la fréquentation du *souq* ou, plus généralement, de plusieurs *souq-s*, détermine dans l'espace une aire et, dans la vie économique et sociale, une unite."[3] (Certainly, the visits to the *souq* or, more generally, to many *souqs*, determines the space of a zone and in the economic and social life, a unity.) This has particular resonance and importance for the rural Moroccan communities about which Khaïr-Eddine was writing. Social organization around the *souq* is operative in the contemporary period in rural Morocco, since the more dominant structures of urban architecture (ancient mosques, modern administrative edifices, and so on) do not decenter the primordial social and cultural role of the *souq*: "Quoi qu'il en soit, de nos jours encore au Maghreb, la vie rurale s'organise autour de marchés, c'est-à-dire sur un rythme hebdomadaire."[4] (Be what may, even today in the Maghreb, rural life is organized around markets, that is to say according to a weekly rhythm.)

The commercial, social, and cultural centrality created by the space of the souq was not overlooked by French military strategists during the colonial period. In his three-volume work *Lyautey et l'institution du Protectorat français au Maroc 1912–1925*, Daniel Rivet explains that control over tribal communities under the protectorate was secured by the military and administrative bases situated within the very space of the *souq*: "La tentation s'impose irrésistiblement à l'authorité coloniale de faire coïncider en un même lieu le chef-lieu administratif et le centre de gravité économique de la tribu."[5] (The temptation was irresistible to the colonial authorities to make the administrative headquarters coincide spatially with the tribe's economic center of gravity.)

Several passages of *Légende et vie d'Agoun'chich* describe how traditional ways of inhabiting the *souq* coexist, collide, and cohabitate with the modern methods of transportation. Noteworthy is this description, in the beginning of the novel, of the village of Tafraout:

> Ce que l'on éprouve de prime abord en arrivant à Tafraout, c'est un sentiment de paix que n'entame pas la morsure vive du soleil. Tout ici baigne dans une torpeur chaude et quiète, les murs et les êtres, mais le *souk*, situé dans l'enceinte des anciens abattoirs, continue de s'agiter mollement, traversé de temps en temps par un poids lourd

qui oblige les marchands de fruits et légumes installés à même le sol
à défaire les ficelles qui maintiennent tendue la bâche dont ils se ser-
vent en guise de parasol. (p. 16)

(What one notices when one first arrives in Tafraout, is a feeling of
peace that the sharp biting of the sun does not interrupt. Everything
here bathes in a hot and quiet torpor, the walls and the beings, but
the *souq*, situated in the enclosed space of the old slaughterhouses,
continues to slowly stir, crossed from time to time by a lorry that
forces the fruit and vegetable merchants set up on the ground to
untie the strings that keep tight the tarp that they use as a parasol.)

If this description appears to present a relatively harmonious coexistence of
modern and traditional practices of space, the effects of this cohabitation
upon the reproduction of cultural identity become increasingly profound and
disruptive throughout the narrative.

For instance, in Tafraout, the traditional layout of the local *souq* is
notably disrupted and in its place have been built repetitive square structures
associated with a new socioeconomic axis: Europe–Maghreb replaces the
Sub-Sahara–Maghreb axis:

L'ancienne place de Tafraout, c'est-à-dire l'ancien centre où les
camelots déballaient épices, dattes, herbes rares, produits importés
d'Afrique noire et où les maquignons vendaient boeufs, vaches
laitières, ânes et moutons, cette place n'existait plus. On y a con-
struit des boutiques qui se suivent sous des arcades identiques d'où
s'exhalent les mêmes odeurs. (p. 17)

(The old Tafraout square, that is the old center where the vendors
displayed their spices, dates, rare herbs, products imported from
black Africa and where the cattle dealers sold beef, milk cows, mules,
and sheep, that place no longer existed. They built boutiques that
were lined up in rows covered with identical awnings and from
which came the same odors.)

At this very center is felt the economic and military invasion of the French:
"Depuis la pénétration française, les souks avaient changé d'aspect. On y
avait édifié des bâtiments administratifs et des locaux commerciaux plus spa-
cieux. Insensiblement, le paysage changeait" (p. 138). (Since the French
invasion, the *souqs* have changed their appearance. They built administrative
buildings and more spacious commercial centers. Imperceptibly the land-
scape changed.) With the arrival of the French and the transformation of the
souq, the region's economic structure and the culture of everyday life are
transformed, and as we shall see later, so also will its artistic production.

Along with the modernization of the traditional space of the *souq*, the

women will begin to practice new ways of circulating within the city. Berber girls who find themselves living in a modern Europeanized town are confronted with a foreign way of inhabiting the space with regard to sexual difference: "Maintenant elles se laissent cloîtrer dans des appartements exigus ou des villas, elles ne sortent qu'accompagnées et elles ignorent tout des dangers extérieurs. Elles savent qu'elles sont dans une ville mais elles ne comprennent pas son fonctionnement" (pp. 11–12). (Now they allow themselves to be shut up in minuscule apartments or villas, they only go out with an escort, and they have no idea of the dangers awaiting them outside. They know that they are in a city but they do not understand how it works.) In this novel, the intrusion of the French and subsequent reordering of the city displace a preexisting social practice.

The description of the French soldiers' arrival is repeatedly noted both in the landscape and in mentalities: "L'intrusion des étrangers, comme tous les conquérants, bouleverserait durablement les mentalités et les paysages. . . . Ils chasseraient les plus pauvres de leurs terres pour édifier à la place des arganiers indestructibles des complexes touristiques et des villas de prestige" (p. 136). (The intrusion of foreigners, like all conquerors, considerably overturned mentalities and landscapes. . . . They chase the most poor from their land to build in place of the indestructible argan trees tourist complexes and fancy villas.) Changing the landscape of the region, notably the cutting down of the argan tree, will have direct impact on regional identity, memory, and iconography.

Legends

What is transformed through the "modernization" of physical space, the *souq*, the Berber city, and the argan tree is also the transmission of literary or legendary tales. Towns are conventionally the sources of stories, tales, and myths. For instance, the town of Tiznit had its own founding myth: "On racontait qu'elle [Tiznit] avait pour fondatrice une prostituée repentie. Elle était venue du Sahara, accompagnée d'une chienne" (p. 140). (It is said that Tiznit had a repentant prostitute as a founding figure. She came from the Sahara, accompanied by a dog), and the story continues. Describing the destruction or essential transformation of physical space, there is also the description of a story that loses its existential ground. Along with the legendary spaces, disappears a legendary world to which belongs the protagonist Agoun'chich:

> On bifferait leur liberté légendaire d'un trait de plume sur toutes les pages du grand livre de l'histoire. Il ne resterait d'eux qu'un mythe vague et fugitif impossible à reconstituer. . . . Le monde à venir

exclurait les aventuriers, les hommes d'honneur qui avaient mené
l'humanité primitive hors du labyrinthe géologique par la force et
l'intelligence. . . . Ce serait le règne des médiocres, des matérialistes
et des lâches. (p. 135)

(Their legendary freedom was crossed out in one pen-stroke on all
the pages of the big history book. The only thing that will remain of
them is a vague and fugitive myth impossible to reconstitute. . . .
The world to come will exclude adventurers, those men of honor
that led primitive man out of the geological labyrinth by their force
and intelligence. . . . That will be the reign of mediocrity, material-
ists and cowards.)

The legendary Agoun'chich's eventual decision to abandon his nomadic life
and move to Casablanca personifies a general displacement of legend as a
form of cultural expression in favor of the new commercialism and capi-
talist culture. At the end of the narrative, Agoun'chich says to himself:
"Mon monde à moi est enterré comme ma mule" (p. 159). (My world is
buried as is my mule.) As a legendary figure, Agoun'chich exists as a prod-
uct of traditional forms of cultural transmission, and this story recounts his
disappearance.

The implantation of a modern space at the heart of Arabo-Berber spaces
during the colonial repression of the southern Moroccan tribes is clearly rep-
resented in *Légende et vie d'Agoun'chich*. The novel occasionally lapses into a
theoretical metanarrative that articulates a critique of capitalist, scientific,
and Western culture and its effects on traditional practices: "Aujourd'hui le
gaz butane lui-même brûle dans les maisons. On fait sa cuisine et on s'éclaire
au gaz butane. On se veut résolument moderne, mais cette course effrénée à
la modernité est perçue comme une mode anesthésiante parce qu'elle n'a
pour but ultime que la consummation" (p. 14). (Today butane gas burns in
the houses. We cook and we light the butane gas. We want to be resolutely
modern, but this frenetic race toward modernity is perceived as an anes-
thetizing modality because all it has is consumption as its ultimate goal.) The
tension between a materialist, techno-capitalist culture and the traditions of
the rural south is explained in a theoretical metanarrative. With respect to
Moroccan intellectuals who have had contact with the West, the narrative
shows that a loss of roots must be combated with a constant revitalization of
the traditions that have been repressed. The author writes:

Ce travail de tous les instants se comprend non comme une suite
d'actes nostalgiques mais comme la recherche inlassablement recom-
mencée de soi; il faut y voir l'inventaire des richesses occultées sans
lesquelles il ne saurait être question de génie spécifique et pas de

futur où l'échange interhumain ne soit pas seulement mercantile et stérilisant, mais porteur d'espérance et générateur de confiance, de culture vraie qui se partage comme le pain et l'eau entre gens du même voyage que tout devrait rapprocher sur cette planète effervescente et solitaire. (p. 16)

(This constant work is understood not as a series of nostalgic acts but as the relentless and recommencing search for the self; one must see the inventory of hidden riches without which there would be no question of specific genius and no future where intersubjective exchange is not more than mercantile and sterilizing, but rather endowed with hope and generating confidence, of true culture that is shared like bread and water among the people on the same journey on this effervescent and solitary planet.)

This passage traces the trauma of a crumbling symbolic system. This critique of the way in which the West introduced itself at the expense of the traditions of southern Morocco also points to the importance of reaching out to these traditions. The question of a loss, of the marginalization of the self through the intrusion of Western scientific ways of thinking, practicing space, and representing is posed through the use of language itself. Again, the search to rediscover the "tribe" or origin is performed through all phases of history, including the French colonial invasion.

Agadir

Agadir portrays the effects of a natural disaster, an earthquake that actually occurred in the southern Moroccan city of Agadir on February 29, 1960, at 11:41 PM. This natural disaster effectively destroyed the city, and this earthquake and urban destruction become ways to represent a symbolic and psychological rupture brought about by colonization. The earthquake is made analogous to the protectorate, the colonial period in which legend and local customs began to crumble or loose ground as effective modes of cultural production. These natural and metaphoric earthquakes meet in the story when the main character, an inhabitant of the city, is hired to describe the damage and make plans to reconstruct it. On this occasion, the protagonist is confronted with a choice of reconstructive strategies and their corresponding discourses. He is coerced into using a scientific discourse that brings about the total collapse of the narrative as well as the character's psychological coherence. The protagonist finds that "Westernization" signifies foreign and apparently helpful plans for reorganizing the city space, but also a new symbolic system that creates a break with the past and tradition.

Colonial history, through the metaphor of the (actual) earthquake, is visible in the novel's poetics of violence, breakdown, and trauma.

Upon the narrator's arrival in Agadir, he is hired to make what I will call an "instrument-map," an official, scientific description of the city. The instrument-map is an imposed mode of representation, since the local population has never used this type of language to describe its city. Much to his disappointment, the new discourse is now locally generated; the foreign propagators of the instrument-map and the Moroccan political authorities are working in a relation of complicity. The narrator criticizes this scientific discourse, which is complicitous with a colonial and Western notion of modernization. What he mourns is the disappearance of his tradition: he witnesses the space of tradition being transformed into a tourist attraction.

What does this instrument-map look like? As any other scientific document, these descriptions employ numbers to construct verisimilitude and aim to represent a known object. In the official documentation of the earthquake, the geological team described the earthquake in this way:

> On peut dire, en résumé, que le séisme d'Agadir a été causé par un mouvement qui s'est produit vers 2 à 3 kilomètres de profondeur au sein de l'élément pré-atlasique; le mouvement à entraîné une amorce de rupture le long du fleuve sud-atlasique qui joue le rôle de charnière entre l'Atlas plissé et la fosse de subsidence de la plaine de Souss.[6]
>
> (One could say, in sum, that the earthquake of Agadir was caused by a movement that was produced about two-to-three meters below the earth's surface in the heart of the pre-Atlas element; the movement led to an explosive rupture along the south Atlas river that links the folded Atlas and the gulf of subsistence of the plain of Sousse.)

In the geological representation of the earthquake of Agadir, there is a clear distinction between the Agadir of before and the Agadir of afterwards. The photographs of the casbah and the consular building show a clear difference between construction and destruction.

Since it aims to be factual, the scientific account of the disaster does not register or communicate the trauma of cultural collapse felt in the wake of the earthquake. The geological report of the earthquake differs strikingly, if not surprisingly, from the novel's representation of the same event. The narrator is ultimately not able to be as objective as the French scientists or the Moroccan politicians that have hired him. He grapples with two opposing idioms that are in conflict throughout the novel. The "official" discourse is scientific, French, mimetic, and symmetric; the "subjective," affective lan-

guage is violent, disturbed, and unpredictable. The narrator abandons his assignment to produce an objective description, which gradually degenerates into to an "image-map"—a description defined by his own imagination, memories, and pains. Fonts change, line-spacing changes, the language is marked by his affective state. As the city crumbles, the writing mourns its lost object and the language trembles, breaks, and dissolves. Punctuation is missing or appears in ungrammatical ways. The print varies between italics, boldface, capital lettering, and so on. The irregular fonts are also one aspect of the narrative's disorder. The novel's language becomes the fault-line of Agadir as the novel-map represents the destruction of traditional spaces. The relationship between the self and the found pieces of the past becomes determinate of poetic descriptions of the absent object. The novel vividly articulates the relationship between the rupture of the earth (source of traditional imaginary and storytelling) and the symbolic rupture that followed colonial intervention. For this reason, the narrative becomes a form of symbolic disorder.

The narrator is supposed to be producing a scientific description, but the narrative continually describes the city by regressing into the past to resurrect lost spaces. Note, for example, how this description alludes to, or "spatially remembers," tribal entry into the city and the subsequent urban formation to accommodate the installation of sedentary tribes. The city is represented as circular, radiating from a center filled with plants and dotted with houses and without streets:

> DONC DES POINTS ISOLES SEPARES PAR UNE DISTANCE INVARIABLE SUR L'ENSEMBLE DU PLAN ainsi de suite UNE VILLE EN CINQ BRANCHES AYANT UN CENTRE VIDE CIRCULAIRE OU CHACUN PLANTERAIT UN ARBRE A SA CONVENANCE . . . pas comme on m'a dit une *ville disparate ou une ville-cage* UNE VILLE-ETOILE sans doute la verrait-on d'en haut EN VRAI PIERRE. (p. 123)

> (SO THE ISOLATED POINTS SEPARATED BY AN INVARI-ABLE DISTANCE THROUGHOUT THE MAP and so on A CITY WITH FIVE BRANCHES HAVING AN EMPTY CIRCU-LAR CENTER WHERE EACH PERSON WOULD PLANT A TREE TO HIS LIKING . . . not like what one told me a *dispersed city or a city-cage* A STAR-CITY without a doubt it can be seen from above IN TRUE ROCK.)

The sudden appearance of this form could be seen as a "spatial memory" of tribal genealogy inscribed in and domesticated by the Arabo-Islamic city. Abdessamad Dialmy explains that the foundation of the city aimed at unit-

ing different segments of tribal identity in the name of the religious community: "La médina arabo-islamique est en effet, dans son projet constitutif, une volonté de dépasser les divisions tribales, au nom d'une même foi islamique."[7] (The Arabo-Islamic city is, in effect, in its constitutional project, a desire to surpass tribal divisions, in the name of a singular Islamic belief.) The tribal genealogies shaped the Arabo-Islamic city according to tribal segments: "Il est possible que la tribu (y) immigre en entier, et s'y installe dans des campements, des rues et des quartiers selon les divisions internes de la tribu."[8] (It is possible that the tribe migrates there in its entirety, and settles in camps, the streets, and the neighborhoods according to the internal divisions of the tribe.) This type of urban organization, fantasmatic as it reappears in this narrative, reiterates urban history, the lost urban effects of a tribal genealogy: "La raison généalogique continua donc à s'imposer sa loi, et d'adapter l'architecture de la cité naissante à son vouloir-vivre, voire à sa volonté de puissance."[9] (Genealogical reason continued to impose its law and to adapt the architecture of the incipient city to its lifestyle, to its will to power.) However, the ability to remember is impaired and only fragments of the past can be recalled. Because of this disturbance, the image (image-map) of tribal formations ultimately disappears and another image of the past quickly takes its place. The memory of tribal organization within the city quickly disappears and the imagination continually turns to different forms of cultural memory. The reproductive tools for historic and spatial memory are not intact and the disappearance of the city and the social organizations lived through the city space provokes a recurrent disfunctionality of language.

This confusion between space and writing produces a language of trauma. Opposed to the instrument-map is the vision of the home that includes the human aspect of the transformation: memories, affect, and the imagination. The "image-map" is produced by human disturbance. The effect of loss is a confusion of writing with space, the symbolic with the physical. Note the conflation between the home and writing: "De nouveau ma demeure. Les murs sont couverts de longues taches d'encre noire" (p. 86). (Again my house. The walls are covered with long stains of black ink.) The house is the surface upon which he writes, like on a piece of paper. Note the ambiguity of the phrase "*un mot sur elle*," which means both "a word *about* it" and "a word *on* it": "Ma demeure? Un mot sur elle" (pp. 133–34). (My house? A word on/about it.) The entire novel acts as an obsessive description of Agadir, both as it is, destroyed, and as it was before. However, unlike the scientific descriptions, the chronology is confused. The text functions as a simulacrum of the crumbled home space, an affective map that confuses the past, present, and future. The narrative searches to rediscover the lost home.

Every part of the narrative is another description of home: "Le théâtre qui se déroulera sous vos yeux aura pour cadre ma demeure."[10] (The theater that will unfold before your eyes will have my home as its stage.) On the next page is the stage description, which is logically a description of the narrator's home: "*Une chambre à coucher aux murs lézardés, couverts de dessins à la plume. Un lit défait. Une table. Une chaise de fer verte. Une malle. Sur la malle une pile de livres et de revues. La chambre est insuffisamment éclairée*" (p. 50). (*A bedroom with cracked walls, covered with pen drawings. An unmade bed. A table. A green iron chair. A suitcase. On the suitcase a pile of books and journals. The room is not well lit.*) The next act of the play (within the narrative prose) commences with the following stage description: "*Réapparaît ma maison, au milieu de cendres tièdes, de journaux attaqués par des cercles de flammes. Chez moi. Je suis chez moi*" (p. 64). (*My house reappears, amid warm ashes, newspapers attacked by a circle of flames.* Home. I am home.) Destruction of the home is consistently repeated in the description and is often followed by the home's imaginary reappearance.

Other destroyed objects are also mourned, forgotten, and remembered by the narrator. In *Agadir*, the argan tree is connected to the cultural identity and legends of the region. The argan tree is a rare timber tree whose oil has medicinal qualities and is found only in the Moroccan south. The tree, an important legendary object, is noted as forgotten in the following passage:

> [D]es ruines antiques n'ont absolument rien à voir avec ma maison perdue. . . . Ma maison était sur une pente, à quinze mètres au-dessus de la plage. Au pied d'un grand arbre immémorial dont j'ignore le nom, peu importe son nom! Cette sorte d'arbre est prédominante dans la région, et particulièrement sur la côte. Ma maison est indescriptible. On l'a abolie. (p. 127)
>
> ([A]ncient ruins have absolutely nothing to do with my lost house. . . . My house was on a slope, fifteen meters above the shoreline. At the foot of a large age-old tree whose name I have now forgotten, no matter its name! This type of tree is predominant in the region, and particularly on the coast. My house is indescribable. They eliminated it.)

The age-old tree whose name has been forgotten is undoubtably the argan tree, the legendary tree of the Agadir region. But because "they have destroyed his house" he seems to have lost his ability to remember the name of this tree, and consequently because he cannot remember the name of this tree, he cannot properly reconstruct his house. It is this tree that marks the specificity, identity, and memory of the narrator's home.

A Suspect Political Authority

The mistrust of official representation extends to discourses used by the authorities. Journalistic writing is part of this discourse of knowledge and is rejected in the novel: "Décrire ça à la manière des reportages journalistiques? Ce serait trahir le séisme" (p. 66). (Describe that in the manner of the newspaper reports? That would be to betray the earthquake.) The narrator parodies newspaper articles and subverts their authority as instruments of Moroccan royal authority. We can compare a newspaper article from the daily *L'Opinion* of October 18, 1997 and a journalistic passage from the novel. *L'Opinion* prints:

> Le cabinet Royal a rendu public, jeudi, un communiqué dont voici la traduction: "S.M. le Roi Hassan II, que Dieu le préserve, a bien voulu ordonner une grâce totale au profit des personnes traduites devant les tribunaux du Royaume pour des affaires de contrebande. Cette mesure concerne les personnes en détention et celles en état de liberté. Puisse Dieu préserver S.M. le Roi, garant de l'intégrité de la nation et source de magnanimité et de clémence, et le combler en la personne de SAR le Prince Héritier Sidi Mohammed, de SAR le Prince Moulay Rachid et de l'ensemble des membres de l'illustre famille Royale. Dieu exauce les voeux de ceux qui l'implorent." (MAP)[11]

> (The Royal Cabinet made public, Thursday, a communiqué whose translation we will now print: "His Majesty the King Hassan II, may God preserve him, decided to proclaim a total immunity upon persons brought before the courts of the Kingdom for reasons of contraband. This measure concerns individuals in detention and those in freedom. May God preserve His Majesty the King, guarantor of the integrity of the nation and source of magnanimity and of clemency, and to bestow upon the Heir Prince Mohamed and Prince Moulay Rachid and the totality of the illustrious Royal family. God grants the wishes of those who implore Him.")

The narrator reproduces this royal journalistic representation in *Agadir* and renders it burlesque. In the novel, the city's loudspeaker blasts:

> Que notre Monarque Soit Glorifié au su et à l'insu de toute étoile. Que Le Tout-Puissant l'Enrichisse davantage. Que les esprits du mauvais sang n'accrochent point Son Ame. Il Nous promet la fortune et le Paradis. La jouissance éphémère et la durée tranquille du sel marin. Il Nous lie au Ciel par le Cordon Ombilical et la Force de Ses Prières. Que Son Excellence Le Général Main-Droite de sa Majesté soit guéri de ses troubles hémorroïdaires. Priez pour Lui.

Priez pour qu'Il révise le cas des condamnés politiques. Pour qu'Il amnistie nos frères rebelles. Pour que l'Economie Nationale s'équilibre. Llah Akbar. (pp. 78–79)

(May our Monarch Be Glorified to the knowledge and ignorance of each star. May the All-Powerful Make him even more rich. May the spirits of bad-blood not trap His Soul. He promises us fortune and paradise. Ephemeral pleasure and the tranquil duration of sea salt. He ties us to the Sky by the Umbilical Cord and the Force of His Prayers. May His Excellency The General Right-Hand of his Majesty be healed from his hemeroidal troubles. Pray for Him. Pray that he revise the case of the political prisoners. May he grant amnesty to our rebellious brothers. May the National Economy be balanced. God Is Great.)

This parody of the official royal discourse ridicules the present state of political and linguistic representation. The king, leader of the faithful, is ridiculed in this passage through reference to his body parts and bodily functions and the call to prayer for his digestive problems. The passage makes a mockery of his role as leader of the faithful and alludes to Hassan II's repression of political dissidents and artists. Mention is made of the country's unequal distribution of wealth, which lies overwhelmingly in the hands of the king. This type of direct critical commentary on official royal discourses is perhaps one of the primary reasons the book is banned in Morocco. This is a critique of internal political hegemony. The official discourses associated with authority are deeply mistrusted: "Mais je sais que les cartes mentent" (p. 31). (But I know that maps lie.) Within the space of power from which emerges the instrument-map, untruth is measured by one's complicity with authority: "Je dois avouer que je ne cherche pas la vérité. J'ai reçu des ordres à cet effet. Ce qui compte: Aboutir à des conclusions qui se tiennent. Peu importe leur véracité" (p. 49). (I must admit that I do not look for truth. I got my orders to that effect. What counts: Come to conclusions that hold up. Veracity is of little importance.) This commentary on the relationship between political control and writing demonstrates how points of political control can relativize truth according to undivulged agendas and exigencies of coherence.

The narrator states that the most important part of the city is the the medina, or old city, that was completely destroyed by the earthquake, "des rues sombres puantes où court l'eau des fontaines publiques, et ces bâtisses malodorantes crevées de fenêtres d'où pendent le linge à moitié lavé et des morceaux de viande sèche; c'est le côté le plus significatif de la ville" (p. 20) (dark and stinking streets where water flows from public fountains, and these bad-smelling buildings with broken windows where hangs half-washed laundry and pieces of dried meat; it's the most meaningful part of the city). This

"most meaningful part of the city," the *medina*, is precisely the locus of the earthly rupture. In the following sentences the streets of the *medina* form a semiotic space, not easily decoded: "Je suis né dans un de ces trous fangeux, parmi l'odeur du poulet égorgé et le miaulement opiniâtre des chats. Ma ville n'est pas un entassement vulgaire. Il m'a fallu dix ans pour la connaître rue par rue, square par square" (p. 20). (I was born in one of these muddy holes, amidst the odor of slaughtered chicken and the opinionated meowing of cats. My city is not a vulgar heap. It took me ten years to know it street by street, square by square.) The loss of this area, the narrator's neighborhood, excludes the possibility of representing it according to scientific modes of representation.

The destruction of the city is linked to cultural identity, and the narrator consistently contemplates this loss: "*Cette presque-ville explose en moi et pour-quoi je m'y accroche en rêvant nuitamment*" (p. 21). (*This almost-city explodes in me and why do I cling to it dreaming about it nightly.*) The self accumulates, crumbles, and metamorphoses and the past, present, and future blend into one another: "*Me morfonds, me morfonds et, cicatrice par cicatrice, ramasse mon temps de vrai rainette*" (p. 21). (*I'm bored, I'm bored and, scar by scar, gather my froggy-time.*) The material loss and symbolic recovery of the home is an identificatory process that both produces and problematizes writing, since the object no longer exists. The disappearance of the referent produces a state of psychological instability:

> Je me dis J'existe mais rien autour de moi ne me le rappelle. Autrefois je découvrais mon existence sur les murs de ma maison, ses fenêtres d'où je voyais la mer. . . . C'étaient donc les murs, les fenêtres, les portes, les meubles et les carreaux de ma maison qui me rappelaient mon existence. (p. 130)
>
> (I tell myself that I exist but nothing around me reminds me of it. Before I discovered my existence on the walls of my house, its windows from where I looked at the sea. . . . It was the walls then, the windows, the doors, the buildings, and the stones of my building that reminded me of my existence.)

The link between the home and the ability to produce meaning and identity are continually recalled through their loss: "[V]ous savez ce que signifie pour moi cette maison. . . . Si vous la retrouvez, je redeviendrai normal. Je m'en sortirai. Sinon tant pis pour nous deux" (p. 131). ([Y]ou know what that house means to me. . . . If you find it, I would become normal again. I would come out of it. If not, too bad for the both of us.) The absence of the home has affective repercussions on the writing subject—he no longer knows if he exists. The absence of the city produces physical difficulties and the question

of survival is raised: "Ma maison n'existe plus. Moi même je n'existe presque plus" (p. 130). (My house doesn't exist any more. I myself, I almost don't exist anymore.)

This identification with the home-space and its destruction is not exclusively individual, but rather is a collective experience. The collective is seen in the language itself, always beyond the individual. The identification (self/space) is evident by the heterogeneity of the novel's fonts, discourses, and genres. The absence of legendary information about the city is due to the disappearance of the terrain upon which cultural identity and history are produced. Discursive heterogeneity in this case is a symptom of the impossibility of constructing any sort of knowledge.

In both of the novels examined here there is a clear discomfort with, and at times pathological reaction to, the interruption of the traditional practices of Morocco. In *Légende et vie d'Agoun'chich*, we see the disappearance of local customs and traditional modes of storytelling. In his novel *Agadir*, the critique of external impositions of modernism and scientificity while at the same time the mourning of the native culture is expressed through the French. Fragments of official discourses (both Moroccan and Western) are reproduced and shown to be repressive within a narrative of trauma and loss of the home city. For this critical reason, Mohamed Khaïr-Eddine's writings, although "Francophone," cannot be easily assimilated into the French literary traditions that remain in a hegemonic relation to Maghrebi cultural production.

▼▼▼▼▼▼▼▼▼

Conclusion

This book began with a modern musing on an ancient tale by Jahiz. A paradoxical riddle about a bedouin lost in the desert who found his tribe by turning into a dog and barking. I suggested that this riddle illustrates the linguistic condition of the North African avant-garde writer, writing in a new idiom that allows him or her to represent the events of history. These new idioms create a new space outside a double hegemony, both internal and external. The avant-garde writer resists two, equally backward-looking cultural postures: on the one hand, the sallafist posture that chooses a return to Islamic and precolonial cultural identity; and on the other—an equally reactionary posture taken up by North African intellectuals—is the choice of blind return to the colonial period as if this were the golden age of national civilization, rejecting Arabo-Islamic culture as wholesale fundamentalism. Both of these positions—both surprisingly widespread in North African intellectual production—imply a failure to engage all the elements of the predicament of the present. In different ways, each of the writers treated in this book is an avant-gardist, writing in his or her own language (Arabic) inflected by foreign language, or in a foreign language (French) as if it were the mother tongue. Each writer grapples with the inevitable and difficult interface in North African culture of the traditional practices and an ever-more-powerful Western influence.

Each author does this in a very different way, and there is no set formula that I have used in order to define what the Arab avant-gardist does. Ramses Younan uses the language of the French avant-garde to create new creative paths in an Egypt that is culturally and politically opposed to the West. Younan attempts to forge ahead to diversify, instead of homogenizing, national culture. His "internationalist" cultural politics were not in conflict with his clearly articulated nationalism and opposition to foreign rule in Egypt.

The films of Moncef Dhouib provide a particularly vivid illustration of the artistic avant-garde of North Africa. Using the visual image itself, his films critique the Tunisian government's internal and political use of Western

hegemony. On the one hand, the images in these films confront the Western-style "commodity-image" that has been deployed in Tunisian society for political purposes. What Dhouib produces is not specifically a critique of "the West" but rather a vision of how North African societies internalize modern orientalist images of themselves, much to the detriment of the local culture and identity. On the other hand, the images work to recover the repressed or lost culture, in this case Soufism and popular Islam, by challenging the radical and orthodox religious tendencies that contributed to its marginalization. Indirectly, the internalization of Western dominance over the region is linked to religious orthodoxy both tendencies having distorting effects. The filmmaker has sought to reframe and "cleanse" the image of the North African.

Assia Djebar was considered as being unconventional as early as 1957 with her precocious publication of *La soif* at the age of twenty. This graceful novel of a Western-style, bourgeois Algerian girl was viewed as an outrage, since it made no reference to the outbreak of the independence struggle. It was defiant in not conforming to the literary conventions of political *engagement* of the 1950s; I consider it a precursor to post-1968 penetration of the personal narrative into the public realm of political writing. Her novel *Vaste est la prison* is also experimental, combining the collective experience of being inscribed into French history with the personal intimacy of a failed love affair. Djebar's intellectual project in this novel is rooted in the search for the origins of Algerian identity, both historiographic and personal. In her novel she traces the origins of the Berber language and history through the historiography of the European explorers. She uses their language and texts in an inquiry into the roots of Berber identity, thereby displacing the Arabic linguistic hegemony that exists in Algeria while simultaneously, and implicitly, objecting to Western invasion.

Abdelwahab Meddeb's inventive language deploys the French and the Arabic seemingly simultaneously, a sort of Franco-Arabic idiom that constantly points to the violences of the French colonization of North Africa, Tunisian secular dictatorship, and the violence inherent in the cultural return to pure Islam. He is critical of the violence of these opposing hegemonic cultural practices, while constantly recognizing and exploiting the riches of each tradition. His prose produces a strange perspectival effect. There is an uncanny indistinguishability in his concepts, and the reader is left wondering if the ancient and the ultra-contemporary are not one and the same, or at least not widely similar. His prose, seemingly so impenetrable, communicates the experience of the Maghrebi who is educated in both the Islamic and French traditions.

Mohamed Choukri, the subversive Arabic novelist, is clearly avant-garde

both within the Arabic literary canon and when viewed alongside Franco-phone Maghrebi fiction. His cultural references are constantly traveling outside in a movement of diasporic thought, thus deterritorializing the Arabic language. Arabic is meant to create meaning in a horizontal and organically organized way. His combination, within the context of an Arabic novel, of "pulp fiction" and Christian confessional narratives dramatically undermines the conservatism of the genre's conventions. More powerfully—or shockingly for the Arabic readership—in this novel written in the sacred language of the Holy Quran is the multiplicity of moral registers that ruptures the theologic order that assimilates Arabic prose with the sacred text of Islam.

Also seeming to reorganize the Islamic space, Abdelkebir Khatibi creates a new poetic form by returning to the pre-Islamic sign of the tattoo. He combines this sign with the "pastiche" effect of cutting Derrida's language into his. The combination of the archaic and modern form the critical language of the novel. Mohamed Khaïr-Eddine, like Mohamed Choukri, remains minoritarian within Morocco. Their doubly marginalized Berber identity (and language) means that not only is French a foreign language, but to a certain degree so is Moroccan Arabic. Khaïr-Eddine, although he writes in French, produces a language of trauma after the destruction of his native mode of storytelling. His language performs a "post-trauma disorder" at the arrival and invasion of the French and the disruption of tribal communities. His direct contestations of the king's political authority and his prose style of mixing the literary genres of theater, the novel, political essay, and poetry have given him the reputation of being one of the great experimental novelists of contemporary Morocco.

What many of these authors describe as the "intrusion of modernity" into their traditions requires a response through reinvention, not a forgetting of the cultural effects brought about by historical conflict and struggle. Writing in the wake of colonialism implies a *translation* of the physical and discursive presence of colonialism. During the period in which these writers were working—after the departure of formal colonial structures and administrations—what was called for was a reinterpretation of Berber and Arabo-Islamic cultures. Recourse to a precolonial past, linguistic origin, or unchanged tradition is a mythification that emerged as a response to cultural marginalization. Michel Gilsenan has made pertinent claims about the notion of origin and tradition: "Tradition, therefore, is put together in all manner of different ways in contemporary conditions of crisis . . . it becomes a language, a weapon against internal and external enemies, a refuge, an evasion, or part of the entitlement to domination and authority over others."[1] A refusal to include a dialogue with foreign idioms in this modern period is

a form of reaction, of isolation. As Gilsenan writes, this reaction in a period of crisis "becomes a language . . . a weapon" that continues to oppose civilizations. What these and other writers seek through their fiction and critical essays is rather a way to create new, nonoppositional meanings of their identities.

All of these texts, in my interpretation, are deeply committed to criticizing and reforming Arabo-Islamic identity. However, they do so in an experimental literary discourse of multicultural belonging. They signal the creation of a new language that recognizes history and pushes it in a new direction. This new direction is distinct from the common posture of intercultural resentment and misunderstanding. This is what I find so captivating about this literature: it exposes the historical and political experience of violence between France and North Africa through the medium of human affectivity and artistic expression. Responding to the current need to reexamine their culture and societies, they sketch out a new future through the pathos and memories of artistic and affective human creativity.

Appendix: Plot Summaries of Films by Moncef Dhouib

Al-Hadra (The trance, 1990; 21 minutes)

This film, like the other two shorts, is set in late-nineteenth-century Tunisia. It begins with a scene on the day of the couple's wedding. Several well-dressed bourgeois women are seated around the naked bride, commenting on her stunning beauty. Two servant women are preparing to apply her *harqoos* (a clove-based skin dye used in Tunisia to paint designs on the skin of brides). One servant woman is asking the other where to put it. One of the bourgeois women suggests putting it behind her ear. They all finally decide to hide the *harqoos* behind her ear. This same night, the bridegroom is blindfolded and tries to find the *harqoos* by virtue of its strong perfumed scent. He presumably never manages to find it. It seems that their problems originate in his failure to find the harqoos.

In order to cure this malediction, the husband goes with his bride to a *zaouia* organized around the tomb of Saida Manoubia. Saida Manoubia is believed to cure sicknesses, end curses against a happy marriage, or to enhance beauty, sexual strength, or fertility. As they are stepping out of their carriage to enter the sanctuary, the husband says to his mother that he does not believe any of this superstitious saint worship. The *zaouia* is animated and the visitors are performing several rituals in honor of the saint. Men are dancing and playing music praising God. Incense is burning. Women are praising the purity and beauty of the virgin saint who, divinely beautiful, she stays like an angel in heaven. The women proceed to a room where the musicians are preparing to play music.

Off in a quiet room, the man is advised by the sheikh to contemplate God and focus on his own heart that is a temple of love. We learn that it seems to be the man's inability to love that is cursing the marriage. He instructs the man to take some oil from the candle burning above the virgin saint's tomb and gives him the key to the sanctuary.

The husband ventures into the room where the saint's tomb is kept and looks into the coffin. The coffin is empty and at the moment he sees this, the room's door is sealed off by a cement wall. He is trapped in the room for the duration of the trance ceremony. Meanwhile, the bride has been adorned again with *harqoos* and the music begins. The men are playing music and several women begin to dance, swinging their heads and hair around in time with the drums and falling into trance-like states.

After having been trapped, the husband is finally released and tells the sheikh that there is no saint and that his words were a sham. The sheikh follows the husband back into the room where the tomb is and when the husband opens the casket to show him that the tomb is empty, we see that his bride—beautiful, adorned in golden clothing and jewels—is lying motionless within the depths of the tomb, dead, with her glowing eyes wide open. At the moment when the casket is opened, the sheikh says, "Now that your heart knows disquiet, you can know love." The last shot, as the credits are rolling, is of the man in despair riding back to his home on a horse-driven carriage.

Tourba (The cemetery, 1995; 26 minutes)

The film opens with a man ("the disciple") on horseback who enters through an arched door entering into the courtyard of a house. He is lead in to see the mistress of the household. He tells her that it is strange that she doesn't recognize him, since he is the one who brought her late husband's body back. She seems indifferent and mumbles in a somewhat listless manner, "Allahyir'hamou." He wants to thank their daughter. "For what?" she asks. "For having saved my life," explains the apprentice. "Which daughter, one of those?" indicating two young women peering into the room from the courtyard through a small, iron-wrought window. "No," he replies. "The other one is not here," says the mother. He replies, "But I saw her yesterday, she gave me water and saved my life. The proof is that I have her scarf that she gave me in the cemetery." The mother examines the scarf and smells it, as if she recognizes the scent of her daughter. He looks at the portraits on the wall and identifies the girl in the painting as the one who saved his life. "But she's been dead for twenty years," says the mother.

The opening credits follow.

The apprentice is walking up a hill with this horse carrying a casket and explains to a passing stranger that it's his master, the sheikh who died abroad and wished to be buried in his country. (This scene is shot at Dougga, the ancient Punic, then, Roman site.)

In a bourgeois household, music lessons are being given to young

women, presumably the sisters. The casket arrives in the courtyard and there is a long scream. We understand that the father's casket has just been brought into the courtyard. The Quran is recited and all the members of the household cry bitter and hot tears, except one of his daughters. They criticize her for not mourning the death of her beloved father. The mourning continues and people arrive at the house to offer their condolences. The mother curses her. "Your heart is hard," she tells her daughter. She asks herself why she can't cry. The servant women say that the mourners are actually crying for their own miseries. The apprentice goes to the sheikh of the brotherhood and gives him a list of his master's expenditures at the perfume shop.

All the women of the house go to the cemetery at night to mourn the dead man. The daughter is still there in the morning and the man comes and asks her if she witnessed the burial. She nods, and he says "Shame—women are not allowed." She confesses that she loved him so much. He replies that if she wishes to resuscitate a loved one, she has to cry. She must cry by filling seven flasks with her tears. After one year, the seven flasks filled with tears will bring the loved one back.

The brothers of the deceased's brotherhood are reading his writings. He had written, "I deny everything I have written, ask God to forgive me, and wish only to die as a Muslim and to be buried among Muslims."

The daughter prays to God to bring her father back and begins to spend all her time crying for her dead father over his tomb and funneling her tears into the flasks. The keeps the delicate glass bottles in an ornate jewelry box and begins to cherish them. The other women of the household recommence their normal, happy lives once the forty days of mourning are over. The men start to give away the household and inheritance to the great-uncle. All are now concerned with material matters. The daughter is in deep mourning and continues to cry into her glass bottles and to pray.

One night when she is crying in the cemetery a man arrives, almost dead. She recognizes the apprentice and is worried that he will die. He gasps for breath and says he will die if he doesn't drink. She runs to her box of tear-filled flasks. She pours one, two, then all of their contents into the dying man's mouth.

In the next scene the apprentice is seen riding out on his horse through the arched door of the house.

Hammam D'hab (The golden bath, 1985; 25 minutes)

The film opens with recitation of a *daoua'a* while an image of the moon and then towels hanging out to dry and a view of the rooftops on the medina are shown. The image is mystical, the text invoking God and using

imagery found in the Quran, but not religious in the strict sense; the text is not the Quran and the images are of everyday scenes.

Three women are walking through the streets of the medina with a young girl. As they walk by, a pair of eyes stares out at their feet from a basement window. The man scoops up some sawdust and starts feeding the fire that will heat the walls and water of the Turkish bath (*hammam*). A man who works as a barber across the street hears his caged bird chirping, indicating to him that his beloved is passing by to enter into the *hammam*. Indeed, the woman passes by and she stops before the *hammam* door and glances back at him.

An older woman arrives with her son and tries to disguise him as a girl. He pulls the scarf off his head. The woman who tends the door of the *hammam* is middle-aged, stony-faced, and wears too much makeup. She is staring vacantly at a burning candle. The women undress and prepare for entry into the *hammam*. The beloved is offered some gum and chews it in a dreamy fashion, thinking of her beloved that she has just seen. Some women walk back and forth over some incense and talk about wanting to get pregnant. One bride puts on a body tattoo (*harqoos*) and talks about her fiancé. The beloved takes out the gum she's chewing and puts it into a small silver box. A rich woman is in a private, carpet-lined chamber. Her servant, pronouncing "*T'bar'kallah, mashallah*" and other such religious formula, removes the woman's gold bracelets and wraps them in a cloth. Another servant brings the beloved's silver box out to the street and passes it to her beloved, who acts pleased, tossing it into the air and gleefully catching it. The old-maid doorkeeper fondles a large pair of black-iron scissors that she keeps in her drawer under the counter.

Inside the *hammam*, the women tell stories and the furnace-keeper listens from below through the furnace opening. A woman tells a story of a widow who has a beautiful daughter. The daughter was very fair with long black locks, whose color faded into the night. One day a stranger came and said there was a treasure belonging to a red devil hidden beneath their feet. If they gave him a lock of her silky black hair, the treasure would be theirs.

In the *hammam* the heat becomes too intense and the women pass into a cooler room for washing, *henna*, and massages. There is a close-up of the young boy's face, suggesting that he is perhaps the narrator of the story.

The woman continues her story, talking directly to the bride this time. "The stranger said that the treasure would be theirs if they gave him a lock of the maiden's hair. They gave it to him and he burned some incense, slaughtered a goat, and lit a candle. He warns them that they should only take the money during the time that the candle is burning. The earth opens up and gold and money flow out from the abyss. The girl and her greedy

mother take them with undying thirst and pay no attention to the candle that had burnt out. The girl was getting short of breath and wished to come out. Her mother was greedy and wanted more gold and money. Soon the girl was swallowed up by the earth and suffocated by its engulfing mass." This is the end of the tale.

The boy's mother says that she is tired and asks the beloved to go wash her son. The beloved goes in a small washroom to wash the boy. He says he's afraid because of the story that the old woman was telling. She tells him not to be afraid, baths do not swallow-up people. The furnace-keeper gets some wood-chips to feed the fire and finds a big lock of black hair. He throws it into the fire. The small boy is chased out of the *hammam* because all the women are yelling that he is too old to be there. The beloved falls asleep in the small wash chamber. All the women exit the *hammam* and the furnace is put out. The bathing time is over and the beloved remains sleeping there.

Shot of the moon over the city.

Then there is a dream sequence, presumably the dream of the sleeping beloved. She is in a room full of candles. She is holding one and hears a scream. She hurries to see who is screaming. In a dark, wet room a hand is waving from under the water. The beloved undresses and goes into the water. Then a shot of a stone floor with black hair quickly growing out between the bricks. The old-maid door-keeper gets the scissors from her drawer. The candle she is looking at is finished burning. She cuts the hair from the floor.

▼▼▼▼▼▼▼▼▼▼

Notes

Introduction

1. Abdelfattah Kilito, "Les mots canins," in *Du Bilinguisme* (Paris: Denoël, 1985), 205.

2. Ibid., 206.

3. Ibid.

4. Ibid.

5. Ibid.

6. Ibid., 208.

7. Ibid.

8. Gilles Deleuze and Félix Guattari, *Kafka: Pour une littérature mineure* (Paris: Minuit, 1975), 40.

9. Ibid., 65.

10. Homi Bhabha, *The Location of Culture* (London: Routledge, 1994), 164–65.

11. Abdul R. JanMohamed and David Lloyd, "Toward a Theory of Minority Discourse: What Is to Be Done?" in *The Nature and Context of Minority Discourse*, ed. A. R. JanMohamed and D. Lloyd (New York: Oxford University Press, 1990), 15–16.

12. Arif Dirlik, "Culturalism as Hegemonic Ideology and Liberating Practice," in *The Nature and Context of Minority Discourse*, ed. A. R. JanMohamed and D. Lloyd (New York: Oxford University Press, 1990), 414.

13. With the exception of Kateb Yacine's avant-garde novel *Nedjma* (1956), which was published contemporaneously with the work of Ramses Younan. *Nedjma* is perhaps unjustly excluded from this book since it was one of the earliest and most experimental novels of North Africa.

Chapter 1

1. Abdelwahab Meddeb, "La dissparition," *Cahiers Intersignes* (1992): 156.

2. Abdelwahab Meddeb, "Abdelwahab Meddeb par lui-même," *Cahiers d'études maghrébines* (1989): 13.

3. Abdelwahab Meddeb, "L'urgence de la modernité," *Parcours maghrébins* (1987): 16.

4. Meddeb, "La dissparition," 150.

5. Ibid., 148.

6. Ibid., 152.

7. Abdelwahab Meddeb, "Entretien avec Abdelwahab Meddeb," *Prétexte* (1996): 37.

8. Beïda Chikhi, *Maghreb en textes: Ecriture, histoire, saviors, et symboliques* (Paris: Harmattan, 1996), 59.

9. Ibid.

10. Gilles Deleuze and Félix Guattari, *Kafka: Pour une littérature mineure* (Paris: Minuit, 1975), 29.

11. Abdelwahab Meddeb, *Talismano* (Paris: Sindbad, 1987). Other quotations from *Talismano* are from this edition; page references will be given in parentheses in the text.

12. Gilles Deleuze and Félix Guattari, *Mille Plateaux* (Paris: Minuit, 1980), 18.

13. Michel Foucault, "Nietzsche, la généalogie, l'histoire," in *Hommage à Jean Hyppolite* (Paris: Presses Universitaires de France, 1971), 149.

14. Ibid., 148–49.

15. Deleuze and Guattari, *Mille Plateaux*, 11.

16. Ibid., 16.

17. Ibid., 13.

18. Foucault, "Nietzsche, la généalogie, l'histoire," 146.

19. Ibid., 145.

20. Abdelkebir Khatibi, "Bilinguisme et littérature," in *Maghréb pluriel* (Paris: Denoël, 1983), 187.

21. Foucault, "Nietzsche, la généalogie, l'histoire," 154.

22. Ibid., 153.

23. Michel de Certeau, *La culture au pluriel* (Paris: Seuil, 1993), 214.

24. Roland Barthes, *Le degré zéro de l'écriture* (Paris: Seuil, 1972), 13.

25. Abdelwahab Meddeb, "Abdelwahab Meddeb, le chantre de l'entre-deux cultures," *Lamalif* (Rabat) (1979): 50.

26. Barthes, *Le degré zéro de l'écriture*, 13.

27. Friedrich Nietzsche, *Le gai savoir* (Paris: Robert Laffont, 1993), 29.

28. Khatibi, "Pensée-autre," in *Maghréb pluriel*, 17–18.

29. Ibid.

30. Abdelkebir Khatibi, "Incipits," in *Du Bilinguisme* (Paris: Denoël, 1985), 193.

31. Meddeb, "L'urgence de la modernité," 16.

32. Abdelwahab Meddeb, "Voiles," *Cahiers Intersignes* (1991): 140–41.

33. Meddeb, "Abdelwahab Meddeb, le chantre de l'entre-deux cultures," 49.

34. Ibid.

35. Deleuze and Guattari, *Mille Plateaux*, 30.

Chapter 2

1. Wadi Bouzar, "Espaces de pause, espaces de mouvance, espace de souvenance," in *Maghreb/Machrek: Espaces et sociétés du monde arabe* (Paris: La Documentation française, 1989), 42–43.

2. "Being and Place," interview with Mohamed Choukri in *The View from Within: Writers and Critics on Contemporary Arabic Literature*, ed. F. J. Ghazoul and B. Harlow (Cairo: American University of Cairo Press, 1994), 222.

3. Ibid.

4. Ahmed Boukous, "La situation linguistique au Maroc," *Europe* (1979).

5. Mohamed Choukri, *Le pain nu*, translated by Tahar Ben Jelloun (Paris: Maspero, 1980). All subsequent quotations are from this edition and will be followed by the page number between parentheses in the text.

6. Ahmed Boukous, *Société, Langues, et Cultures au Maroc* (Rabat: Faculté des Lettres et de Sciences Humaines, 1995), 36.

7. Ibid., 40.

8. Mohamed Boughali, *La représentation de l'espace chez le marocain illétré* (Casablanca: Afrique/Orient, 1974), 12–13.

9. Michel de Certeau, *La prise de parole* (Paris: Seuil, 1994), 214.

10. Gilles Deleuze and Félix Guattari, *Mille Plateaux* (Paris: Minuit, 1980), 20.

11. Saïd Bennani, "La symbolisation de l'espace dans le discours Coranique," in *Imaginaire de l'espace, espaces imaginaires*, ed. K. Basfao (Casablanca: Faculté des Lettres et de Sciences Humaines, 1988), 207.

12. Saint Augustine, *Confessions* (Paris: Gallimard, 1993), 74.

13. Thongchai Winichakul, "Siam Mapped: A History of the Geo-Body of Siam" (PhD thesis, University of Sydney, 1988), 310. Quoted in Benedict Anderson, *Imagined Communities* (London: Verso, 1991), 177.

14. Homi Bhabha, *The Location of Culture* (London: Routledge, 1994), 177.

15. Ibid., 178.

Chapter 3

1. Sonia Lee, "Daughters of Hagar: Daughters of Muhammad," in *The Marabout and the Muse: New Approaches to Islam in African Literature*, ed. K. Harrow (Portsmouth, NH: Heinemann Press, 1996), 54.

2. Patricia Geesey, "Women's Words: Assia Djebar's *Loin de Medine*," in *The Marabout and the Muse: New Approaches to Islam in African Literature*, ed. K. Harrow (Portsmouth, NH: Heinemann Press, 1996), 43.

3. John Erickson, *Islam and the Postcolonial Narrative* (Cambridge: Cambridge University Press, 1998), 41.

4. Assia Djebar, *Vaste est la prison* (Paris: Albin Michel, 1995), 106. All quotations from *Vaste est la prison* are from this edition; page references will be given in parentheses in the text.

5. Assia Djebar, *So Vast the Prison*, translated by Betsy Wing (New York:

Seven Stories Press, 1999), 108. All quotations from the English translation of
Vaste est la prison are from this edition; page references will be given in paren-
theses in the text.

6. Michel de Certeau, *L'écriture de l'histoire* (Paris: Gallimard, 1975), 317.

7. Michel de Certeau, *The Writing of History*, translated by Tom Conley
(New York: Columbia University Press, 1988), 312.

8. De Certeau, *L'écriture de l'histoire*, 316.

9. De Certeau, *The Writing of History*, 312.

10. Gayatri Chakravorty Spivak, "Acting Bits/Identity Talk," *Critical Inquiry*,
vol. 18 (1992): 795.

11. Jacques Derrida, *Le monolinguisme de l'autre* (Paris: Galilée, 1996), 85.

12. Jacques Derrida, *The Monolinguism of the Other*, translated by Patrick
Mensah (Stanford, CA: Stanford University Press, 1998), 51.

13. Derrida, *Le monolinguisme de l'autre*, 55.

14. Derrida, *The Monolinguism of the Other*, 29.

15. Scott Durham, *Phantom Communities: The Simulacrum and the Limits of
Postmodernism* (Stanford, CA: Stanford University Press, 1998), 150.

16. Derrida, *Le monolinguisme de l'autre*, 15.

17. Derrida, *The Monolinguism of the Other*, 21.

18. Derrida, *Le monolinguisme de l'autre*, 25.

19. Ibid., 10.

20. Ibid., 73.

21. Ibid., 42.

Chapter 4

1. John Voll, "Sultans, Saints, and Presidents: The Islamic Community and
the State in North Africa," in *Islam, Democracy, and the State in North Africa*, ed.
J. P. Entelis (Bloomington: Indiana University Press, 1997), 4.

2. John P. Entelis, "Poltical Islam in the Maghreb: The Nonviolent Dimen-
sion," in *Islam, Democracy, and the State in North Africa*, ed. J. P. Entelis (Bloom-
ington: Indiana University Press, 1997), 47.

3. Derek Hopwood, *Habib Bourguiba of Tunisia: The Tragedy of Longevity*
(New York: St. Martin's Press, 1992), 137.

4. Emile Dermenghem, *Le Culte des saints dans l'Islam maghrébin* (Paris: Gal-
limard, 1954), 17.

5. Ibid.

6. John Waterbury, *The Commander of the Faithful* (London: Trinity Press,
1970), 21.

7. Hedi Khelil, "Abécédaire du cinéma tunisien," *La Presse* (March 3, 2002).

8. Waterbury, *The Commander of the Faithful*, 17. Saint worshippers not
only resisted authority, they also resisted foreign conquest. Waterbury writes:
"The intrusion of the infidel required the resistence of the faithful, and the
inspiration and the organization of this resistence fell to a large extent into the

hands of the murabitin," 26. On this subject, also see Julia Clancy-Smith, *Rebel and Saint: Muslim Notables, Populist Protest, Colonial Encounters (Algeria and Tunisia, 1800–1940)* (Berkeley: University of California Press, 1994).

9. For a discussion on these notions and Tunisian film, see Victor Bachy, *Le cinema de Tunisie* (Tunis: Société tunisienne de diffusion, 1976), especially page 23.

10. *Military Expeditions Led by the Prophet (Al-Maghaazi).* Translation of Sahih Bukhari, volume 5, book 59, number 338.

11. *Good Manners and Form (Al-Adeb).* Translation of Sahih Bukhari, volume 8, book 73, number 151.

12. Quoted with permission of Moncef Dhouib.

13. Short summaries of these films are provided in the appendix. Since the films are not easily accessible for viewing, inside and outside of Tunisia, I believe that short descriptions would be useful to the reader.

Chapter 5

1. For an excellent presentation of the publications, exhibitions, and activities of the Art and Freedom group, see Abdel Kader el-Janabi, "Le Nil du Surréalisme: le groupe 'Art et Liberté' (1938–1952)," in *Entre Nil et Sable* (Paris: Centre nationale de documentation pédagogique, 1999).

2. *Suq al-Sauda* (The black market), Kamel El-Telmessany, 1945.

3. Oleg Grabar, "Islam et les Arts," in *Les sociétés musulmanes au miroir des oeuvres d'art* (Tunis: Centre d'études et de recherches économiques et sociales, 1996), 26. Grabar does not give the exact source or date of this statement but says that it dates from about four years prior to the publication of the article.

4. Younan translated many works from French into Arabic and from Arabic into French. The most famous is perhaps his Arabic translation of Albert Camus's *Caligula* and Arthur Rimbaud's *Une saison en enfer*.

5. el-Janabi, "Le Nil du Surréalisme," 60.

6. Younan was the editor of the journal a*l-Majalla al-Jedida* between 1941 and 1944, the year it was shut down by the government. In it, he published many articles, including: "From Dada to Surrealism" (1942), "The Problems That Will Continue after the War" (1943), "We Are on the Front" (1942), and "The Decision Belongs to the People" (1943).

7. Although it is not the main focus of their work, both Lilian Karnouk and Abdel Kader el-Janabi's books acknowledge the important criticisms of the European avant-garde launched by the Art and Freedom group. Silvia Naef, on the other hand, does not even mention Art and Freedom except in a footnote.

8. Silvia Naef, "Le Turath comme expression de la modernité dans l'art arabe contemporain," in *Les sociétés musulmanes au miroir des oeuvres d'art* (Tunis: Centre d'études et de recherches économiques et sociales, 1996).

9. Ramses Younan, "La désagrégation des mythes," *Les Cahiers de Chabramant*, no. 5 (1987): 171. Translated by Allain Roussillon.

10. Roland Barthes, *Mythologies*, translated by Annette Lavers (New York: The Noonday Press, 1989), 129.

11. Ramses Younan, "Beyond the Mind's Logic," *El-Tatawer* (May 1940).

12. Ramses Younan and Georges Henein, *Notes sur une ascèse hystérique* (Cairo: La Part du sable, 1948). All other passages from this text will be given between parenthesis in the text.

13. The anonymous author of this article states that Ramses Younan "does not go so far" as Georges Henein in his critique of Surrealist automatism. The article was originally printed in *Arts*, April 30, 1948 (Cairo) and reprinted in *Ramses Younan* (Cairo: Organisation egyptienne générale du livre, 1978).

14. Gilles Deleuze and Félix Guattari, *Cinéma II. L'Image-Temps* (Paris: Minuit, 1985), 195. All subsequent quotations from this book will be followed by the page number between parentheses in the text.

15. *Cinema II. The Time-Image*, translated by Hugh Tomlinson and Robert Galeta (Minneapolis: University of Minnesota Press, 1989). All subsequent quotations from this book will be followed by the page number between parentheses in the text.

16. Ramses Younan, "Dream and Truth," *El-Tatawer* (March 1940).

17. Younan, "La désagrégation des mythes," 167.

18. Ibid.

19. Ibid., 171.

20. Ibid., 168.

21. Ibid., 171.

22. Barthes, *Mythologies*, 135.

23. Ibid., 135. Italics in original.

Chapter 6

1. Réda Bensmaïa, *The Year of Passages*, translated by Tom Conley (Minneapolis: University of Minnesota Press, 1995), 3.

2. Michael Gilsenan, *Recognizing Islam* (London: Croom Helm, 1982), 142.

3. Ibid., 144.

4. Gilles Deleuze and Félix Guattari, *Mille Plateaux* (Paris: Minuit, 1980), 631.

5. All quotations from *La Mémoire tatouée* will be followed by the page number between parentheses in the text.

6. Daniel Rivet, *Lyautey et l'institution du Protectorat français au Maroc 1912–1925*, vol. 3 (Paris: Harmattan, 1996).

7. Abdelkebir Khatibi, *La blessure du nom propre* (Paris: Denoël, 1974), 59–130.

8. Ibid., 69.

9. Ibid., 78.

10. Ibid., 69.

11. Homi Bhabha, *The Location of Culture* (London: Routledge, 1994), 181.

12. Abdelfattah Kilito, *L'Auteur et ses doubles: Essai sur la culture arabe classique* (Paris: Seuil, 1985), 20–21.

Chapter 7

1. Mohamed Khaïr-Eddine, *Légende et vie d'Agoun'chich* (Paris: Seuil, 1984), 10. All quotations from *Légende et vie d'Agoun'chich* are from this edition; page references will be given in parentheses in the text.

2. Louis Massignon, cited in André Raymond, *Grandes villes arabes à l'époque ottomane* (Paris: Sindbad, 1985), 169.

3. Jacques Berque, *Maghréb histoire et sociétés* (Algiers: S.N.E.D.-Duculot, 1974), 6.

4. Ibid., 9.

5. Daniel Rivet, *Lyautey et l'institution du Protectorat français au Maroc 1912–1925*, vol. 3 (Paris: Harmattan, 1996), 215.

6. *Le séisme d'Agadir* (Casablanca: Editions du service géologique du Maroc, 1962), 15.

7. Abdessamad Dialmy, *Logement, sexualité et Islam* (Casablanca: Eddif, 1995), 30.

8. Ibid., 31.

9. Ibid., 32.

10. Mohamed Khaïr-Eddine, *Agadir* (Paris: Seuil, 1967), 49. Other quotations from *Agadir* are from this edition; page references will be given in parentheses in the text. All quotations from this book will be printed exactly as they appear in the novel.

11. *L'Opinion* (Rabat) (October 18, 1997).

Conclusion

1. Michael Gilsenen, *Recognizing Islam* (London: Croom Helm, 1982), 15.

▼▼▼▼▼▼▼▼▼▼

Bibliography

Anderson, Benedict. *Imagined Communities*. 1983. Reprint, London: Verso, 1991.

Augé, Marc. *Non-lieux: Introduction à une anthropologie de la surmodernité*. Paris: Seuil, 1992.

Augustine, Saint. *Confessions*. Paris: Gallimard, 1993.

Bachelard, Gaston. *La poétique de l'espace*. 1957. Reprint, Paris: Presses Universitaires de France, 1998.

Bachy, Victor. *Le cinema de Tunisie*. Tunis: Société tunisienne de diffusion, 1976.

Barthes, Roland. *Le degré zéro de l'écriture*. 1953. Reprint, Paris: Seuil, 1972.

———. *Le plaisir du texte*. Paris: Seuil, 1973.

———. *Mythologies*, translated by Annette Lavers. New York: The Noonday Press, 1989.

Bataille, Georges. *La littérature et le mal*. Paris: Gallimard, 1957.

———. *La part maudite*. Paris: Minuit, 1967.

———. *Histoire de l'oeil*. 1928. Reprint, Paris: Gallimard, 1970.

Ben Jelloun, Tahar. "Une technique de viol," *Le Monde* (June 9, 1972).

———. *La réclusion solitaire*. Paris: Denoël, 1976.

———. "A la défense de l'individualisme rebelle," in *Adeb*. Unpublished translation by Abderrahim Gzour, 1980.

———. "L'ultime ressource," *Le Monde* (February 6, 1981).

———. *La Priere de l'absent*. Paris: Seuil, 1981.

Bennani, Saïd. "La symbolisation de l'espace dans le discours Coranique," in *Imaginaires de l'espace, espaces imaginaires*, edited by Kacem Basfao (pp. 199–211). Casablanca: Faculté des Lettres et de Sciences Humaines, 1988.

Bensmaïa, Réda. *The Year of Passages*, translated by Tom Conley. Minneapolis: University of Minnesota Press, 1995.

Berque, Jacques. *Maghréb histoire et sociétés*. Algiers: S.N.E.D.-Duculot, 1974.

Bhabha, Homi. *The Location of Culture*. London: Routledge, 1994.

Boughali, Mohamed. *La représentation de l'espace chez le marocain illétré*. Casablanca: Afrique/Orient, 1974.

Boukous, Ahmed. *Language et culture populaires au Maroc: Essai de sociolinguistique*. Casablanca: Dar el Kiteb, 1977.

————. "La situation linguistique au Maroc," *Europe* (1979): 5–22.

————. *Société, Langues, et Cultures au Maroc*. Rabat: Faculté des Lettres et de Sciences Humaines, 1995.

Bourkhis, Ridha. *Tahar Ben Jelloun: La poussière d'or et la face masque*. Paris: Harmattan, 1995.

Bousfiha, Nourreddine. "Les écrivains maghrébins de langue française: entre la marginalité littéraire et l'identité nouvelle," in *Nouvelles du Sud* (pp. 103–25). Ivry: Silex, 1989.

Bouzar, Wadi. *Lectures maghrébines*. Paris: Publisud, and Alger: OPU, 1984.

————. "Espaces de pause, espaces de mouvance, espaces de souvenance," in *Maghreb/Machrek: Espaces et sociétés du monde arabe*. Paris: La Documentation française, 1989.

Brahimi, Denise. "A l'écoute de la littérature: la maison et le monde," in *Maghreb/Machrek: Espaces et sociétés du monde arabe*. Paris: La Documentation française, 1989.

Certeau, Michel de. *L'ecriture de l'histoire*. Paris: Gallimard, 1975.

————. *The Writing of History*, translated by Tom Conley. New York: Columbia University Press, 1988.

————. *La culture au pluriel*. 1974. Reprint, Paris: Seuil, 1993.

————. *La prise de parole*. 1968. Reprint, Paris: Seuil, 1994.

Chikhi, Beïda. *Maghreb en textes: Ecriture, histoire, savoirs, et symboliques*. Paris: Harmattan, 1996.

Choukri, Mohamed. *Le pain nu*, translated by Tahar Ben Jelloun. Paris: Maspero, 1980.

————. "Being and Place," interview in *The View from Within: Writers and Critics on Contemporary Arabic Literature*, edited by F. J. Ghazoul and B. Harlow. Cairo: American University of Cairo Press, 1994.

Clancy-Smith, Julia. *Rebel and Saint: Muslim Notables, Populist Protest, Colonial Encounters (Algeria and Tunisia, 1800–1940)*. Berkeley: University of California Press, 1994.

Dakhlia, Jocelyne. *L'oubli de la cite*. Paris: La Découverte, 1990.

Deleuze, Gilles. *Foucault*. Paris: Minuit, 1986.

————. *The Fold: Leibniz and the Baroque*, translated by Tom Conley. Minneapolis: University of Minnesota Press, 1993.

Deleuze, Gilles, and Guattari, Félix. *Kafka: Pour une littérature mineure*. Paris: Minuit, 1975.

————. *Mille Plateaux*. Paris: Minuit, 1980.

————. *Cinéma I. L'Image-Mouvement*. Paris: Minuit, 1983.

————. *Cinéma II. L'Image-Temps*. Paris: Minuit, 1985.

————. *Cinema II. The Time-Image*, translated by Hugh Tomlinson and Robert Galeta. Minneapolis: University of Minnesota Press, 1989.

————. *Qu'est-ce que la philosophie*. Paris: Minuit, 1991.

Dermenghem, Emile. *Le Culte des saints dans l'Islam maghrébin*. Paris: Gallimard, 1954.

Derrida, Jacques. *Le monolinguisme de l'autre*. Paris: Galilée, 1996.

————. *The Monolinguism of the Other*, translated by Patrick Mensah. Stanford, CA: Stanford University Press, 1998.

Dialmy, Abdessamad. *Logement, sexualité et Islam*. Casablanca: Eddif, 1995.

Dirlik, Arif. "Culturalism as Hegemonic Ideology and Liberating Practice," in *The Nature and Context of Minority Discourse*, edited by Abdul R. JanMohamed and David Lloyd. New York: Oxford University Press, 1990.

Djebar, Assia. *Vaste est la prison*. Paris: Albin Michel, 1995.

————. *So Vast the Prison*, translated by Betsy Wing. New York: Seven Stories Press, 1999.

Donadey, Anne. "Rekindling the Vividness of the Past: Assia Djebar's Film and Fiction," *World Literature Today 70*, no. 4 (autumn 1996): 885–93.

Duncan, James. "Sites of Representation," in *Place/Culture/Representation*. London: Routledge, 1993.

Durham, Scott. *Phantom Communities: The Simulacrum and the Limits of Postmodernism*. Stanford, CA: Stanford University Press, 1998.

Entelis, John P. "Political Islam in the Maghreb: The Nonviolent Dimension," in *Islam, Democracy, and the State in North Africa*, edited by J. P. Entelis. Bloomington: Indiana University Press, 1997.

Erickson, John. *Islam and the Postcolonial Narrative*. Cambridge: Cambridge University Press, 1998.

Foucault, Michel. "Nietzsche, la généalogie, l'histoire," in *Hommage à Jean Hyppolite*. Paris: Presses Universitaires de France, 1971.

————. "Intellectuals and Power," in *Language, Counter-Memory, Practice*, edited by D. F. Bouchard, translated by D. F. Bouchard and Sherry Simon (pp. 205–17). Ithaca, NY: Cornell University Press, 1977.

————. "Two Lectures," in *Power/Knowledge: Selected Interviews and Other Writings 1972–1977*, edited by Collin Gordon, translated by Collin Gordon, Leo Marshall, John Mepham, and Kate Soper. New York: Pantheon, 1980.

————. "Of Other Spaces," in *Diacritics*. Baltimore: Johns Hopkins University Press, 1986.

Freud, Sigmund. "The Antithetical Meaning of Primal Words," vol. 2, in *The Standard Edition of the Complete Psychological Works of Sigmund Freud*, translated under the general editorship of James Strachey in collaboration with Anna Freud, assisted by Alix Strachey and Alan Tyson (pp. 153–62). London: Hogarth Press, 1953.

Frishman, Martin. "Islam and the Form of the Mosque," in *The Mosque: History, Architectural Development and Regional Diversity*, edited by Martin Frishman and Hasan-Uddin Khan (pp. 17–38). New York: Thames & Hudson, 1994.

Geesey, Patricia. "Women's Words: Assia Djebar's *Loin de Medine*," in *The Marabout and the Muse: New Approaches to Islam in African Literature*, edited by Kenneth Harrow (pp. 40–50). Portsmouth, NH: Heinemann Press, 1996.

Gilsenan, Michael. *Recognizing Islam*. London: Croom Helm, 1982.

Gontard, Marc. *Violence du texte: Littérature marocaine de langue française*. Paris: Harmattan, 1981.

————. *Le moi étrange: Littérature marocaine de langue française*. Paris: Harmattan, 1993.

Grabar, Oleg. "Islam et les Arts," in *Les sociétés musulmanes au miroir des oeuvres d'art* (pp. 17–34). Tunis: Centre d'études et de recherches économiques et sociales, 1996.

Hopwood, Derek. *Habib Bourguiba of Tunisia: The Tragedy of Longevity*. New York: St. Martin's Press, 1992.

Huggan, Graham. "Decolonizing the Map: Post-Colonialism, Post-Structuralism and the Cartographic Connection," in *Ariel*. Bloomington: Indiana University Press, 1989.

Huntington, Samuel P. *The Clash of Civilizations and the Remaking of World Order*. New York: Simon & Schuster, 1996.

Hussein, Mahmoud. "L'individu postcolonial," in *Dédale*, edited by Abdelwahab Meddeb (pp. 164–74). Paris: Maisonneuve & Larose, 1997.

el-Janabi, Abdel Kader. "Le Nil du Surréalisme: le groupe 'Art et Liberté' (1938–1952)," in *Entre Nil et Sable*. Paris: Centre nationale de documentation pédagogique, 1999.

JanMohamed, Abdul R., and Lloyd, David. "Toward a Theory of Minority Discourse: What Is to Be Done?" in *The Nature and Context of Minority Discourse*, edited by A. R. JanMohamed and D. Lloyd. New York: Oxford University Press, 1990.

Karnouk, Lilian. *Modern Egyptian Art*. Cairo: American University in Cairo Press, 1988.

Kaye, Jacqueline. *Maghreb: New Writings from North Africa*. York, UK: Talus Editions, 1992.

Kaye, Jacqueline, and Zoubir, Abdelhamid. *The Ambiguous Compromise*. London: Routledge, 1990.

Kazi-Tani, Nora-Alexandra. *Roman africain de langue française au carrefour de l'écrit et de l'oral (Afrique noire et Maghreb)*. Paris: Harmattan, 1995.

Khaïr-Eddine, Mohamed. *Agadir*. Paris: Seuil, 1967.

————. *Légende et vie d'Agoun'chich*. Paris: Seuil, 1984.

Khatibi, Abdelkebir. *Le roman maghrébin*. Paris: Maspero, 1968.

————. *La Mémoire tatouée*. Paris: Denoël, 1971.

————. *La blessure du nom propre*. Paris: Denoël, 1974.

————. *Le livre du sang*. Paris: Gallimard, 1979.

————. *Amour bilingue*. Montpellier: Fata Morgana, 1983.

————. *Maghréb pluriel*. Paris: Denoël, 1983.

————. "Incipits," in *Du Bilinguisme* (pp. 171–204). Paris: Denoël, 1985.

Khelil, Hedi, "Abécédaire du cinéma tunisien," *La Presse* (March 3, 2002).

Kilito, Abdelfattah. *L'Auteur et ses doubles: Essai sur la culture arabe classique*. Paris: Seuil, 1985.

————. "Les mots canins," in *Du Bilinguisme* (pp. 205–26). Paris: Denoël, 1985.

Laroui, Abdellah. *L'idéologie arabe contemporaine*. 1967. Reprint, Paris: Maspero, 1982.

Lee, Sonia. "Daughters of Hagar: Daughters of Muhammad," in *The Marabout*

and the Muse: New Approaches to Islam in African Literature, edited by K. Harrow (pp. 51–61). Portsmouth, NH: Heinemann Press, 1996.

Lefebvre, Henri. *The Production of Space*, translated by Donald Nicholson-Smith. Oxford: Blackwell, 1991.

McLennan, Gregor, Molina, Victor, and Peters, Roy. "Althusser's Theory of Ideology," in *On Ideology*. London: Hutchinson Press, 1978.

Mafessoli, Michel. "L'imaginaire dans l'espace urbain post-moderne," in *Imaginaires de l'espace, espaces imaginaires*, edited by K. Basfao (pp. 23–34). Casablanca: Faculté des Lettres et de Sciences Humaines, 1988.

Meddeb, Abdelwahab. "Abdelwahab Meddeb, le chantre de l'entre-deux cultures," *Lamalif* (Rabat) (1979): 47–50.

———. *Talismano*. 1978. Reprint, Paris: Sindbad, 1987.

———. "L'urgence de la modernité," *Parcours maghrébins* (1987): 16–17.

———. "A bâtons rompus avec Abdelwahab Meddeb," *Cahiers d'études maghrébines* (1989): 17–21.

———. "Abdelwahab Meddeb par lui-même," *Cahiers d'études maghrébines* (1989): 11–16.

———. "Voiles," *Cahiers Intersignes* (1991): 133–42.

———. "La disparition," *Cahiers Intersignes* (1992): 147–58.

———. "Epiphanie et jouissance," *Cahiers Intersignes* (1993): 137–51.

———. "Hors la rémanence de la servitude," *Cahiers Intersignes* (1994): 43–48.

———. "Entretien avec Abdelwahab Meddeb," *Prétexte* (1996): 34–39.

———. *La maladie de l'Islam*. Paris: Seuil, 2002.

Mezgueldi, Zohra. "L'espace 'sudique' chez Mohamed Khaïr-Eddine," in *Imaginaire de l'espace, espaces imaginaires*, edited by K. Basfao (pp. 89–96). Casablanca: Faculté des Lettres et de Sciences Humaines, 1988.

———. "Mohamed Khaïr-Eddine," in *Littérature maghrébine d'expression française*, edited by C. Bonn, N. Khadda, and A. Mdarhri-Alaoui (pp. 153–58). Vanves, France: EDICEF, 1996.

Miller, Christopher L. "Nationalism as Resistance and the Resistance to Nationalism in the Literature of Francophone Africa," in *Yale French Studies: Post/Colonial Conditions*, edited by F. Lionnet and R. Scharfman (pp. 62–100). New Haven, CT: Yale University Press, 1993.

Miller, Susan G. "Narrations maghrébines d'exile et de retour," in *Migration internationale et changements sociaux dans le Maghreb* (pp. 181–200). Tunis: University of Tunis, 1993.

Mouzouni, Lahcan. *Le roman marocain de langue française*. Paris: Publisud, 1987.

Muir, Richard. *Modern Political Geographies*. New York: Macmillan, 1975.

Naef, Silvia. "Le Turath comme expression de la modernité dans l'art arabe contemporain," in *Les sociétés musulmanes au miroir des oeuvres d'art*. Tunis: Centre d'études et de recherches économiques et sociales, 1996.

Nietzsche, Friedrich. *Le gai savoir*, in *Oeuvres*. Paris: Robert Laffont, 1993.

Planhol, Xavier de. *Les nations du Prophète: Manuel géographique de politique musulmane*. Paris: Fayard, 1993.

Rabinow, Paul. *French Modern*. Cambridge: Massachusetts Institute of Technology Press, 1989.

Raybaud, Antoine. "Nomadism between the Archaic and the Modern," in *Yale French Studies: Post/Colonial Conditions*, edited by F. Lionnet and R. Scharfman (pp. 146–57). New Haven, CT: Yale University Press, 1993.

Raymond, André. *Grandes villes arabes à l'époque ottomane*. Paris: Sindbad, 1985.

Rivet, Daniel. *Lyautey et l'institution du Protectorat français au Maroc 1912–1925*, vol. 3. Paris: Harmattan, 1996.

Rivet, Daniel, and Roche, Anne. "Espace imaginaire et utopie dans Phantasia d'Abdelwahab Meddeb," in *Imaginaires de l'espace, espaces imaginaires*, edited by K. Basfao. Casablanca: Faculté des Lettres et de Sciences Humaines, 1988.

Roussillon, Alain. "Ramsès Younane et *Les Cahiers de Chabramant*," *Les Cahiers de Chabramant*, no. 5 (1987).

Said, Edward. *Orientalism*, 2nd ed. New York: Vintage, 1979.

Sayad, Abdelmalek. *L'immigration ou les paradoxes de l'altérité*. Brussels: De Boeck, 1991.

Le séisme d'Agadir. Casablanca: Editions du service géologique du Maroc, 1962.

Soja, Edward. *Thirdspace: Journeys to Los Angeles and Other Real-and-Imagined Places*. London: Blackwell Press, 1996.

Spivak, Gayatri Chakravorty. "Acting Bits/Identity Talk," *Critical Inquiry*, vol. 18 (1992): 771–803.

Venn, Couze. "Algeria and Occidentalism," in *Parallax*, edited by J. Morra and M. Smith (pp. 79–89). London: Taylor & Francis, 1998.

Voll, John. "Sultans, Saints, and Presidents: The Islamic Community and the State in North Africa," in *Islam, Democracy, and the State in North Africa*, edited by J. P. Entelis. Bloomington: Indiana University Press, 1997.

Wahbi, Hassan. *Les mots du monde*. Agadir: Publication de la Faculté de Lettres et de Sciences Humaines d'Agadir, 1995.

Waterbury, John. *The Commander of the Faithful*. London: Trinity Press, 1970.

Woodhull, Winifred. *Transfigurations of the Maghreb: Feminism, Decolonization and Literatures*. Minneapolis: University of Minnesota Press, 1993.

Younan, Ramses. *Ghayat al-risam al-'asri*. 1938 (*Aims of the Contemporary Artist*). Unpublished translation by Marwa El Naggar (2000).

———. "Dream and Truth," *El-Tatawer* (March 1940). Unpublished translation by Marwa El Naggar.

———. "Beyond the Mind's Logic," *El-Tatawer* (May 1940). Unpublished translation by Marwa El Naggar.

———. "La désagrégation des mythes" (1959), translated by Allain Roussillon in *Les Cahiers de Chabramant*, no. 5 (1987).

Younan, Ramses, and Henein, Georges. *Notes sur une ascèse hystérique*. Cairo: La Part du sable, 1948.

Zizek, Slavoj. *The Sublime Object of Ideology*. London: Verso, 1989.

Index

'Abdelwahab, Muhammed ibn, 75
abstract art, 97
Academy, French, 109
Agadir (Khaïr-Eddine), 43, 115, 121–25
'Aisha, 78
Al-Azhar University, 85
Algeria: Djebar as historiographer of, 47–49; identity of, 59–63; language politics in, xxiv, 60–61
Al-Hadra (The trance) (Dhouib), 69–71
'Ali Ibn Abi Taleb, 78
Al-Jaziri, Fadel, 77
Al-Khubz al-hafi (Choukri), 29–45; genre of, 32; multilingualism in, 29–32, 36; publications of, 30–32
Allah, 39, 74, 75–76, 78
al-Majjalla al-Jadida (The new magazine), 86
anarchism, 85
anthropology, 102
Arabic language: *Al-Khubz al-hafi* and, 30–31; and Berber languages in *Al-Khubz al-hafi*, 32–36; classical, 34–35; and morality, 31–32; roots and meaning in, 19–20; in *Talismano*, 18–20
Arabo-Islamic culture: break in, xvi; versus Western culture, xxvii, 79–80
archeology, xxiii, xxiv, 10, 52, 54
Art et liberté (Art and freedom), 83–97;

Christianity in, 86; criticism of European avant-garde by, 84–85, 87
art, in Egypt, 83–97
Artaud, Antonin, 44
Atlas Mountains (Morocco), 101, 122
Augustine, Saint, 41–43
authorial identity, xiv, xvi
autobiography, 51–53, 59–60
automatism, 86–87, 89–90
avant-garde: *Art et liberté* and European, 84–85, 87; definition of, xiii–xiv, xviii; double-edged critique by Arab, 6, 131–34
âya/âyat, 39

baraka, 71, 76
Barthes, Roland: on the body, 15–16; on mythology, 87–88, 96
Basra (Iraq), 78
Bataille, Georges, 21, 23
bedouins, xv–xviii, 112–14
Ben Ali, Zine el-Abadine, 67
Ben Jelloun, Tahar, 31, 45
Bensmaïa, Réda, 101
Berber languages: *Al-Khubz al-hafi* and, 31; in Algeria, xxiv; and Arabic language in *Al-Khubz al-hafi*, 32–36; in Morocco, xxiii; social rank of, 32–33; in *Vaste est la prison*, 51–52
Berque, Jacques, 117

Bhabha, Homi, xx, 45, 112
bilingualism, xv. *See also* multilingual-
ism
Bistami, 21
body: in *Hammam D'hab*, 71–72; and
identity, 9–17
Boughali, Mohamed, 35
Boukous, Ahmed, 34
bourgeois, 11, 84, 86, 87–90, 92, 96,
132, 135, 136–37; mythology,
87–89
Bourguiba, Habib, 67
Bouzar, Wadi, 29–30
Bowles, Paul, 30–31, 45
Breton, André, 84
Breton-Trotsky Manifesto, 85
bricolage, 14

Cartes, Des/Cartesian, 37, 107–8
Carthage, 49, 54
Chikhi, Beïda, 6–7
Choukri, Mohamed, xxiii–xxiv, 12,
29–45, 132–33
Christianity, 39, 41–43, 78, 85
colonialism: earthquake as metaphor
for, 121–25; effect on Islamic cul-
ture of, xvi; in Morocco, 101–14,
120–21
communism, 84, 85
Conley, Tom, 18
cultural identity, 17–18, 21
culture: hegemony in, xxii; and place
in Morocco, 116–19; restoration
of, xvii–xviii, xxii, xxvii, 133–34

dâr al-Islam, 39, 43
dâr al-kufr, 39, 43
de Certeau, Michel, 36; on history,
50–51; on minority use of culture,
13–15
death, and the self, 22–23
deconstruction, xx–xxi
Deleuze, Gilles: on art, 93–94; on cin-
ema, 90, 91, 94, 95; concept of
devenir-femme in, 21; on genealogy,

7–8; on metamorphosis, xix; on
minority languages, xvii; on Picasso,
96; on space, 103
Derrida, Jacques, xxiv, xxvi, 55–56, 59,
60–61, 133
desert, 112–14. *See also* Sahara Desert
devenir-femme (becoming-woman), 21
Dhouib, Moncef, xxv, 67–82; critique
of Tunisian self-presentation by, 68–
69, 70–71, 75–76, 79; and Islamic
discouragement of images, 79; use
of Western medium (film) by, 79–
82
Dialmy, Abdessamad, 123–24
diasporic thought, 29, 45
dictators, dictatorships, xx, 89, 92,
132
Dirlik, Arif, xxii
displacement, xxvii, 7, 18, 20, 28, 44,
77, 120
Djebar, Assia, xxiii, xxiv, 7, 47–63,
132; on Algerian identity, 59–63;
as historiographer, 47–49, 52–
53
Donadey, Anne, 48
Dougga (Tunisia), 49, 50, 52, 54–55,
57, 58–59, 136
Ducasse, Isidore. *See* Lautréamont,
Comte de
Durham, Scott, 60

Egypt, 83–86, 96–97
El-Telmessany, Kamel, 84
Erickson, John, 48–49
exile, xxvii, 6, 18, 19–20, 21, 22, 32,
47, 51, 53, 55, 56, 59, 85, 86,
110

fascism, 84
Fatima (Muhammad's daughter), 48
FIARI (International Federation of
Independent Revolutionary Art),
85
film, as medium, 80–82
folklore, 31, 80, 110

For Bread Alone (Choukri). *See Al-Khubz al-hafi*

Foucault, Michel: on the body, 10–13; on genealogy, 8, 9

fqih, 105

Francophone literature, xiv, xvi–xviii, xix–xx; *Al-Khubz al-hafi* as, 31; chiasm in, 110; and critique of internal hegemony, xxii; in Egypt, 83; Khaïr-Eddine and, 129; *Vaste est la prison* as, 59–60

Freud, Sigmund, 50–51

fundamentalism: avant-garde versus, xiv; as exclusive, xvii–xviii, 82; and national identity, xx; in Tunisia, 74–75

Geesey, Patricia, 48

genealogies: the body and, 10–11; versus origins in determining identity, 4–9; ruptures in, 7

Genet, Jean, 60

Gilsenan, Michael, 103, 133–34

Grabar, Oleg, 85

Guattari, Felix, xvii, xix, 7–8, 103

hadith, 78

Hadra (Al-Jaziri), 77

Hagar (Hâjir), 6, 19–20, 48, 114

halal, 39

Hallaj, Mansur al-, 4

Hammam D'hab (The golden bath) (Dhouib), 71–75

haram, 39

harem, 61

harqoos, 69, 74, 135, 136, 138

Hassan II, King of Morocco, xxvi, 126–27

Henein, Georges, xxv, 84, 86–87, 90–92, 96

henna, 74, 138

hierarchy: linguistic, 32–36; theological, 38–43

hijab (head scarf), 68

hijra, 19, 20

historiography: colonial, in Morocco, 108–9; in Djebar's work, 48–53; motivation for, 58–59; North African, 63

history: the body and, 10–11, 13, 15; relationship to, xiv

homelessness, 37–38

Ibn 'Abbas, Abdullah, 78–79

Ibn 'Arabi, Muhammad, 4

Ibn Khaldun, Abd al-Rahman, 6

identity: authorial (*see* authorial identity); cultural (*see* cultural identity); destruction of cultural, in Morocco, 128–29; in Djebar's work, 51–53; loss of, xxi; minorities and non-, xxi; multiplicity of, 4–9; national (*see* national identity); personal (*see* personal identity); in Tunisia, 77, 82

immigrants, and culture, 13–14

imperialism, 88

indigenous (culture), 103, 106

Islam: critique of, xxiii–xxiv, 38–44, 77–78, 104–5; orthodoxy and mysticism in, 74–75; and tattoos, 111–12; in Tunisia, 67–68, 74–75; and visual representation, 77–79, 82, 85–86. *See also* Quran

Islamic culture. *See* Arabo-Islamic culture

Ismaël, 6, 19, 20, 114

'Issa, Sheik Ahmad Mohammad, 85

Jabès, Edmond, 7

Jahiz, Abr 'Uthman al-, xiv–xvi

JanMohamed, Abdul, xxi

journalism, 126–27

Kafka, Franz, xvii

Kamel, Fouad, 84

Khaïr-Eddine, Mohamed, xxvi–xxvii, 7, 43, 115–29, 133; *Agadir*, 121–25; *Légende et vie d'Agoun'chich*, 115–21

Khatibi, Abdelkebir, xxvi, 10, 17, 18–19, 60, 101–14, 133; on colonial-

ism and control of space, 103–11;
 on tattoos, 111–14
Khelil, Hedi, 76
Kilito, Abdelfattah, xiv–xviii, 113
Kitab Al-Hayawan (Book of animals)
 (Jahiz), xv
Kristeva, Julia, 70

"*La désagrégation des mythes*" (The dis-
 aggregation of myths) (Younans),
 87–90, 93
"La disparition" (Meddeb), 5
La Mémoire tatouée (Khatibi), 101–14
La Part du Sable, 86
language of composition, xiv, xvii
languages: the body and, 10; Choukri
 and, 29–38, 44–45; Khatibi and,
 109; Meddeb and, 17–20; minority
 (*see* minority languages); and space/
 place, 34–35, 36–37
Lautréamont, Comte de (Isidore
 Ducasse), 115
Le pain nu (Choukri). *See Al-Khubz
 al-hafi*
Lee, Sonia, 48
Légende et vie d'Agoun'chich (Khaïr-
 Eddine), 115–21
legends, 119–21
Lettres Nouvelles, 115
literary tradition: in Djebar's *Vaste est
 la prison*, 49; present–past relation-
 ship in, xiv–xv
literature. *See* Francophone literature;
 minority literature; Third World
 literature
Lloyd, David, xxi
L'Opinion, 126–27
loss, in Dhouib's films, 69–75
Lyautey, Hubert, 106

Maghreb: identity in, 11–12; literature
 of, 9
makhzen, 76
Marinetti, Filippo Tommaso, 84
Marxism, 85

Mecca, 21, 105
Meddeb, Abdelwahab, xvi, xxiii, 3–28,
 60, 82, 111, 132; and the body, 9–
 17; complexity of culture in, 17–23;
 on cultural genealogy, 4–9
medina (old, pre-French part of city),
 103–7, 127–28
melancholy, 7, 50, 57
memory, 124–25
metamorphosis: definition of, xix;
 identity and, xv–xviii; versus meta-
 phor, xviii–xx; in *Talismano*, 3–28
Metamorphosis, The (Kafka), xvii
metaphor, xviii–xx
Miller, Christopher L., 107
minority languages, xvii
minority literature, xviii–xxiii;
 Choukri's, 36
modernity, 4–5, 133
Morocco: Arab versus Berber languages
 in, xxiii, 32–36; colonialism and
 control of space in, 102–3, 106–8,
 117, 119; criticism of official dis-
 course in, 126–27; critique of soci-
 ety in, 44–45; culture and place in,
 116–19; and French culture, 109–
 10; French language in, 102; iden-
 tity in, 34; language hierarchy in,
 32–33; reaction to *Al-Khubz al-hafi*
 in, 31; traditions and colonialism in,
 120–25; Western thinking in, 102
Moses et Monotheism (Freud), 50–51
mosque(s), 24, 74, 105, 117
Moussa, Salama, 86
Muhammad (prophet), 48
multilingualism, xviii; in *Al-Khubz
 al-hafi*, 29–32, 36. *See also*
 bilingualism
Muqaddimah (Ibn Khaldun), 6
murabit/murabitin, 77
mysticism, xxi, 21–23; filmic medium
 and, 82; in *Hammam D'hab*, 73;
 Islam in Tunisia and, 74–75; and
 politics in Tunisia, 76–77; in
 Tourba, 80

mythology, 87–90, 93–97

Naef, Silvia, 87
narrative structure: the body and, 11–12, 15–16; filmic medium and, 81; genealogies and, 9
Nasser, Jamal Abdel, xxv
national identity, xix–xx; avant-garde versus, xxii; the body and, 11; Moroccan, versus Arabo-Islamic identity, 34; in Tunisia, 67–68, 76
newspapers, 126–27
Nietzsche, Friedrich, 7, 16, 95
nomad/nomadism, 12, 18, 27, 44, 111, 112, 113, 120
"*Notes sur une ascèse hystérique*" (Notes on an hysterical asceticism) (Younans), 87–90, 95

oppositional thinking, xxii, 79–80, 90–92
oral languages, 31, 33, 34–35
orientalism, 80
origins: versus genealogies in determining identity, 4–9; and truth, 8
Other: geopolitical, xx; self's relationship to, xvi

paradise, 39–40
personal identity, and death, 22–23
Picasso, Pablo, 96
pied-noir, 51
place: and culture in Morocco, 116–19; and identity, 128–29; and language, 34–35, 36–37; significance of, in Tunisia, 75–76. *See also* space
postcolonialism, xx
poststructuralism, xxi, 96; theory of image in, 89–90
Présence africaine, 115
Preuves, 115
Protectorate, French, 37, 54, 115, 117, 121
Punic, 53, 54, 136

Quays, Imru' ul-, 113
Quran, 6, 78, 105, 111; classical Arabic language of, 34–35; in *Hammam D'hab*, 74

Rabinow, Paul, 106
religion: critique of hierarchy in, 38–43; in Dhouib's films, 71, 74–75. *See also* Christianity; Islam; mysticism
representation: figurative, 9, 24, 25–26, 40–41, 68, 69, 74, 75, 76, 77–78, 79, 80, 82, 85, 87, 88, 90, 91, 122, 126–27, 128; mimetic, xiv, xvi, 5–6, 10, 13, 16, 17, 50, 61, 77, 82, 91, 97, 104
revolutionary (effect/event/idea/spirit), 27, 84, 85, 86, 87, 110, 112
rhizome, as metaphor for genealogy, 7–9
Rif (mountainous northeast Morocco), 33
Rimbaud, Arthur, 115
Rivet, Daniel, 106, 117
roots: as metaphor for origin and genealogy, 7–8; in structure of Arabic language, 19–20

Sahara Desert, 27, 118, 119
Saida Manoubia, 69, 76, 135
saint worship, 69–71, 74–75, 77
sallafism, 104
scientific discourse, 121–23
secular/secularism, xxv, 21, 67, 68, 76, 77, 79, 132
sociology, 101, 102
Sohrawardi, 4
Sorbonne (University of Paris), 101
Soufism, 21–23, 75; *tariqa*, 81
souqs, 117–19
space: and language, 34–35, 36–37; social production of, 102–3, 106–8; and tribal genealogy, 123–24. *See also* place
Spanish language, 36–37

Spivak, Gayatri Chakravorty, 51–53
Suez Canal, 85, 86
suicide, 23
surplus-space, 29–30
Surrealism, 83–90, 97

Talismano (Meddeb): body in, 10; and
 cultural identity, 17–18, 21; French
 and Arabic aspects of, 4–6; geneal-
 ogy in, 7; languages in, 17–19;
 narrative structure of, 9; Tunis in,
 24–28; writing in, 111
Tangiers, 29, 30, 36, 38, 40, 41
Tarifite, 31, 32–33
tattoos, 111–14
Tel Quel, 97
Temps modernes, 115
Third World literature, xiii
time, cyclical, 6, 12
totalitarianism, 89–90
Tourba (The cemetery) (Dhouib),
 80–82
tradition, 120–25, 133
translations, 29
tribe(s), xvii, xviii, 12, 25, 49, 77, 117,
 120, 121, 123, 124, 131
Tristan et Iseut, 49
truth: and illusion in Younan's aesthet-
 ics, 92–97; and origins, 8; and rep-
 resentation, in Henein's aesthetics,
 90–92
Tuaregs, 55
Tunis: cultural critique of, 17; identity
 in, 24–28; in *Talismano*, 24–28

Tunisia: identity formation in, 67–68,
 75; mysticism in, 74–77; and
 Western culture, 67–68
Turkish/Ottoman, 54, 55, 71, 117,
 138

ulema, 74
Umma, 34, 35
uncanniness, xiv, xx, 59, 76
urban areas, in Morocco, 103–11,
 117–19

Vaissière, Captain, 103
Vaste est la prison (Djebar), 47–63
ville nouvelle, 107–11
Voll, John O., 67

Wahabism, xvi
Waterbury, John, 77
weakness, ethics of, 17
Western culture: versus Arabo-Islamic
 culture, xxvii, 79–80; avant-garde
 versus, xiv; Tunisia and, 67–68,
 79
writing, separation and, 51. *See also*
 narrative structure

Younan, Ramses, xxv, 83–97, 131;
 career of, 85–86; on mythology,
 87–90; on truth and illusion in
 art, 92–96

zaouia, 75, 135

About the Author

ANDREA FLORES KHALIL is an assistant professor of comparative literature at Queens College, City University of New York.